Montana PEAKS, STREAMS AND PRAIRIE

A NATURAL HISTORY

E. DONNALL THOMAS JR.

Foreword by

DOUG & ANDREA PEACOCK

THE
History
PRESS

Published by The History Press
Charleston, SC 29403
www.historypress.net

Front cover, clockwise from top left: Mountain goat in Glacier. *Photo by Tim Rains, courtesy of the NPS*; Lewis's woodpecker. *Photo by Mike's Birds (https://creativecommons.org/licenses/by-sa/2.0/)*; Lamar Valley wolf with black fur. *National Park System photo by Jim Peaco*; Soda Creek, Lamar Valley. *Public domain.*

Back cover, clockwise from top left: This handsome fellow was the first Arctic grayling to be collected in our fish trap this season (April 23, 2014). The trap, located on Red Rock Creek, Red Rock Lakes National Wildlife Refuge, Montana, is one of the sampling and monitoring methods utilized by Montana Fish and Wildlife Conservation Office personnel to assess fish population trends. The Fish and Aquatic Conservation Division of the U.S. Fish and Wildlife Service has been assisting with monitoring this unique population of Arctic grayling for nearly two decades. *U.S. Fish & Wildlife photo by Andrew Gilham*; The National Elk Refuge's Outdoor Recreation Planner witnessed a spectacular standoff between two juvenile mountain lions and five coyotes. The coyotes let the cats know they weren't welcome in the area. The mountain lions sought safety on a buck and rail fence for over an hour while the coyotes lurked in the background. Here, one of the coyotes has moved in closer. Notice the flattened positions of the mountain lions. *U.S. Fish & Wildlife Service photo, by Lori Iverson*; The Continental Divide in the Anaconda-Pintler Wilderness. *Photo courtesy of Ryan Jordan.*

First published 2015

Manufactured in the United States

ISBN 978.1.46711.755.5

Library of Congress Control Number: 2015944407

Notice: The information in this book is true and complete to the best of our knowledge. It is offered without guarantee on the part of the author or The History Press. The author and The History Press disclaim all liability in connection with the use of this book.

To our parents, Ben and Darlene Beaudry
and the late Dorothy and E. Donnall Thomas

CONTENTS

FOREWORD

*T*here has never been a more urgent time for a wide-ranging overview of Montana's natural history. Our climate is in flux with the early signs of global warming manifest in our mountains and watersheds, clearly visible in Glacier National Park's melting ice fields and the near-total loss of whitebark pine forests throughout their range. Continuing droughts are predicted for the state, and with them comes wildfire. Plants and animals of all species face challenging habitat changes, the need for rapid adaptation and, for many, extinction.

To comprehend these changing times, and perhaps help mitigate some of the more dire effects of climate change, we need a modern baseline of understanding. A practical compendium of Montana wildlife is a necessity, told by a worthy guide, literate in the science of wildlife biology and management but also with the authority and personal touch of an elder spinning fables around the campfire.

A trusted guide as author is critical. If we had the choice of a wildlife biologist, game manager, tree-hugging animal lover, mechanized big-game shooter or Native American subsistence hunter, we'd go with the aboriginal point of view. But that voice is hard to find and seldom writes books. Our own nominee is E. Donnall Thomas Jr.

That's because Don Thomas's life encompasses all these experiences, and his is probably closest to that old-time hunter. Physician, commercial fisherman, guide, photographer and longbow hunter extraordinaire, Thomas has spent his adult life in the wild outdoors. As a longbow hunter

and hunting guide, he has probably spent as much time observing—just watching—wild animals as anyone we know. To succeed as a traditional bow hunter, you need to learn the habitats and behavior of the animals you have selected, scent the wind and begin the long stalk, then silently creep close enough to make the clean kill—or not, in Thomas's case, if conditions don't meet his strict self-imposed standards. This man doesn't care how many fish he has caught.

The organization of this book is simple, efficient and comprehensive: "High Country," "Timber and Mountainsides," "Prairie," "Rivers and Streams" and, of course, "The Top of the Food Chain"—the eagles, wolves and bears that roam, or roamed, all over the state and up and down the peaks and valleys. This division of landscapes into provinces and their respective food economies is as an organic way of looking at the land that we know, not unlike the viewpoint of that aboriginal hunter.

Thomas's efficiency carries over into language. He nails the essence of grizzly behavior in a single sentence: "The high-protein calorie content [in foods like salmon]…has allowed brown bears to grow larger than their inland cousins and reduced their need to compete intensely for food." Inland grizzlies, like those in and around Glacier and Yellowstone National Park, have a leaner diet and "more aggressive behavior." You could read a number of good books or many dozens of scholarly studies on the subject, but you'd come to the same nut of a conclusion.

Similarly, what is the value of a top predator like a wolf? The usual argument is economic, polarized with monotonous animosity, ranchers versus out-of-state environmentalists. Thomas suggests otherwise; the wolf's howl is important because of "the sense of wildness it enforces." He speaks of Alaska: "No sound that has ever reached my ears has made me appreciate my surrounding more."

We met Thomas a decade ago when he agreed to be interviewed about hunting brown bear with a traditional longbow in the Russian Far East for a book we were writing about grizzly-human relationships. Thomas invited us to his home in Lewistown, Montana, in the lush Judith Basin, overlooking the Big Spring Creek watershed, within sight of some of the most beautiful and under-used mountain ranges in the state: the Snowies, the Belts, the Judith and the Highwoods. Though he might have felt some trepidation about a conversation on bear hunting with Doug, he was generous with his time and his story, inviting us back for another visit to learn more about traditional bowhunting.

The tale Thomas told us of his Russian bear hunt radiated courage. He went after one of the largest predators on the planet armed with

"a stick and a string." A devotee of fair-chase hunts, he did everything ethically: the tracking, the stalking, the actual killing—all were faultless. But something nagged at both of us—something about the privilege it takes to set up a hunt like this felt like an indulgence and not a good enough reason to kill. In the intervening years, Thomas writes us, he's re-thought his feelings as well: "My attitudes have evolved significantly since then, and while I'm not recanting anything I said then I'm not sure I would respond in quite the same way now. In fact I'm sure I wouldn't. I think it would make for an interesting discussion."

This is what makes Thomas's work so valuable. He approaches the landscape with an open mind. He sees what's there, not what he expects. He challenges himself physically and intellectually and brings us all along on the journey. We're really looking forward to that discussion.

At a time when the looming catastrophe of climate change threatens to overwhelm and dishearten, perhaps the most effective campaigns are those to save our remaining wild lands. In doing so, we give other species a fighting chance and ourselves some remnants of our original homeland. It's a service to the planet, and armed with the kind of knowledge in this book, it's a fight we can win.

— Doug and Andrea Peacock are Montana authors whose latest book is *In the Shadow of the Sabertooth: Global Warming, the Origins of the First Americans, and the Terrible Beasts of the Pleistocene*

ACKNOWLEDGEMENTS

*M*any people contributed factual information and constructive criticism while I was preparing this text. At the risk of a regrettable omission, I would like to thank the following: Ed Arnette, Ed Bangs, Mike and Karen Hoffman, Mona Longknife, Tom McGuane, Doug and Andrea Peacock, John Roseland, Diana Six, David Tetzlaff and Ken Smoker.

My old friend Dick LeBlond, whose background in both biological science and the outdoors mirrors my own, boldly volunteered to review this entire manuscript for accuracy, for which I cannot thank him enough.

Special thanks to Artie Crisp, who conceived this project and whose enthusiasm and energy brought it to fruition. Thanks as well to Darcy Mahan for her precise editing.

INTRODUCTION

*H*ardly anyone reads introductions, and if I were not a writer myself, I wouldn't either. The fact that you are here confirms that you are an exception to the rule, and for that I am grateful.

The introduction offers the author a unique opportunity to speak to the reader personally and explain the workings of the text that lies ahead. That kind of intimate conversation is important to an understanding of what follows here.

Despite my lineage (my father received the Nobel Prize in Medicine in 1990), I am painfully aware that a discussion of even the most exciting science can grow tedious. Anyone or anything can tell you what an average mountain goat weighs, including your computer. In the text that follows, my intention is to introduce the reader to a broad cross section of Montana wildlife while conveying some of the personal excitement I feel in its presence. The scientific facts—the average weight of a mountain goat, for example—are important, but they can take you only so far. Among other things, scientific facts have a nasty habit of proving false with the passage of time. My goal is to present the wildlife science to the best of my ability but also to supplement it with personal observations derived from a lifetime spent outdoors, much of it in Montana.

My intense interest in wildlife and wild places began as a child, for I grew up in what was very much an "outdoor" family. A lot of that outdoor activity involved hunting and fishing, pursuits in which I still actively engage. This is not a book about those subjects specifically, and readers averse to the idea of killing their own dinner rather than paying someone else to do it for them should not worry about encountering material they might consider offensive. However, many of the wildlife observations described in this text

were made during the course of such activities, and in the interest of full disclosure, I wish to acknowledge as much here.

This book's geographic scope deserves comment. It refers to "Montana" wildlife because we needed to draw an arbitrary line somewhere. All of the species described enjoy ranges that extend well beyond the state's borders, and almost all that is said about them here applies wherever they are found. Yellowstone National Park is not technically part of Montana. However, wildlife does not appreciate this distinction, and Montana and Yellowstone have enjoyed such a long cultural association that I have chosen to ignore the distinction too.

Biological science is often less precise than one might think. Ideas about wildlife change constantly, particularly with regard to subjective elements like names and subspecies divisions. To the best of my knowledge, the information presented in this text was accurate at the time it was written, but that does not guarantee its accuracy at the time it is read. Biologists change their minds all the time. The frequent inclusion of scientific names may seem like a distraction, but it is my experience that common names can be so confusing that a fixed reference in the nomenclature is often useful.

I have made a point of including wildlife perspectives from the region's original human inhabitants, and in doing so I sometimes use the terms "Native American" and "Indian" interchangeably. I have spent seven years living and working on two different Montana reservations and have strong ties to those communities. On numerous occasions, friends there have told me, "We're Indians. We call ourselves Indians. You should too." I do so not out of ignorance or insensitivity but because that's the way it is.

At the completion of this text, I realized that two themes received more attention than I originally intended. The first is the social and political controversy surrounding some of the species profiled. While I would much rather write about the animals, it is impossible to discuss wolves, grizzlies and bison in Montana today without addressing controversial aspects of their management. When doing so, I attempted to confine the discussion to biological and historical facts while leaving the polemics to others.

The second theme that caught me somewhat by surprise concerns the number of species that have been, or likely will be, listed as threatened or endangered according to the terms of the Endangered Species Act (ESA from here on). This suggests an atmosphere of gloom and doom that is not really accurate. Populations of most Montana wildlife are stable or thriving. However, it would be irresponsible to write about species like fluvial grayling, greater sage-grouse and bull trout (among others) without reminding readers of the work that must be done in order to keep them part of the Montana wildlife landscape for future generations.

PART I
HIGH COUNTRY

Chapter 1

FROM ISLAND RANGES TO THE CONTINENTAL DIVIDE

*M*any first-time visitors think Montana is covered in mountains, and why not? That's what the state's name means. Our two great National Parks lie in mountainous terrain, as do our destination ski resorts. Our famous trout streams arise in the mountains and run through their foothills, and while most of them eventually reach the prairie, they don't hold much besides catfish and carp once they get there (or so most visiting anglers think, but that's another story). In fact, only about a third of Montana is mountainous, and most of those mountains are concentrated in the western part of the state. Much of our most interesting wildlife inhabits the seldom-visited open country to the east, as I hope readers will appreciate by the time they finish this book. However, it would be impossible to review Montana natural history without discussing mountain wildlife habitat. We'll begin by looking at some geologic curiosities that blur the distinction between eastern prairies and western peaks: central Montana's island mountain ranges.

"The earth hath bubbles, as the water has," Banquo observes of the three witches in Act 1 of Shakespeare's *Macbeth*. I cannot think of a better brief description of interesting geologic formations called laccoliths. Before we can discuss their origins, we have to go even further back in time. In the beginning, God created—well, maybe not that far back. Let's settle on the Paleozoic Era starting some 500 million years ago, when shallow seas intermittently covered most of eastern Montana. Shorelines created beaches, beaches created sand and sand created sandstone that eventually became overlain by layers of limestone as countless generations of marine organisms died and returned

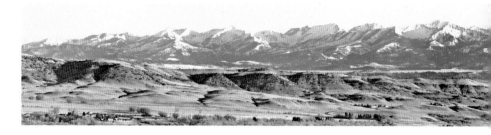

South face of the Crazies. *Photo by Mike Cline.*

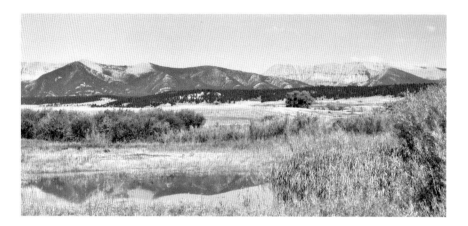

Big Snowy Mountains near Judith Gap, Montana. *U.S. Forest Service photo by Roger Peterson.*

their calcified shells to the earth. Further accumulations of organic debris added seams of shale to the mix—currently the subject of intense interest to the energy industry. The result of all this geologic evolution was a superficial crust containing parallel strata of sedimentary rock by the time of the mid-Cretaceous period of the Mesozoic Era roughly 100 million years ago.

Considerable igneous activity then occurred in the region. Lava flows and volcanoes spouting fire and ash are the most visible expression of such events and hence the best known, but hot magma from the earth's core doesn't always reach the surface. When hard igneous rock pushes vertically upward through sedimentary strata, it produces a dike. When it moves laterally between or sometimes across layers, it creates a sill. When a sill finds a soft spot and creates a large bulge of igneous rock beneath the upper sedimentary layers (often aided by a magma feeder from below), it creates a laccolith—just the kind of bubble in the earth Banquo noted in references to the witches that undid Macbeth.

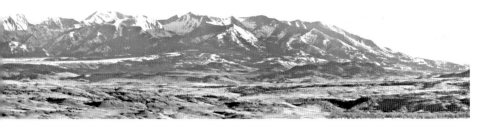

When large or confluent laccoliths rise above the surrounding plains, they form isolated island mountain ranges distinct from contiguous mountain ranges like the Rockies. Over time, erosion removes the softer layers of overlying sedimentary strata leaving varying amounts of hard igneous rock exposed. Central Montana contains nine island ranges, or eight if you discount the Crazies, which lie closer to the Rockies than the rest. I can see five of them from my home in the foothills of the Big Snowy Mountains. While the Snowies are one of those nine island ranges, they are not laccoliths but a buckle in the surrounding sedimentary strata. Around 65 million years old, they contain no igneous rock.

In addition to the Big Snowy Mountains, the Judiths, Highwoods and North and South Moccasins all lie within a hundred-mile radius from the center of the state. The Little Rockies, the Bear Paws and the Sweetgrass Hills sit farther north, between the Missouri River and the Canadian border. Access for visitors isn't always easy because most are nearly surrounded by private land. Nonetheless, they dominate the local scenery and provide a remarkable diversity of wildlife habitat in an area that would otherwise be an uninterrupted prairie landscape.

The island ranges may be quiet, sleepy places today, but that was hardly the case a century ago. Hot magma brought a variety of minerals with it from deep within the earth's crust, including heavy metal ores. After the collapse of the fur trade (see chapter 8), mining drove much of Montana's young economy, as evidenced by the state motto, *Oro y Plata* (Gold and Silver, for those who have forgotten their Spanish). The Little Rockies, North Moccasins and Judiths were particularly important mining centers during the late 1800s. By 1900, the Judith Mountains contained ten mining towns, each with its own surprisingly sophisticated infrastructure. All ten lie abandoned today. (These mountains derive their name from the nearby Judith River, so named in honor of his girlfriend by William Clark, of whom we shall hear much more in the text ahead. Unfortunately, the young woman's name was actually Julia. It's a guy thing.)

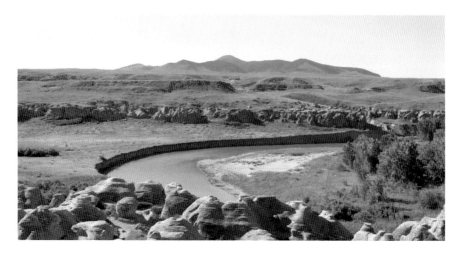

Looking south over the Milk River toward the Sweetgrass Hills. *Wikicommons public domain.*

Grain elevator in the Highwoods. *Courtesy of Dean Kershner.*

In the North Moccasins, the mine near the once thriving town of Kendall (also now long gone) produced gold worth over $1 billion at current prices between 1900 and 1920. Late 1800s gold discoveries in the Little Rockies created the towns of Zortman and Landusky, where some houses stand today. The Little Rockies acquired a special place in the annals of western lore when they served as a base of operations for Butch Cassidy and the Sundance Kid. Gold mining operations resumed in the Little Rockies, Judiths and South Moccasins during the 1980s as newer extraction techniques allowed miners to work tailings and low-quality ore. Most of what local residents derived from these efforts consisted of scars on the mountainsides and concern for the water quality in the streams that drained them.

What remains of Zortman, Montana. *Photo by Carroll Van West, courtesy of montanahistoriclandscape.com.*

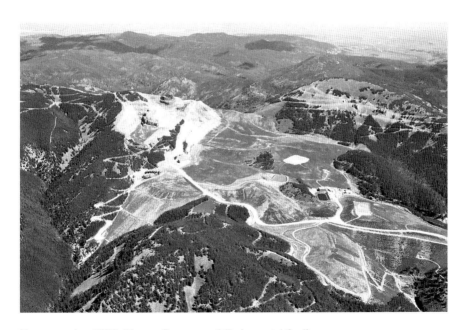

Zortman mine, 2006. *Montana Department of Environmental Quality.*

The Rocky Mountain front in Teton County near Augusta, seen from the eastern side of the Continental Divide. *Photo by Don and Lori Thomas.*

A continental divide is what happens when a large land mass breaks its back and sends rivers flowing to different oceans. The high points along the division between those drainages form lines on the map determined by geology rather than politics. In the continental United States, one such line marks the division between rivers running west toward the Pacific and north to the Arctic or east toward the Atlantic and the Gulf of Mexico. (Montana contains one of the country's two exceptions to this simple linear scheme, which we'll discuss shortly.) That divide begins at Cape Prince of Wales in northern Alaska and runs south all the way to the Straits of Magellan, making it the longest in the world. Some geographers appropriately refer to it as the Great Divide, and a long segment of it runs right through Montana.

Taking an imaginary hike along its course from north to south, we would begin at the boundary line between Glacier and Waterton Lakes National Parks on the Canadian border. The hike south through Glacier runs through some of the most spectacular mountain scenery in the world. At Marias Pass, we would leave Glacier and enter the Great Bear Wilderness, a segment of the Bob Marshall Wilderness Complex, one of the largest federally protected backcountry areas in the lower forty-eight states. The Divide leaves the Bob via the Scapegoat Wilderness near Rogers Pass, where a blizzard always seems to be in progress whenever I cross the Divide by road. There the terrain levels off a bit,

Little Dog, Summit and Calf Robe Mountains above Marias Pass. *Courtesy of Blake Passmore.*

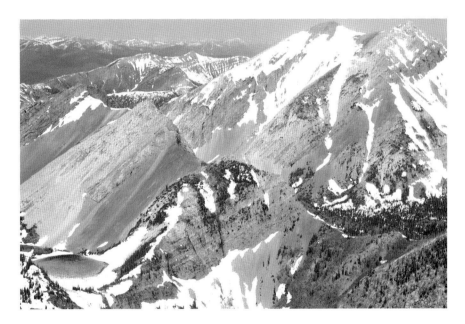

Peaks and a glacial lake in the Bob Marshall Wilderness, Montana. *Photo by Sam Beebe.*

but by the time the Divide reaches the Anaconda-Pintler Wilderness, it's back to serious up and down in the Anaconda Range. We would then reach the border between Montana and Idaho (the Divide defines that border from this point south) at Lost Trail Pass and continue through the Beaverheads and then the Centennials until entering Wyoming at

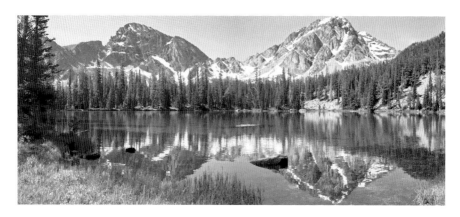

Maloney Lake in the Anaconda-Pintler Wilderness. *Courtesy of Pete Ferranti.*

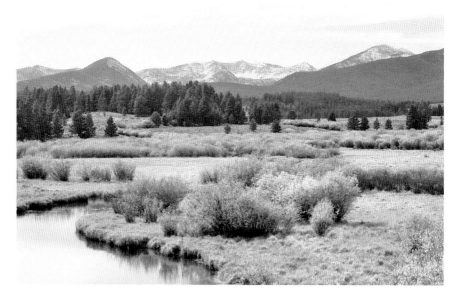

Beaverhead-Deerlodge National Forest, Montana. *U.S. Forest Service Northern Region photo.*

Yellowstone National Park. At this point, we would definitely be very tired and probably very happy.

One unique feature of Montana's geography lies atop Triple Divide Peak in Glacier National Park. Here the Great Divide meets the Laurentian Divide, which separates water flowing to the Arctic Ocean and Hudson's Bay from water flowing to the Atlantic and the Gulf of Mexico. Theoretically, there is a point (as when any two lines intersect)

The twenty-eight-thousand-acre Centennial mountain range, which forms the boundary between southwest Montana and Idaho, is some of southwest Montana's wildest country. Designated as an Area of Critical Environmental Concern in 2006, it is considered an important corridor for wildlife movement, providing an east–west trending mountain range connecting the Yellowstone ecosystem with the rest of the northern Rocky Mountains. *Bureau of Land Management California photo by Bob Wick.*

on top of Triple Divide Peak from which a raindrop could wind up in the Pacific, Hudson's Bay or the Gulf. This isn't the country's only triple divide—another one lies at the intersection of the Laurentian Divide and the St. Lawrence River Divide near Hibbing, Minnesota. But water from Triple Divide Peak can reach the sea at far more distant locations than rain falling on the divide in Minnesota, so I am arbitrarily declaring Montana's Triple Divide Peak the more remarkable example of this rare accident of geography.

Mountain divides separate other things besides raindrops, including people and the way they live. Consider Washington State, where I spent my later childhood and received much of my education. To the west of the Cascade Crest: temperate rainforest, Microsoft, Starbucks, Seahawks. To the east: cold desert, wheat farms, cattle. A similar phenomenon plays out in Montana, although the cultural divide parallels the geographic version by about one hundred miles to the east. To the west: colleges, Subarus, NPR radio, vegetarian sections in restaurant menus. To the east: pickups with gun racks, cowboy boots, chicken-fried steak, "Impeach Obama"

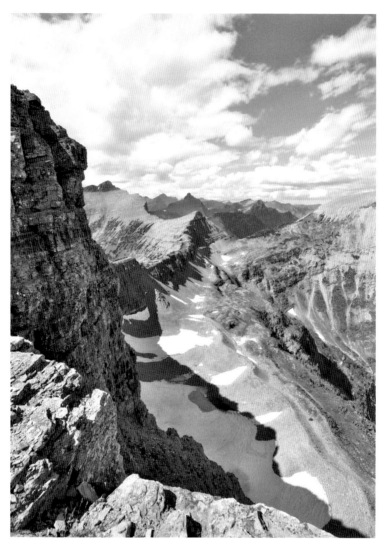

The three bowls of Triple Divide Peak, viewed from Razors Edge, send falling rain to the Pacific, Hudson's Bay or the Gulf of Mexico. *Photo courtesy of Anders Olsen.*

bumper stickers. Like all stereotypes, these are subject to frequent exception, but if you subscribe to Jared Diamond's view that geography determines culture, Montana offers great supporting evidence.

Now that we have reviewed some geographic facts about Montana's mountains, let's move on to an even more interesting topic: the wildlife that inhabits them.

Chapter 2

MOUNTAIN GOAT

Oreamnos americanus

As acknowledged in the foreword, many of the observations noted in this book came about while I was hunting or fishing. Neither of those activities is our subject here, since this volume is devoted to wildlife and habitat. Nonetheless, I am going to begin this chapter by describing the first day of my first wilderness hunt after I moved to Alaska in 1980. Non-hunters need not worry. No goats were harmed in the making of this chapter. What follows tells little or nothing about hunting mountain goats with a bow, but it tells plenty about the places where these fascinating animals live.

After flying in to a glacial lake just above the Prince William Sound tideline, a friend and I set up camp, cooked dinner and began to glass the surrounding peaks during the long northern twilight. Goats were everywhere, and we laid ambitious plans for the morning. I'd spotted several mature billies high in the alpine about two miles away to the north. Young, in shape and new to Alaska, I estimated that I'd reach them easily before noon, an assumption that shows just how little I knew about goat country. The following morning, I wished my companion the best, and we set out in different directions.

I spent most of the morning thrashing my way through a mile of remarkably nasty alders. Then I had to pick my way through the boulders forming the terminal moraine of a large glacier. Late that afternoon, I finally began to climb toward a goat far above the valley floor. The ascent began easily enough, but eventually I was facing nearly vertical rock faces that should have called for technical climbing gear. Thanks to a mix of determination and stupidity, I pushed on.

At that latitude, August days seem to last forever, and plenty of light remained when I finally peeked over the last rim of rock beside the little basin where I expected to find the goat. And there it was, grazing on tufts of grass protruding from the rock. Two problems remained. The goat was still sixty yards away, over twice my maximal range with a longbow. A chasm whose depth I had not appreciated from below separated us, and I saw no way around or across it. I then made one of my few intelligent decisions of the day and decided to turn back.

Experienced mountaineers know that going down is often harder than going up. That is especially true when you have no climbing gear and light is draining from the sky. Slipping and sliding, I "cliffed-out" several times, forcing me to retrace my steps back up the mountain. By the time I reached the valley floor, darkness—such as it is during August in Alaska—had fallen. Since I had packed no overnight gear (a stupid mistake I never repeated), I decided to push on toward camp. I knew that if I continued down the fall line I would reach the lake and that if I turned left and followed the shore once I got there I would reach the comfort of my tent.

Unfortunately, I had once again underestimated the terrain. After fighting my way through more alders than I thought the world contained, I did reach the lake, although I didn't know how far I was from camp. The shoreline offered no relief, since it consisted of nothing but brush and steep, sharp rock that forced me into waist-deep water as I forged ahead. (Yet another stupid mistake.) I finally admitted that I had hit the wall and curled up on top of the softest boulder I could find, thankful that northern summer nights are as short as the days are long. When I finally set out again once I could see, I realized that I had "siwashed" just a few hundred yards short of camp.

Welcome to mountain goat country.

———————

Montana's large mammals derive from two basic points of origin. Some, including the black bear, coyote and pronghorn, evolved in the New World. Others' ancestors, such as those of the moose, grizzly and bighorn sheep, crossed the Bering Sea land bridge from Asia tens of thousands of years ago. The mountain goat belongs to the second group, although today it is found nowhere other than North America.

The mountain goat has puzzled biologists since the animal's first encounter with western science. In a theme repeated throughout this

book, that initial meeting came—at least partially—courtesy of the Lewis and Clark expedition. Clark spotted one once as noted below, but Lewis never did. Nonetheless, on August 24, 1805, Lewis noted the following while among native people near what is now Lemhi, Idaho. (Note throughout this book that the original spelling, punctuation and grammar in the Lewis and Clark *Journals* are always imaginative.)

> *I have seen a few skins among these people which have almost every appearance of the common sheep. they inform me that they finde this animal on the high mountains to the West and S.W. of them. It is about the size of the common sheep, the wool is rather shorter and intermixed with long hairs particularly on the upper part of the neck. These skins have been so much woarn that I could not form a just Idea of the animal or it's color, the Indians however inform me that it is white and that it's horns are lunated comprest twisted and bent backward as those of the common sheep…I am now perfectly convinced that the sheep as well as the Bighorn exist in these mountains. (Capt. C. saw one at a distance today.)*

Based on minimal evidence, Lewis made his usual accurate observations about the hide and, by inference, the animal, although he incorrectly classified it as a sheep. He was not the last to make this mistake.

Lewis later bartered with the Indians along the Columbia for some mountain goat specimens, which returned to the east along with the rest of the expedition's monumental biological haul. They eventually wound up in the hands of Philadelphia naturalist George Ord, along with the first specimens of the grizzly and pronghorn to reach western science. In 1815, Ord published his observations in the *Journal of the Academy of Natural Sciences*, along with the following tribute to Lewis: "It is to Captain Lewis to whom belongs the honor of having been the first to assure his countrymen by the exhibition of a genuine specimen that the animal does exist." Ord named the animal *Ovis montana*. Unfortunately, the genus *Ovis* refers to sheep, as anyone who remembers their Latin knows. Ord had unwittingly repeated the erroneous classification Lewis had made in the field ten years earlier.

The French zoologist Henri de Blainville, a protégé of the great comparative anatomist George Cuvier, eventually gave the animal its current scientific name. But even he got it wrong, since part of that name derives from the Greek *amnos*, or lamb. While the mountain goat has no immediate relatives anywhere in the world, it resembles the European chamois more than anything else. (Recall the mountain goat's original Eurasian origins.) To

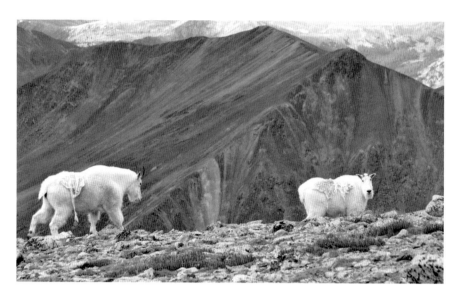

Mountain goats in Glacier. *Courtesy of Bob Sihler.*

the extent that the biologically unique mountain goat belongs to any family, it is not a goat but an antelope. And to further the confusion, the pronghorn is not an antelope but a goat. I hope I have made all of this clear.

A rose by any other name…Let us move beyond this record of taxonomic confusion and look at the animal and the places where it lives. The mountain goat, like the paddlefish described in a later chapter, looks like it came from another planet. With good reason—it is a striking animal, and there's nothing else like it in the world.

Although a mature billy stands only about three feet tall at the shoulder, goats (as I shall call them) are bigger than they look. Occasional males will tip the scales at over 300 pounds, and most will weigh around 250. Nannies are about 30 percent lighter. Distinguishing between sexes can be difficult for those unfamiliar with the species. Both sexes have horns, but the bases of the males' are thicker and carry their width farther out toward the tips. Observing urination posture is the most reliable way to make the distinction for those who haven't looked at lots of goat horns. Females squat by lowering their hindquarters, while males stretch their front legs forward while keeping their back legs stationary.

Goats are well adapted to their preferred cold, high alpine environment. Their off-white coats consist of two layers: fine, dense wool beneath long, hollow guard hairs. The insulating qualities are remarkable, which is no doubt why Lewis found their hides so popular among the Indians. Goats

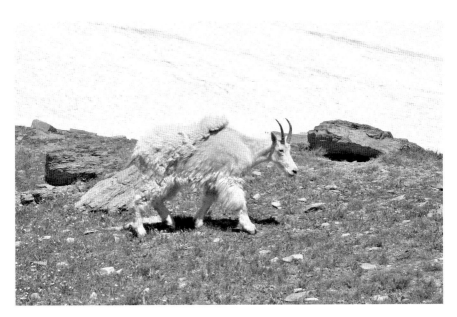

Mountain goats shed their winter coats during the spring. This nanny is only about halfway through the process on July 15. *National Park Service photo by David Restivo.*

shed large quantities of hair during the summer, and clumps of white hair on brush can be a reliable indicator of goats in the vicinity. In their summer coats, goats look crew cut, like new recruits in the military. To appreciate the length and thickness their hair attains, one needs to observe them on their winter range.

The construction of their cloven hoofs represents another splendid adaption to their challenging habitat. The two lobes spread apart widely, and soft inner pads provide additional traction on rock. Prominent dewclaws help keep them from slipping backward. While the ability of wild sheep to scale cliffs is legendary, mountain goats frequently occupy even more rugged terrain. Watching a group of goats scamper up, down and across nearly vertical rock faces that offer no apparent footholds can be a breathtaking experience. Even young kids do it well. Nonetheless, falls are a significant source of mortality during a goat's first year of life.

The ability to occupy such formidable escape habitat allows goats to elude most potential predators. However, there are exceptions. When goats descend below tree level, as they sometimes do to escape snow, stay cool in the summer or visit mineral licks, wolves and bears occasionally kill one. Some observers have reported goats successfully defending themselves during these attacks and even killing larger predators with their horns. I have never seen

East face of the Crazies. *Photo by Mike Cline.*

evidence of such events, which are certainly rare. The most lethal predator goats face is the mountain lion, a superb stalker capable of reaching goats in rugged terrain. I have often been amazed by the number of cougar tracks I've seen at high elevations in goat country. Next to lions, the goat's most significant predators are golden eagles (see chapter 30), which are powerful enough to grasp kids with their talons, drag them off ledges and drop them to their deaths before feeding on the carcasses.

The natural range of the mountain goat extends south from southern Alaska through British Columbia to Washington, Idaho and Montana. Transplants have successfully introduced self-sustaining populations in a number of western states as far south as Colorado and as far west as Washington's Olympic Peninsula (where one of the rare documented instances of a goat killing a human took place in 2010). In Montana, the goats' native range runs between the Continental Divide and the western border of the state. Between 1941 and 2008, Montana state biologists transplanted a total of 495 goats to over twenty different mountainous areas as far eastward as Carbon and Fergus Counties. Many introductions proved successful, but goat populations in isolated mountain ranges tend to fluctuate erratically due to local climate extremes and lack of genetic diversity. As Montana's goat population expanded, some were sent south to establish populations in Colorado and Wyoming.

Those transplants required a lot of human effort and expertise. Biologists initially trapped goats in wooden pens at salt licks and caught others with hand-thrown nets. By 1984, net guns fired from helicopters were being used to trap goats on the National Bison Range. Transportation from source to destination employed trucks, bush aircraft and rafts down the South Fork of

the Flathead River. A vintage photo from the early 1940s shows a string of packhorses carrying goats in wooden crates, one to each side. Those must have been exceptionally docile horses.

Were those transplants biologically justified, or were goats being artificially introduced to areas where they did not belong? The locations that received them certainly contained suitable goat habitat. The fossil record does not confirm whether goats were never present in those areas or were subject to recent local extinctions. These introductions certainly broadened the mountain goat's range and increased its numbers in Montana and elsewhere. Readers will have to answer the question for themselves.

<p style="text-align:center">≻∞≺</p>

The day after my first Alaska goat misadventure, I made myself a solemn promise that I would never enter mountain goat habitat again. Fortunately, I had my fingers crossed. Alpine goat country proved irresistible, and I've spent plenty of time there since, including twenty-eight mostly solo nights in central Montana's Crazy Mountains in 2005. The fact that I survived proves that I'd learned a lot about goat country since 1980.

Mountain goats are spectacular, biologically unique large mammals, and watching them cavort effortlessly across the cliffs they call home is a wonderful experience. Fortunately, more casual wildlife observers need not go to the extremes I've described in order to see them. A well-marked pullout on the south side of Highway 2 just east of the Glacier Park border leads to an observation platform overlooking a heavily used salt lick on the cliffs across the Middle Fork of the Flathead River. During spring

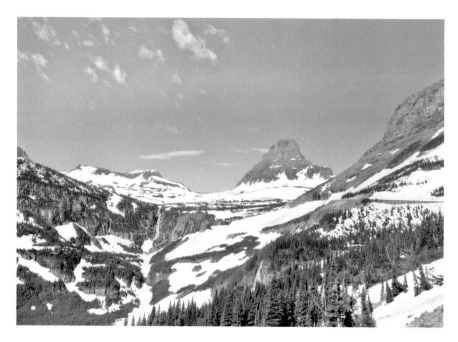

Logan Pass looking from the east. *National Park Service photo by Jean Tabbert.*

and summer, a short walk leads to an excellent opportunity to observe mountain goats. To find goats in more typical alpine habitat, try hiking the Logan Pass trail in Glacier.

The continental population (which is also the worldwide population) of mountain goats is around 100,000 animals, most of them in Alaska and British Columbia. Montana is home to between 2,000 and 3,000 goats, and those numbers appear stable. The nature of their habitat has historically provided them with insulation from human development, but they don't tolerate our presence particularly well. Their future in Montana and elsewhere will depend on our continued ability to allow them the four things Aldo Leopold told us all wildlife needs to thrive: clean air, clean water, adequate food and a place to live.

Chapter 3

ROCKY MOUNTAIN BIGHORN SHEEP

Ovis canadensis canadensis

*T*he two combatants squared off from a range of perhaps fifteen yards, eyes locked, stocky bodies poised motionless like duelists waiting for the signal to raise their pistols and fire. The rams were both magnificent animals, with heavy horns curling up and out far enough to suggest ages between eight and ten years old. Finally, each one raised its head, transferred its weight to its rear legs and stood, balancing upright briefly. Then they sprang forward, snapping their necks down sharply at the moment of impact between their horns.

Although the sound of the collision echoed around the valley like a rifle shot, the ewe grazing placidly nearby didn't even flinch. She had evidently heard enough of that sound recently to become inured to it, for the time was late November and the bighorn rut had been in progress for several weeks. While it was hard to imagine anything surviving the blow each ram had just administered to its rival, both seemed unfazed.

Although the encounter did not appear to produce a clear winner, one of the rams eventually began to sidle up to the ewe, at which point she threw up her head and streaked for the base of a nearby cliff. The natural human tendency is to overestimate the pitch of a slope, but this one honestly looked steep enough so that I wouldn't have tackled it on a dare. Wild sheep see the world in different terms, however, and the ewe didn't even break stride as she hit the nearly vertical face with both rams in hot pursuit.

Two hundred feet above the valley floor, the lead ram suddenly pivoted and stared down at its rival, which stubbornly held its ground. Fascinated,

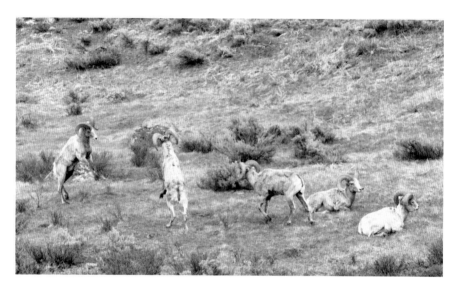

Dueling bighorns charging in the Lamar Valley. *Courtesy of Val Schaffner.*

Opposite, top: Bighorn ewe in Glacier. *Courtesy of Aaron Jones.*

Opposite, bottom: Bighorn sheep ram in Lamar Valley. *National Park System photo by Jim Peaco.*

I watched the earlier battle begin to replay far above. This time around, the lead ram had gravity on its side. At the sound of the second explosive *crack*, the trailing ram lost its footing, slid backward and began a head-over-heels slide down the slope amid a cascade of dirt, snow and loose rock. The fall likely would have killed me, but when the sheep finally came to rest, it rose, apparently none the worse for the licking it had just taken. After a wistful glance back up the cliff, it wandered off while the victor continued uphill in the direction the ewe had taken.

Over the years, I've witnessed many dramatic episodes of conflict involving various species of wildlife, but I've never watched one that left a more lasting impression.

On May 29, 1805, Meriwether Lewis made a journal entry describing "a great abundance of the Argalia or Bighorned animals in the high country." Interestingly, the terrain where he made this observation was

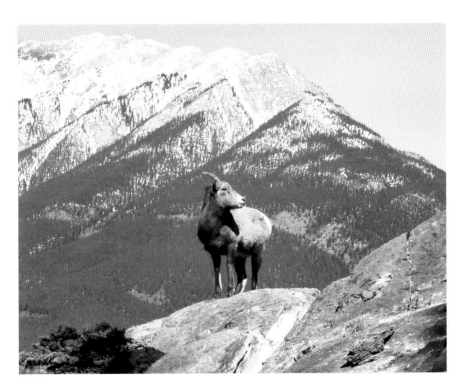

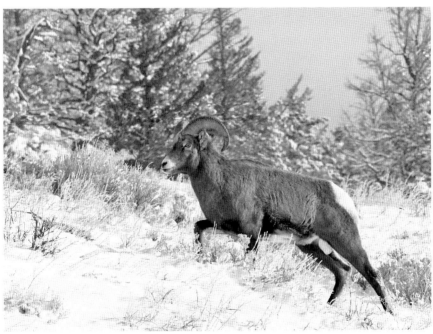

not what we customarily think of as "high country" but the breaks of the Missouri River downstream from what is now Great Falls—the same terrain where I watched those rams battle two centuries later. As valuable as ever in describing what was then as opposed to what is now, records from the Lewis and Clark expedition establish that today's common association of Rocky Mountain bighorn sheep with alpine meadows and soaring peaks, as recognized in their common name, represents a simplification of the species' original range across the West.

The ancestors of two wild sheep species crossed the Beringia land bridge from Asia some 700,000 years ago, while a third representative of this stock, the snow sheep (*O. nivicola*), remained behind in what is now eastern Russia. The thin-horned immigrant species became the Dall sheep (*O. dalli*) and its widely recognized subspecies the Stone sheep (*O. d. stonei*), while the thick-horned version became the bighorn. Recognition of distinct bighorn subspecies has varied over time with the usual back and forth between biological lumpers and splitters, but newer evidence suggests that there are fewer than earlier generations of biologists once thought. Scientists now recognize three: the Rocky Mountain Bighorn of

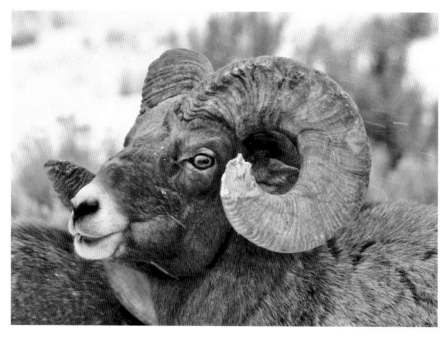

A bighorn ram in Park County, near the end of the annual rut. Note the left horn, which the ram has "broomed" to improve its peripheral vision. *Photo by Don and Lori Thomas.*

this chapter's title (*O. c. canadensis*), the desert bighorn of our Southwest and northern Mexico (*O. c. nelsoni*) and the Sierra Nevada bighorn (*O. c. sierrae*).

While estimates of pre-Columbian wildlife populations always involve a measure of uncertainty, there were probably somewhere between 1 and 2 million bighorns in North America when Lewis and Clark set out for the Pacific. That number had declined to a few thousand by the end of the nineteenth century. The most important factor in that population crash was likely the introduction of domestic livestock throughout much of the wild sheep's range. Domestic sheep and cattle competed with bighorns for forage on their winter range, and wild sheep are particularly susceptible to pneumonia caused by several microorganisms carried asymptomatically in their domestic counterparts. Fortunately, concerted conservation efforts have allowed most bighorn populations to rebound to sustainable levels. Today, only the Sierra Nevada subspecies and the isolated population of desert bighorns that occupies the Peninsular Ranges in southern California are listed as threatened by the United States Fish and Wildlife Service (USFWS).

And then there is the mystery of the sheep that Lewis and Clark encountered in the Missouri River Breaks. The bighorn's historic range extended even farther east than the Montana prairie. Clark referenced their place in Mandan lore on the way up the Missouri in what is now North Dakota, which is where the great painter and naturalist John James Audubon described them on one of his specimen-gathering adventures in 1843. In 1901, naturalist C. Hart Merriam—the descriptor of the western wild turkey that now bears his name—classified the badlands bighorn as a distinct subspecies and named it *Ovis canadensis auduboni*. Canadian biologist Ian Taggart-Cowan reinforced the name and status of this sheep population when he included the Audubon sheep in his then definitive classification of bighorn subspecies in 1940. By this time, the sheep themselves were gone, and the Audubon sheep found its way alongside the heath hen and the passenger pigeon in the annals of American wildlife extinctions.

The extirpation of an animal as regal and striking as a bighorn sheep makes a dramatic story, especially when that animal bears a name as respected as Audubon's. But however regrettable the disappearance of wild sheep from the Missouri River Breaks and the Dakota badlands, the tale as rendered then suffered from an important flaw. Newer science suggests that the fabled Audubon sheep never existed and that the

animals Lewis, Clark and Audubon described were simply bighorns that had expanded their range eastward from the Rockies long before contact with explorers.

The history of wild sheep population numbers in Montana describes a curve with two peaks and a valley between them typical of many wildlife species in North America: staggering abundance prior to European contact, near disappearance by the early twentieth century and gratifying recovery over the next hundred years. By 1940, bighorn sheep were endangered throughout the West. While poorly regulated subsistence hunting certainly contributed to that decline, environmental factors were the prime cause. In 1916, Glacier National Park held 1,500 bighorns, but that number had fallen to 180 by 1965 even though no hunting took place in the park. Massive die-offs due to malnutrition and infectious diseases occurred in the Sun River, Stillwater and Rock Creek wild sheep herds during the 1920s and 1930s.

With the availability of Pittman-Robertson funds derived from a supplemental tax on guns and ammunition in 1941, the Montana Fish and Game Department (now the Department of Fish, Wildlife and Parks) began a concerted program to restore sheep populations. These efforts focused on improving range conditions, purchasing and managing critical winter habitat, separating wild and domestic sheep and transplanting sheep into areas of suitable habitat from which wild populations had been eliminated. Transplants resulted in a mix of successes and failures. One celebrated success took place in the Missouri River Breaks.

The last wild Montana "Audubon" sheep was killed in 1916. The first reintroduction effort came in in 1947, when sixteen Colorado bighorns were released in Garfield County. The herd quickly tripled in size but then disappeared by 1963, most likely due to disease and forage competition from domestic livestock. Between 1958 and 1961, small groups of sheep from several locations in western Montana were introduced into the Two Calf Creek area in Fergus County. They did well initially but experienced a die-off during the severe winter of 1971–72. A few survived, but that population never expanded until it was supplemented by further introductions.

In 1980, twenty-eight sheep were released farther up the Missouri in Fergus County. These animals seemed determined to fill the void left behind when that last ram was killed in 1916. Some promptly swam to the north side of the Missouri, some moved upstream to the mouth of the Judith River and others moved east to merge with the remnants of

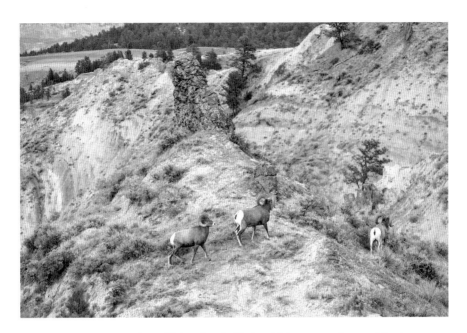

Bighorns in the Upper Missouri River Breaks National Monument. *Bureau of Land Management photo by Bob Wick.*

the original Two Calf herd. By 1995, aerial surveys revealed nearly five hundred sheep in this section of the Missouri Breaks.

Today, Montana's Breaks sheep herd enjoys a national reputation for its quality, a subjective term that requires some explanation. There are many measures of any ungulate population's health, including age structure, winter survival and annual production and survival of newborns, in this case lambs. Since sheep carry true horns rather than antlers and horns are never shed (with the exception of the pronghorn's), the length and mass of a ram's horns correlate well with its age (which can be determined precisely at close range by counting the number of annual growth rings). They also make the animals that carry them an attractive quarry for hunters, who have long held wild sheep of all species in high regard throughout their range in North America.

The expansion of the sheep population in the Breaks provided a biological basis for limited hunting, supervised and carefully managed by the state. While details vary by year and location, this harvest is capped at around one hundred animals, the majority of them ewes, distributed around three hunting districts. Tags are allotted by drawing. Montana law limits nonresidents to 10 percent of the available tags for any limited

drawing hunt, yet the Breaks sheep herd is so highly regarded that thousands of nonresidents apply every year even though the odds of drawing a tag are remote.

Many western states have authorized the auction of "governor's" tags, usually for scarcer game species that cannot be legally hunted without drawing a tag in a random lottery, such as Shiras moose, mountain goats or bighorns. The considerable income these auctions generate are used for game management or, in Montana's case, to provide additional funding for game warden salaries. The Montana governor's sheep tag always commands the highest price of any—over $200,000 for years, a figure that has recently doubled. Although the tag allows the successful bidder to hunt any part of the state that has an open sheep season, hunters who purchase the Montana governor's sheep tag invariably hunt the Missouri River Breaks because of the size of its rams. Hunters willing to pay nearly $500,000 to shoot a sheep obviously aren't going to take the opportunity casually and often arrive in the Breaks with teams of paid guides supported by boats and aircraft. As beneficial as the funds these auctions generate may be for wildlife and their management, at some point one must begin to question their propriety. Two of the six principles that make up the North American Model of Wildlife Management hold that opportunities to utilize wildlife should be distributed democratically and that wildlife should not be bought or sold. By these standards, $400,000 tags that allow the wealthy to bypass the customary lottery procedure would seem to occupy a gray zone at best.

It is December now, and the weather feels appropriate to the calendar. The combination of fog, a low ceiling and a distant sun has reduced the landscape to monochrome—light gray snow, dark gray pines. Lori and I have hiked several miles uphill into the mountainous terrain just north of Yellowstone National Park. In contrast to the Missouri Breaks near our central Montana home, this looks like everyone's idea of wild sheep country, the kind of terrain that justifies including this chapter in the first segment of this book rather than the third. We're hunting sheep with our cameras, and after hours of walking, we've found them.

The snow that made me long for my snowshoes several times during our hike has pushed the sheep down from the highest reaches of their

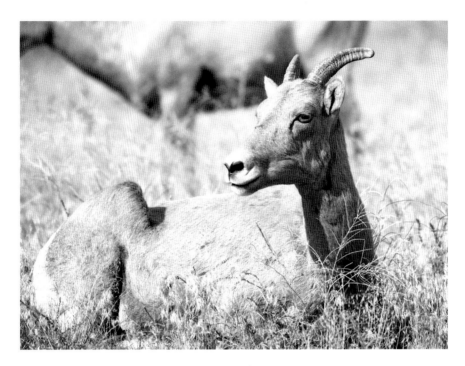

A bighorn ewe in summer. *Photo by Don and Lori Thomas.*

range. The rut is winding down, but rams are still accompanying the ewes. With the raw passions of the previous month behind them, the rams seem to have established an uneasy truce, glaring at one another and making occasional harmless feints without any contact between their horns. The ewes appear as disinterested as ever.

But they are also ungulates that have fed predators for millennia. The Mountain Shoshone who once occupied this high plateau called themselves the Tukudika, or Sheep-Eaters. Sheep meat fed them, sheep hides provided insulation against the brutal winter cold and sheep horns gave them laminates for composite bows. Despite the death of the sheep the Tukudika killed, there was neither good nor bad in this relationship, neither right nor wrong. There was only necessity.

The lesson for today—other than a note to self that I should always strap my snowshoes to my pack when heading into high terrain in December—is that no species can be considered in isolation, not the headline grabbers like bighorn sheep and grizzlies, not the supporting cast members like sagebrush and woodpeckers. Montana's various ecosystems have changed so quickly in the last two hundred years

that nature hasn't been able to keep up. Wildlife needs intelligent, compassionate management of the kind that allowed bighorn sheep to return to the state, from the heights of the Rockies to the floor of the Missouri River Breaks.

Chapter 4

WHITE-TAILED PTARMIGAN

Lagopus leucurus

The climb through two thousand feet of brush deserved a reward, and the broad expanse of open terrain that greeted me when I emerged from the trees provided one. The footing on the way up—thick layers of matted wet grass the consistency of bacon grease—had led to more backward sliding than forward propulsion, but now my boots found welcome purchase on a level base of lichen, moss and heath. Instead of struggling to see ten feet ahead of my face in the heart of bear country, I enjoyed an unobstructed view of an open route. Such are the pleasures of alpine habitat, even though you usually have to work to earn them—or perhaps *because* you have to work to earn them.

My first act was to sit down on a rock and glass the basin for deer. Finding none, I set out for the scree at the base of the nearest peak, walking at a slow, deliberate pace better suited to observation than covering ground. I'd barely made it one hundred yards before a soft, reedy cluck froze me in my tracks. The sound had come from little more than a few feet away, and I knew at once what had made it, but neither proximity nor familiarity helped me spot its source.

The cluck was an alarm call from a white-tailed ptarmigan. Since it was August, when these birds are still gathered in family groups, I knew that a half dozen of them were likely hiding in nearly barren ground cover less than a stone's throw away. But ptarmigan enjoy superb natural camouflage during all seasons of the year, and despite several more resonant clucks, my eyes just couldn't distinguish birds from background. I decided to wait them out.

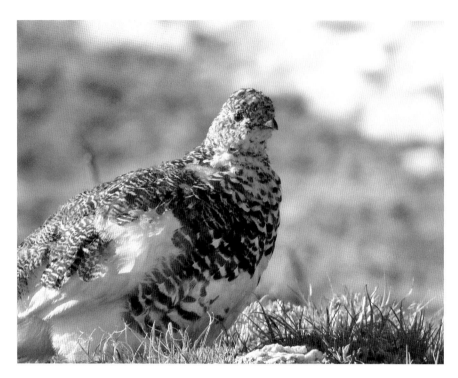

White-tailed ptarmigan in summer plumage. *U.S. Fish & Wildlife Service Mountain Prairie photo by Peter Plage.*

Patience received its due several minutes later when a feathered head popped up out of the tundra, followed by a second and then a third. The birds had endured all the waiting they could take, and as soon as I stepped forward, they erupted in a staggered rise that filled the basin with the sound of wings. White tail feathers flashed in the sun as they sailed across the landscape, confirming what I already suspected about their specific identity.

That encounter took place in Alaska, the state where most of us are likely to see our first ptarmigan even if we're only occasional visitors to the North. Alaska is home to three representatives of this circumpolar family of birds, of which the willow ptarmigan is the most numerous and widely distributed. Chosen as the state bird by Alaska's schoolchildren, the willow ptarmigan (*Lagopus lagopus*), an inhabitant of low-lying tundra and creek bottoms, is also familiar as a subspecies of the British Isles' famous red grouse, as depicted on the label of the scotch brand bearing that name. The rock ptarmigan (*Lagopus mutus*) favors higher, rockier, windswept terrain. Both

of these species occur throughout Alaska. The smallest of the three—and the smallest grouse in North America—the alpine white-tailed ptarmigan occupies a range from the Alaska Panhandle southward. Of interest to us here, it is the only ptarmigan found in the lower forty-eight states.

The three species can be difficult to distinguish on the wing, especially in their white winter plumage. As its name suggests, the white-tailed is the only ptarmigan with white outer tail feathers in all seasons and plumages. But if you see a ptarmigan in Montana, it's a white-tailed, with positive identification guaranteed solely on the basis of range.

While I've seen countless ptarmigan of all three species in Alaska, encounters are rare south of the Canadian border. Colorado is home to most of the white-tailed ptarmigan in the contiguous states. In Montana, ptarmigan are limited to high alpine terrain in the northwestern corner of the state. The white-tailed ptarmigan is the only bird in North America that exclusively inhabits true alpine habitat year round. All of those I have seen here have been in or near Glacier National Park. If you want to look for ptarmigan in Montana, I'd recommend hiking Glacier's Logan Pass trail mid-summer. However, if you're serious about checking ptarmigan off your life list of birds, by all means head to Alaska for the trifecta.

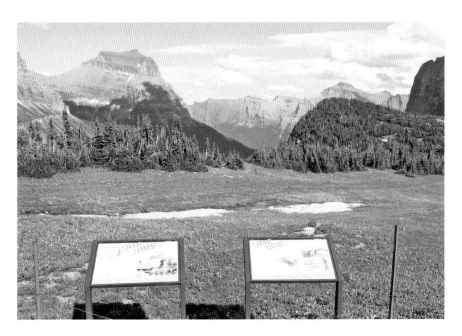

Logan Pass is an ideal location to encounter ptarmigan. *National Park Service photo by Jon Riner.*

Ptarmigan are closely related to sharp-tailed grouse, a far more numerous native of the eastern Montana prairie. Both tend to remain in family groups until early autumn, when they start to coalesce into large, wary flocks. Ptarmigan and sharptails both have feathered feet, which protect their toes from cold and help them walk on top of deep snow during the winter, an ability shared with the snowshoe hare (better

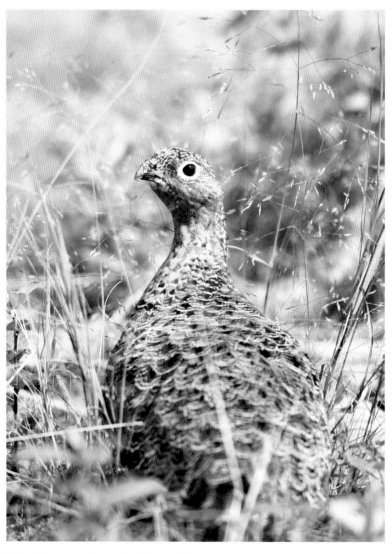

The willow ptarmigan, Alaska's state bird, shows more red in its summer plumage than Montana's white-tailed ptarmigan. *Photo by Don and Lori Thomas.*

known, if incorrectly, as the snowshoe rabbit). The generic *Lagopus* derives from the Greek words for "hare" and "foot." In an unintentional pun, the names for the sharptail and ptarmigan mean "hairy-footed bird" in several Native American dialects.

Ptarmigan are unique among all North American gallinaceous birds in the extent of the color change their plumage undergoes during the course of the seasons. As noted earlier, their summer camouflage is excellent. In his 1909 work on the subject of animal camouflage *Concealing-Coloration in the Animal Kingdom*, Abbott Thayer wrote of the white-tailed ptarmigan:

> *Supremely beautiful and potent is the grass pattern of this same species in summer plumage...The patterns are achieved by light brown marginal bands, with a few small internal spots, on the dark feathers of the upper parts, the predominance of light and dark being gradually reversed as the lower breast is approached.*

By late November, the white-tailed ptarmigan is solid white, while the other two species retain some black on their outer tail feathers. And the birds aren't just sort of white, like mountain goats. If a white purer than a winter ptarmigan's plumage exists anywhere in nature, I have yet to see it. If Herman Melville can write a chapter titled "The Whiteness of the Whale," I should be able to write one titled "The Whiteness of the Ptarmigan." The adaptive advantage this color change confers on birds trying to elude predators on a solid background of snow is obvious.

Despite its low population density and limited range in Montana, white-tailed ptarmigan are not a threatened species anywhere within their range. The birds have been successfully introduced in California's Sierra Nevada, the Pecos Wilderness of New Mexico and Utah's Uinta Mountains. (An introduction attempt in Oregon's Wallowa Mountains proved unsuccessful.) Given the protected status most of their Montana habitat enjoys and the vast tracts of remote wilderness they occupy farther north, there is no specific reason to be concerned about their future at this time.

The ptarmigan's most important predators are raptors and foxes. Adult white-tailed ptarmigan are almost exclusively herbivorous, consuming a wide variety of seeds, leaves, buds and berries during the summer before moving closer to the tree line and surviving on pine needles and twigs over the winter. Newborn ptarmigan chicks, however, subsist primarily on insects, as do the young of many other gallinaceous birds. As they mature, the hen issues a specific call to attract them to herbaceous food sources.

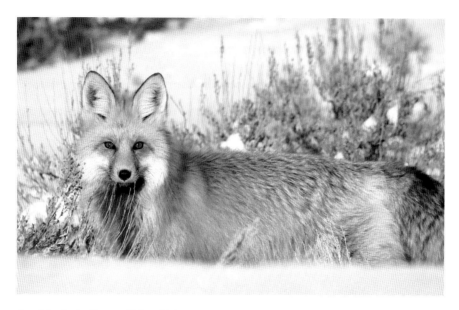

A red fox in the Lamar Valley. *National Park System photo by Jim Peaco.*

With the possible exception of Lewis's woodpecker and the upland plover, the white-tailed ptarmigan is the avian species profiled in this book that readers are least likely to encounter casually. Finding one requires effort to reach its habitat, and even then you'll have to cover some ground and observe diligently. Why bother discussing such an obscure species here?

I will admit a personal bias. I love the Far North and spent the portion of my adult life that I did not live in Montana as an Alaska resident. Ptarmigan represent northern wilderness as surely as the grizzly bear. The fact that they are hard to find here in Montana simply enhances the emotional resonance an encounter with them produces. The presence of the white-tailed ptarmigan in our state should remind us all—visitors and residents alike—that we're closer to the heart of the wild than the maps would have us believe.

I find that reassuring.

Chapter 5

BLACK-BILLED MAGPIE AND COMMON RAVEN

Pica hudsonia and *Corvus corax*

*T*he time was early September, and I was scouting a nearby mountain range for elk. I didn't really care whether I saw or heard any actual animals. Elk leave plenty of signs at that time of year, including rubs and wallows in addition to the usual tracks and droppings. I knew the area well, and I also knew the wapiti were there somewhere.

The forest was predominantly composed of mature lodgepoles interspersed with open meadows, or parks in local parlance. I was hiking down a low ridge between two creek bottoms, zigzagging back and forth as I went to look for rubs and check for water in the streams (there wasn't any). The woods were unusually quiet that day, and the hint of breeze overhead wasn't even strong enough to rustle the pines. The chatter that interrupted the silence when I broke out into the next park sounded raucous and blaring. Stopping abruptly to look, my eyes told me what my ears had already made me anticipate: long-tailed birds with sharply contrasting black and white plumage nattering around in a clump of willows near a low, brushy spot that I thought might still contain water.

I remained motionless and continued to look until I spotted the next thing I expected to see: ravens perched low in the pines across the meadow like glossy, black Christmas tree ornaments designed by Edgar Allan Poe. Suspicions confirmed. Montana's three great avian scavengers are the magpie, the raven and the bald eagle, and I learned a long time ago that whenever any two of the three are concentrated together on or near the ground, there is probably something dead nearby. Because of my innate

Mature trees with open meadow habitat in the Cabinet Mountains. *Forest Service, Northern Region photo.*

curiosity about wildlife, I always want to know what it is, but I do so carefully in bear country.

There weren't any grizzlies in this area, or at least there weren't supposed to be. The presence of the ravens in the trees had still attracted my attention, though. While magpies may flit around a dead carcass chattering at a larger scavenger, ravens usually get off the ground and exercise patience if one shows up. Besides, even a black bear can occasionally become aggressive when guarding a food source. With all this in mind, I wet my finger in my mouth and held it up to check the wind currents, which are always doing something in the mountains even if their direction is not immediately apparent. After noting a suggestion of air movement from the direction of the magpies, I slowly circled around to approach in a way that would broadcast my presence to anything with a nose.

And sure enough. As soon as I picked up a quartering tailwind, a medium-sized black bear exploded from the edge of the brush and tore off across the meadow at high speed, which can be amazingly fast for a squat animal with short legs once it's motivated. After double-checking to make sure there were no cubs in the area, I moved in to examine the cause of the scavenger convention. That turned out to be a dead cow elk. All its visitors had been hard at work, and the carcass was so torn up that I never did determine a cause of death. Even so, the encounter neatly demonstrates how much the woods have to tell you once you've learned to listen.

The inclusion of these two species in the "High Country" section of this book is arbitrary, since both occur throughout Montana at all elevations and in every type of habitat. Despite their obvious differences in appearance, the two have a lot in common. They are both members of the *Corvidae* family of crows and jays and common year-round residents. While both will eat almost anything, their enthusiasm for carrion is so pronounced that all backcountry travelers need to be aware of it, especially in grizzly country. Like most corvids, magpies and ravens are exceptionally intelligent birds that adapt well to new habitat conditions and human presence.

Before proceeding, a definition of terms. The West is home to two species of magpie and two species of raven. Both the yellow-billed magpie (*P. nutalli*) and the Chihuahuan raven (*C. cryptoleucus*) occupy limited ranges, in California and the desert Southwest respectively. Neither comes anywhere near Montana. Throughout this text, the terms "magpie" and "raven" will refer to the two species named in this chapter's title.

The magpie has always aroused conflicting emotions from human beings. Lori's grandmother, a tough but delightful ranch wife who traced her Montana lineage back to the pioneer days, hated them, an attitude common in the old-time farm and ranch community. When Lori was a little kid, her grandmother paid her to collect and destroy magpie eggs around the barn. On the other hand, a Montana legislator once introduced a bill to change the state bird from the meadowlark to the magpie. His main objection to the meadowlark was that it doesn't care enough about Montana to stay around during the winter.

Magpies appear to have differentiated from their Eurasian ancestors after they crossed the Bering Sea land bridge around 3 million years ago. The magpie is a distinctive and actually quite beautiful bird, with sharply contrasting black-and-white markings on its body and wings and an extremely long tail. Among North American birds, only the scissor-tailed flycatcher exceeds its ratio of tail to body length. Magpies are very vocal. While a nagging *rek rek rek* is its most familiar call, magpies communicate by a wide variety of vocalizations. They are also good mimics and can imitate a variety of sounds of both natural and human origin. Oddly enough, no one has ever established an adaptive purpose for this form of mimicry. The birds really seem to do it just for fun.

Magpies are always capable of surprising behavior. I was sitting quietly along the brush line next to an open field one cold November

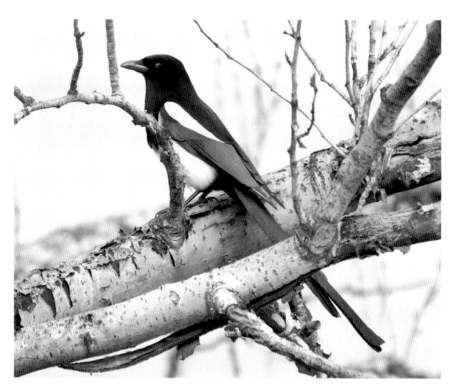

The black-billed magpie. *Courtesy of Kristi DuBois.*

afternoon when a flock of chickadees settled noisily into a tree behind me. Suddenly, a shrike appeared from nowhere, tore through the tree's branches and killed a chickadee as quickly as a trained assassin. As the shrike sat on the snow and went to work on the chickadee carcass with its sharp little bill, a second intruder appeared—a magpie that boldly attacked the shrike while scolding louder than I've ever heard one scold before or since. The shrike retreated at once, and the magpie carried the dead chickadee off into the brush.

Because of their adaptability and aggressive feeding habits, magpies have a long history of seeking out rather than retreating from human contact. They commonly followed Plains Indian tribes across the prairie, living off camp scraps and animal carcasses. To no surprise, the first written description of the American magpie came courtesy of the Lewis and Clark expedition. American naturalists were well acquainted with our magpie's closely related European cousin, but they did not yet realize that a similar bird occupied the American West. On September 16, 1804, Lewis noted that he had

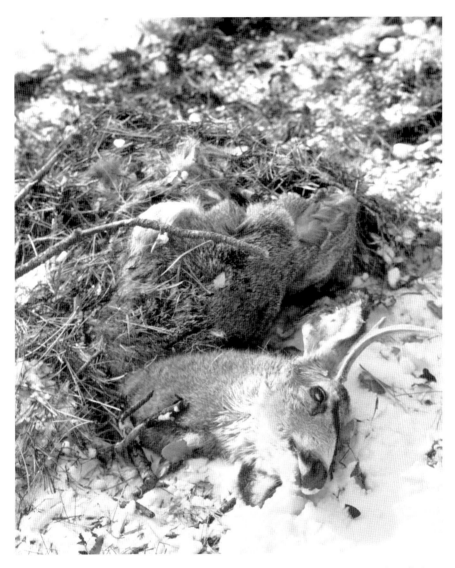

Magpies and ravens both predictably gather near carrion like this lion-killed white-tailed deer. *Photo by Don and Lori Thomas.*

killed "a bird of the *Corvus genus* and order of the pica & about the size of a jack-daw, with a remarkable long tale. beautifully variegated. Its note is not disagreeable but loud—it is twait-twait-twait twait, twait…its head, neck, brest & back within one inch of the tale are of a fine glossey black…the belly is of a beautiful white…the plumage of the tale consists of 12 feathers of equal length."

That certainly sounds just like a magpie to me. Lewis and Clark encountered magpies frequently throughout their journey and made them one of the species commented on most frequently in their *Journals*.

The imaginary raven that croaked at the "nearly napping" Poe was well known in the eastern United States by then and needed no introduction. It is among the most widely distributed of all corvids, with nearly a dozen subspecies scattered about the world. Like the magpie, its ancestors were of Eurasian origin. It is also one of the largest of all passerine (perching) birds, commonly reaching weights of over two pounds at maturity. Because of its size and solid black plumage, the raven is easy to identify, although it can be confused with the crow since relative size can be difficult to determine. Compared to crows, ravens are more solidly built, with a larger, thicker beak; a wedge-shaped tail in flight; and ruffled feathers on the throat. Since both species are vocal and their calls are distinct, vocalization can also be useful in identification. Most of us are familiar with the crow's *caw*. While ravens offer a number of unusual calls, the most familiar is a coarse, throaty *bronk*. They also make an explosive flight call that sounds like *poik poik poik*, reminding me of corks popping from a series of champagne bottles.

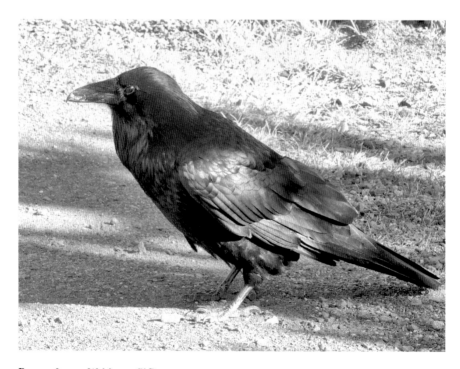

Raven. *Louann W. Murray, PhD.*

Like magpies, ravens will eat almost anything. Because of their taste for carrion, they will follow predators like wolves and cougars to dine off the carcasses of the animals they kill. Road kill and garbage are also favorite food sources. Ravens are also aggressive nest raiders and consume eggs and chicks of many other avian species. That can be a real problem for birds like the endangered California condor. Because of their taste for its eggs, ravens are the condor's primary predator in the wild. Ravens will call other ravens to good food sources, which is why they are often so noisy around animal carcasses.

Ravens fly with slow but powerful wing beats, and I often hear the rhythmic whistle of air through their primaries before I see the airborne bird. They are extremely keen-eyed and often spot me before I see them, even when I am sitting quietly in cover and they are silhouetted against the sky. An approaching raven will usually flare briefly, as if to let me know that it knows I'm there. Despite their customary ponderous flight pattern, paired ravens frequently engage in graceful aerial maneuvers, turning, diving and executing snap rolls in synchrony. These aerobatics take place at all times of year and do not seem strictly related to mating behavior. As with the magpie and its mimicry, the birds just seem to be having fun.

The raven has long been an important symbol in a wide variety of cultural belief systems. In northern European legend, the raven was often associated with death. Native Americans, particularly in the Northwest, had a much more positive view of the raven, which plays central roles in many native creation myths. The traditional Tlingit version credits Raven with bringing the sun and stars into the world by executing a complicated plot to steal light from a selfish old man hoarding it for himself. Variations on this theme are common among native people of the North Pacific coast. The raven is a key figure on totem poles, appearing as a trickster characterized by intelligence, greed, duplicity, curiosity and a vast capacity for mischief.

As noted earlier, intelligence is a characteristic of all corvids. Magpies use twigs as tools to open seeds and nuts. Urban crows have been observed carrying nuts too tough for them to crack themselves to stoplights. When the light turned red, they carried the nuts into the street and placed them in front of vehicle tires. When the light turned green, the advancing vehicle cracked the nuts under the tire and the crows scampered out at the next red light to gobble them up. I'm not sure I could have figured that one out myself.

Ravens may be the sharpest of all. Their brains are among the largest of any bird. Unable to peck through the hide of a large, dead animal, they will call to attract a coyote or bear to the site to do the hard work for them so they can dine on the scraps. They watch other birds—including other

ravens—traveling to and from food caches, memorize those locations and plunder them. In one experiment, investigators tied a piece of meat to a long string fixed to a caged raven's perch. The only way the bird could get the meat was to pull the string up with its beak, step on it to keep it from falling back down, and repeat the process until it had retrieved its reward. Ravens solved this problem easily, without trial and error. So much for terms like "bird-brain" and "feather-head," at least in reference to the *Corvidae*.

Humans have traditionally looked down on scavengers as lazy opportunists that let other species take responsibility for the effort and risk of the hunt for them so they can feed on carrion that would fill us with disgust. But the natural world can be an untidy place, and at the end of the day, someone always has to clean up the mess. If humans did that job as well as magpies and ravens, the world would surely be a cleaner, more pleasant planet.

Chapter 6

HOARY MARMOT

Marmota caligata

*I*was hiking an alpine trail with my camera one day in late July when a piercing whistle shattered the still mountain air. The sound was impossible to ignore, like an ambulance siren or an alarm bell. Brought to an abrupt halt, I began scanning the rocky terrain for its source, fully aware that I was looking for an animal considerably smaller than the noise it had made. That's when I realized that I was unable to localize the origin of the whistle, which could have come from almost anywhere within the basin where I was standing.

The natural urge in such situations is to do something, to forge on in a blind search or climb a nearby rise for a better vantage. But I have learned over the years that the wisest course of action when trying to locate elusive wildlife is to stop, exercise patience and rely on your own senses. After studying the talus along the edge of the meadow for several minutes, I noticed a rock with an unusual contour and soft margins fifty yards ahead. Gradually the visual cues—a beady eye, drooping forelegs, long guard hairs capturing a puff of breeze—coalesced into a recognizable whole. I was looking at a hoary marmot, and the odd mixture of silver and gray in its coat blended in perfectly with the background color of the rock. When I started to ease ahead, another whistle rent the air as several more members of the colony stood and began to study me with what I interpreted as a mixture of curiosity and caution.

Human attention focused on wildlife naturally falls on the glamor species. These are the celebrities of the natural world—the supermodels, headliners

and rock stars. They often epitomize, even subconsciously, human qualities we admire in others and would like others to admire in us: strength, speed, size, beauty. I will not pretend immunity from this phenomenon myself, even though I should know better. In fact, on the morning just described, I was looking for bears and mountain goats, not marmots.

But a thoughtful study of the world around us reveals just how arbitrary such notions really are. A bull elk may strike us as regal, but to a cougar, it just looks like dinner. A beaver may appear to be a large, oddly shaped water rat, but to a vast array of species ranging from trout to waterfowl, the beaver is a benevolent savior working tirelessly to provide them with a place to live—if trout and waterfowl could consider the matter at all, which they can't. Nowadays everyone wants to save the whales, but how many people are campaigning to save the krill on which the whales depend for their survival?

In the text that follows, we will consider some of those glamor species. Grizzlies, sage-grouse and cutthroat trout certainly qualify as such, each in its own way. But I have deliberately chosen to include some wild Montana residents that don't appear on lots of picture postcards and magazine covers—in this case, a seldom seen, largely subterranean mammal that might best be thought of as a squirrel on steroids.

The hoary marmot is not unfamiliar because it is rare but because it inhabits terrain few visit casually. This is a creature of high alpine habitat, and reaching its home usually requires some climbing. Once you're there

Alpine marmot habitat in Glacier National Park. *Photo by Don and Lori Thomas.*

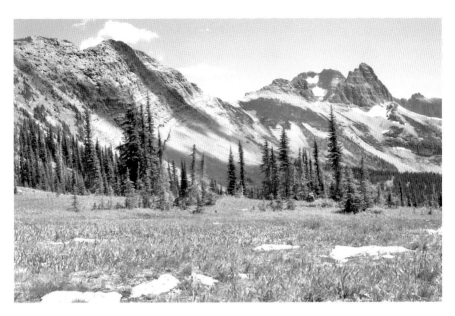

Looking toward Grinnell Glacier Overlook trail from Granite Park on the Continental Divide, prime marmot habitat. *Courtesy of Blake Passmore.*

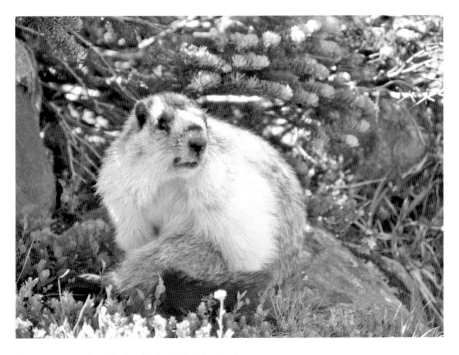

Hoary marmot in Glacier. *National Park Service photo.*

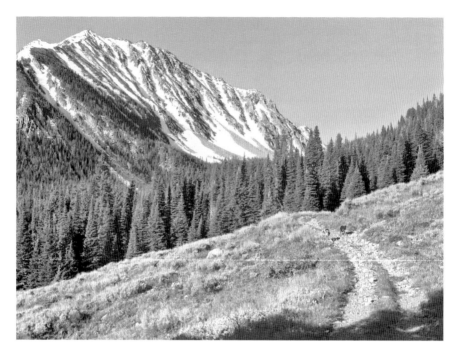

A tree-line, high alpine trail near Bell Lake in the Tobacco Root Mountains. *Courtesy of Dave Glueckert.*

the well-camouflaged marmot is more likely to be heard than seen, and for most of the year it lives hidden underground in a state of hibernation. Nonetheless, hikers traveling alpine trails near the tree line during the summer anywhere between Glacier and Yellowstone will likely encounter them if they pay attention to what their eyes and ears are telling them.

The marmot family contains fifteen species, most of which live in Asia. In our country, the most familiar marmot is the groundhog, or woodchuck (*M. monax*), which inhabits open fields and meadows in the eastern United States. Other than the hoary marmot, the only member of the family native to Montana is the yellow-bellied marmot (*M. flaviventris*), which occupies lower-elevation habitat similar to the woodchuck's.

Most of us think of squirrels as small, bushy-tailed, arboreal rodents, but more squirrel species live on or under the ground than in trees. The hoary marmot is the largest squirrel in North America. Because they hibernate and live off fat reserves during the winter, their weight varies considerably with the season. A typical adult male at its maximum weight in September will tip the scales at fifteen pounds, although exceptional

specimens twice that size have been recorded. Three subspecies live from Alaska south to the Rockies and Cascades, of which only *M. c. okanagana* inhabits Montana, near the southern limit of the species' range.

Hoary marmots are gregarious animals living in colonies of up to three dozen members and engaging in a variety of complex social behaviors including communal grooming and mock fights. Strictly herbivorous, they subsist on a variety of alpine leaves, grasses and forbs. Marmots, in turn, are an important food source for a variety of high-elevation predators, including raptors (especially golden eagles), canids, cougars and bears. One morning, I watched a determined grizzly trying to dig marmots from their burrows in the rocks across the valley from my camp. The summer was waning, hibernation season was approaching for bears and marmots alike and the grizzly really wanted a final meal or two before retiring for the winter. For nearly an hour, dirt, gravel and even boulders flew to little effect. It was hard to imagine all this effort producing a net caloric benefit for the bear, especially since I never saw the grizzly catch a single marmot.

This incident illustrates the security the hoary marmot's underground habitat provides. During the summer, marmots maintain multiple shallow escape burrows so that some form of cover is always nearby in case of sudden surprise by a predator. These refuge burrows are seldom more than a few feet deep, although they are typically dug beneath rocks for additional protection. Prior to hibernation, the whole colony retreats to a more elaborate burrow system called a hibernaculum, with multiple entrances and deep central pits up to twelve feet below the ground. No wonder that grizzly left the mountainside frustrated.

The hoary marmot derives its name from the color of its guard hairs, a striking silvery gray that has few equivalents among other mammals. But beauty and function are always related in nature. In the hoary marmot's case, the adaptive advantage of its coloration derives from the way it allows the marmot to blend in with the rocks it often lies on during the day while sunning. Their vocalizations are as distinctive as their coats. While hoary marmots communicate with a variety of calls, the high-pitched alarm whistle is the one most likely to attract human attention. This call is the source of the marmot's popular nickname "whistle pig" and gave the mountain resort community of Whistler, British Columbia, its name.

Any animal called a whistle pig faces an uphill climb to the ranks of the glamor species referenced earlier. But the hoary marmot is a beautiful

creature in its own way, and its calls have enlivened visits to alpine terrain for countless backcountry visitors. Above all, it represents the unspoiled alpine habitat that will always remain a favorite part of the Montana outdoors for so many of us.

PART II
TIMBER AND MOUNTAINSIDES

Chapter 7

PONDEROSAS AND LODGEPOLES

Pinus ponderosa and
Pinus contorta

*W*hen I moved from Montana to central Alaska in 1980 (I returned seven years later, initiating a game of residential ping-pong that continues to this day), I found myself strangely homesick despite the usual enthusiasm for the Far North most newly arrived outdoor enthusiasts feel. I missed the clear skies and broad horizons my central Montana property offered. I missed the sound of wild turkeys feeding near the yard and the sight of white-tailed deer in the meadows. Above all, I missed the trees—one reason why I eventually moved my base of Alaska operations to the Southeastern Panhandle temperate rain forest.

Save for some scattered cottonwoods, everything at our Montana place tall enough to qualify as a tree is a ponderosa pine. The wooded sections of the property had been logged once, as evidenced by a few wide stumps cut off close to the ground. I was never able to find out when the logging took place. That must have been many years ago, for the stumps have deteriorated considerably. Now the standing pines are old enough to look the way a ponderosa should, with thick orange and gold bark divided into polygonal plates by deep, dark fissures. Their needle-bearing crowns catch the prevailing west wind's frequent gusts and turn them into a lullaby. Their sturdy horizontal branches beg to be climbed and have turned me back into an arboreal kid more times than I can count. Daughter Gen was with us by the time we returned from Alaska for the first time. I'll never forget the day I spotted her giggling seventy feet up in the air at the very top of a backyard ponderosa, swaying back and forth in the breeze like the spire on an outdoor

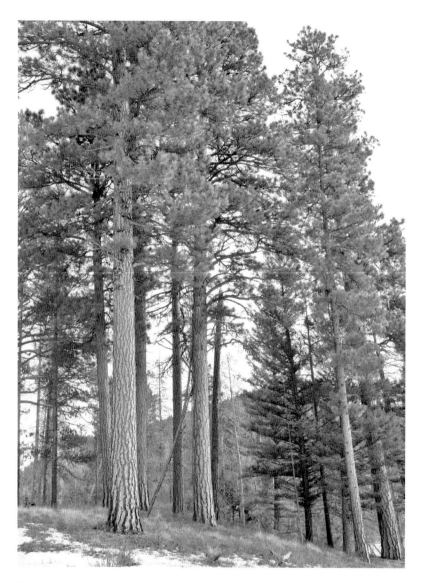

Mature ponderosa pines, showing their characteristic orange bark. *Photo by Don and Lori Thomas.*

Christmas tree. A daredevil since birth, she was all of five years old at the time. I still remember feeling very grateful that she was able to get back to the ground unassisted.

Those trees have grown a lot since then. That's the kind of natural event that you don't appreciate until you look at before-and-after photographs side

by side. Their tops obscure our view of Square Butte now and darken our frequently spectacular sunsets. But I fretted endlessly over them when I saw the first evidence of pine beetle infestation on the place, and I've never felled one of our live ponderosas despite Aldo Leopold's identification of the axe as an essential tool in wildlife management. The reason for all this affection is simple. The ponderosa pine defines its part of the Montana landscape as surely as any bird, fish or animal described in this book.

Ponderosas grow naturally from southern British Columbia and the Pacific coast to mountainous areas in the Southwest. Given the variation in climate conditions across this range, it is perhaps surprising that foresters recognize only five subspecies, of which two live in Montana: *P. p. ponderosa* west of the Continental Divide and *P. p. scopulorum* farther east. The tallest ponderosas grow in the moist Pacific Northwest, including a specimen 268 feet tall, which is the largest known pine tree on the continent.

Native Americans utilized ponderosa needles, bark and pitch for a variety of medicinal purposes. They made dugouts from single logs, a blue dye from the roots and ointments from the pitch. Boughs, pollen and needles became part of sweat lodge rituals and healing ceremonies. More recently, the ponderosa has become an important component of the timber industry, exceeded only by the Douglas fir and western hemlock in annual board

Young ponderosa pine needles after an overnight frost. *Photo by Don and Lori Thomas.*

The mountains of the Scapegoat Wilderness are the backdrop for a young ponderosa pine needle triplet growing on the bank of Meadow Creek. *U.S. Forest Service photo by Brandan W. Schulze.*

feet harvested. The tree's wide, deep root system makes it an important component of natural erosion control.

The esthetic and ecological value of the ponderosa extends beyond the physical characteristics of the tree itself. The ponderosa is a climax species throughout much of its range, except at high elevations where other conifers can compete more successfully. A ponderosa pine forest comprises a unique habitat utilized by a wide variety of bird and animal life. From a human perspective, a hike or a campsite in a ponderosa forest makes an especially enjoyable experience. The trees are naturally spaced far apart with little underbrush beneath the canopy, and fallen needles form a soft carpet that makes for easy, quiet walking. The ponderosa is one of the few North American pines whose needles come in clusters of three. An avid cataloguer and amateur student of conifers (among a great many other things) when I was a kid, I can still remember my excitement when I added my first ponderosa pine needle triplet to my collection.

No wonder the ponderosa pine became Montana's official state tree in 1949. We couldn't have made a better choice.

The easiest way to appreciate the esthetics of a ponderosa forest may be to take a hike through a mature stand of lodgepole pines. Lodgepole forests are often as dark and gloomy as ponderosa forests are light and airy, the trees themselves as nondescript as ponderosas are regal. Packed tightly together above a sterile-looking understory littered with deadfall and stobs, lodgepoles seem to be inviting the visitor to go somewhere else. Naturalists aren't supposed to be judgmental, but sometimes you just can't help it. Despite these arbitrary personal biases, I acknowledge that the lodgepole pine plays an important role in Montana's ecology and social history.

The lodgepole pine shares much of the ponderosa's home range throughout the Rocky Mountains, but lodgepoles don't occur as far south. They are found much farther up the Pacific coast into Alaska. Foresters recognize four subspecies, and in contrast to the ponderosa, there is considerable variation among them. When I first moved to coastal Alaska, I initially failed to recognize the shore pine (*P. c. contorta*) as a variety of lodgepole. Some alpine lodgepoles form krummholz—the stunted patches of trees that grow in the windblown alpine environment—and never reach

Burned lodgepole pines in the wake of the 1988 Yellowstone fire. Note the lush regrowth of grass. *Photo by Don and Lori Thomas.*

ten feet in height. Montana lodgepoles of the *latifolia* subspecies seem to defy the specific name *contorta* originally given to the twisted coastal pines that I had trouble identifying. Straight and lean, Montana's lodgepoles look like—well, lodgepoles.

From our own Great Plains to the Mongolian steppe, nomadic indigenous people inhabiting open terrain needed to develop a form of shelter that was mobile, easy to erect on the spot and wind resistant. The Mongols solved the problem with the yurt, while American Plains Indians came up with the tipi. Dogs and, later, horses provided the mobility, while abundant buffalo hides provided the shelter. But the hides needed a means of support that was long, light and straight. Voila: enter the lodgepole pine.

Plains tribes often traveled long distances to obtain lodgepole pines from their mountain habitat. Dragged travois-style behind horses, trimmed lodgepoles were easy to move wherever the buffalo were, which is as far as they needed to go. Most tipis required sixteen to eighteen lodgepoles, peeled, dried and tapered. The poles were fifteen to twenty feet long, depending on the dimensions of the erected structure. When I worked as a physician on the Fort Belknap Reservation in North Central Montana, my friends there regularly obtained lodgepoles from the nearby Little Rocky and Bear Paw Mountains for use in tipi construction and other ceremonial purposes.

<center>⊰●◆●⊱</center>

It is impossible to discuss these two pine species without mentioning a force that is paradoxically both their enemy and their friend: fire.

The summer of 1910 was unusually hot and dry in the Northwest. By August, over one thousand small forest fires were burning in eastern Washington, Idaho and western Montana, some caused by lightning, others by human activity. On August 20, a strong cold front with unusually high winds blew into the area, fanning the flames and combining numerous small fires into a single inferno. During the next two days, the conflagration known now as the Big Burn consumed over 3 million acres of timber before the arrival of a second front that produced desperately needed rain. Simply too big to fight, the blaze destroyed several towns in Idaho and Montana and killed eighty-seven people, most of them firefighters. The catastrophe laid the foundations for what eventually became the United States Forest Service and led to an unquestioned policy of suppressing all forest fires.

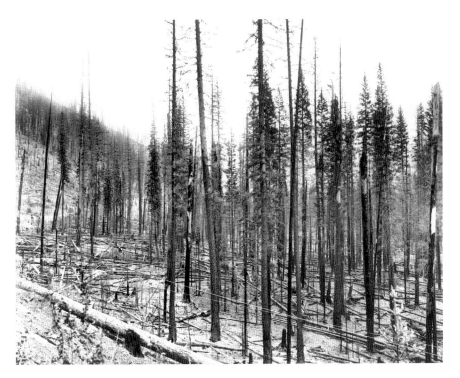

Burned white pine, larch and spruce in upper St. Regis. *U.S. Forest Service photo by R.H. McKay, Lolo National Forest, MT, 1910.*

On August 5, 1949, after another long, hot summer, lightning ignited a blaze near Mann Gulch in Montana's Helena National Forest. A team of fifteen smokejumpers parachuted into the area just after four o'clock that afternoon. Less than two hours later, twelve of them were dead after wind gusts caused a "blowup" and drove the fire back on their position faster than they could outrun the flames. The tragedy led to major revisions in Forest Service firefighting protocols and training and became the subject of Norman Maclean's book *Young Men and Fire*, published posthumously in 1992.

The Big Burn and the Mann Gulch fire represent worst-case scenarios. Both left their marks on Montana history, and it is impossible to deny the magnitude of the tragedy experienced by the friends and families of those who died fighting them. But the optimal management of the relationship between forests and forest fires turns out to be a lot more complicated than everyone assumed in the wake of the Big Burn. Because of their resin content, ponderosas and lodgepoles both make good fuel, especially during hot, dry summers that cause the moisture content of their needles to fall.

The scorched remains of the Mann Gulch fire. Notice the contrast of the barren slopes left behind in the foreground and the forested mountainsides in the immediate distance. *U.S. Forest Service Northern Region photo.*

Intense burns like those described both depend on these trees and destroy them. Paradoxically, both pines also require a certain amount of fire for the optimal health of forests in their natural state.

Because of their thick bark, ponderosas are relatively resistant to low-intensity forest fires—they may burn well, but fire often fails to kill them. In Montana, it's not unusual to see healthy ponderosas with blackened bark standing alive in the wake of a brush fire. These fires decrease the overall fuel load of the forest, reduce competition for nutrients by other less fire resistant plant species, clear out the understory and help make ponderosa forests the pleasant places they are. While the thin-barked lodgepole is more susceptible to fire, heat from low-intensity burns is necessary for lodgepole cones to open and release their seeds. Periodic burns allow lodgepole forests to populate with trees of varying age. Absent all fire, mature lodgepoles form dense forests in which trees compete with one another for sunlight and nutrients. Not all survive, leaving dead trees standing and contributing to the potential fuel load. The result is the potential for rare catastrophic burns rather than a few manageable ones.

The 1988 fire season was difficult throughout the Mountain West, nowhere more so than in Yellowstone Park and adjacent parts of Montana.

This time, I was there to see it happening. In 1968, the National Park Service adopted a policy of letting naturally caused fires burn unsuppressed. However, the Park's dominant forest species is the lodgepole, and earlier decades of fire suppression had allowed these forests to reach a hyper-mature state consisting of densely packed pines and standing dead trees. The area was overdue for a big burn, and a conjunction of environmental conditions created a perfect storm that year. The previous winter's snowpack had been unusually low, leaving the ground dry. Then a brief period of heavy rains in May allowed grass and brush to grow more than usual. Summer brought a severe drought, drying out the understory and turning it into highly combustible fuel. As early as June, dry thunderstorms had begun to ignite small fires throughout the region.

By August, over 250 different fires had started in Yellowstone, almost all of them due to natural causes. Driven by wind and aided by high temperatures and low humidity, they began to coalesce. Fire crossed streams and roads. As they reached the lodgepoles' volatile needles, fires began to crown, racing from treetop to treetop and sending wind-driven sparks ahead to start new fires. Control efforts proved futile. The fires were once again simply too big to fight, as they had been in 1910. Before rain finally arrived, 1.4 million acres in the Greater Yellowstone area had burned and two people had died from fire-related causes outside the Park.

Because of Yellowstone's reputation as the crown jewel of our National Park system and the magnitude of the fires, the event received extensive media coverage. Criticism flowed freely in the aftermath of the fires. It is impossible not to feel sympathy for those adversely affected by the Yellowstone fires of 1988, including the families of those who died and the residents of Cooke City and West Yellowstone who faced the real possibility of losing not just their homes but also their hometowns. However, from the standpoint of habitat, the fires were a long-overdue event that became one of the best things to happen to the area in my lifetime.

Much of the fire burned in a mosaic pattern, leaving strips of timber running up and down mountainsides interspersed with newly opened areas, creating just the kind of "edge" habitat Aldo Leopold identified as optimal for wildlife. As a regular visitor to the area, I was amazed by the speed with which most burned areas came back to life. By the spring of 1989, wildflowers were erupting profusely through the ashes. Within a year or two, the fire-blackened areas had turned green with vegetation, providing an improved forage base for multiple species of wildlife. And the next time—for there will be a next time—fires will not be able to run uninterrupted through vast stands of volatile, hyper-mature lodgepoles.

Providing an improved forage base for multiple species of wildlife, beargrass rises from the ashes in a post-fire rebirth along Johnson Lake in the Anaconda-Pintler Wilderness. *Courtesy of Pete Ferranti.*

In many ways, forest fires are a lot like the predators described in the final segment of this book—they are a problem for people primarily because people, especially in Montana, insist on living in places that are home to fire and large, carnivorous mammals. Since I am one of those people myself, I can't point my finger at others without hypocrisy. At the very least, we need to accept some responsibility for the consequences of our choices.

Chapter 8

NORTH AMERICAN BEAVER

Castor canadensis

*W*ith the exception of the bison and the nonnative horse, I doubt that any mammal has had a greater influence on early Montana history than the beaver. To introduce the species, I offer a brief quote from one of my own works of fiction:

> *He felt pleasantly fatigued by the time he broke out of the conifers at the edge of the meadow where the beavers had turned the trickling mountain stream into something complex and expansive. The long series of dams, ponds, and lodges looked more like the remains of an ancient civilization than mere rodent handiwork.* Busy as a beaver…*Easy as it was to dismiss the clichés, something undeniably remarkable had taken place in the meadow. Never mind the fish—witnessing the miracle of a community built entirely by rats always justified the effort of the hike.*

As the preceding suggests, the largely nocturnal beaver is more often known by its work than by personal appearance. The beaver's legendary industriousness and engineering savvy (which we shall at least partly debunk shortly) changed the physical landscape of the Mountain West more than any other living creature prior to the arrival of modern human technology.

The "North American" modifier in this chapter's title may seem superfluous, since the animal is known simply as the beaver throughout its range in the New World. Scientific "splitters" once identified nearly thirty beaver subspecies in America. Although definitive DNA analysis remains

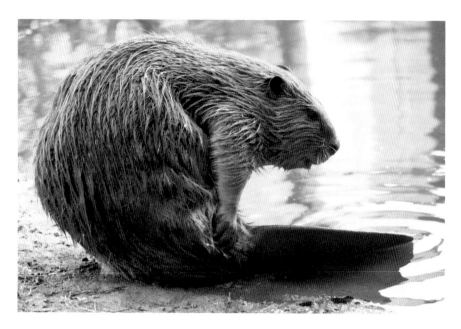

Yearling beaver grooming. *Photo by Cheryl Reynolds and courtesy of Worth a Dam.*

incomplete, current science suggests that most or all of those subspecies are identical. However, there is a Eurasian beaver, actually a bit larger than our own, that does constitute a separate species. That distinction is scientifically accurate, but the term "beaver" will refer to the North American version throughout the text that follows.

The beaver is the second largest rodent in the New World, exceeded in size only by the South American capybara. Adults may weigh up to eighty pounds, although most are little more than half that. Beavers are among the few mammals that live in organized groups, or colonies. Their most distinctive anatomic features are the oversized incisors and the flattened, scaly tail. The teeth are adapted for gnawing and ultimately felling the trees that are essential for the construction of dams and lodges. The flat tail enhances the largely aquatic beaver's ability to swim underwater and serves as a repository for fat and calories over the winter, which explains its popularity as camp fare among early explorers and trappers. The tail also provides a means of alerting other beavers to the presence of potential threats. The sound produced when a beaver's powerful tail impacts the surface of a still pond is like a rifle shot and carries for considerable distances. I once spent a nearly sleepless night when I pitched my tent on a sandbar next to a beaver colony's home. Although my intrusion posed no threat to the beavers, one

animal was perturbed by my presence and spent hours letting me know all about it by slapping the surface of the pool with its tail every time my eyes finally drifted shut.

The beaver's impact on the western landscape is defined less by its appearance than its lifestyle. Beavers require water deep enough to allow their superior swimming abilities (a beaver can remain submerged for fifteen minutes without surfacing for air) to help them escape a wide range of predators, including wolves, coyotes, cougars and occasionally bears. In rivers containing deep pools, beavers live in burrows dug into banks. Lakes and ponds may provide ample aquatic escape habitat, but they rarely have banks steep enough at the waterline to allow burrowing. Small mountain streams are seldom deep enough to accommodate beaver colonies without modification. In these circumstances, beavers become engineers.

Absent suitable bank burrow sites, beavers construct sturdy lodges of sticks, rocks and mud. The lodges have underwater entrances and platforms above the waterline inside. They are thick enough to provide thermal insulation during the winter (beavers routinely tolerate sub-zero temperatures) and sturdy enough to resist invasion by predators, although bears will occasionally tear lodges apart to get at their occupants. The colder the ambient winter temperature, the bigger and thicker the lodge. In Alaska, I've found beaver lodges half the size of my garage.

The heart of the beaver's engineering mythology derives from the dams it builds to create aquatic escape cover deep enough to keep from freezing solid during the winter. Dams are constructed from the same material as lodges. This complicated means of creating its own habitat impressed early observers as signs of the beaver's intelligence. However, beavers are rodents, which are not the brightest of mammals. The beaver's dam building instincts are apparently triggered by nothing more complicated than the sound of running water. Researchers once placed a tape recorder playing the sounds of a babbling brook in an open field next to a beaver colony. The beavers promptly constructed a "dam" on top of the device.

The largest beaver dam ever discovered was nearly a half mile long, a span greater than the Hoover Dam. While it may be tempting to imagine beavers surveying streams and discussing static load bearing prior to beginning such projects, their dams appear to result from little more than instinct responding to simple stimuli. Nonetheless, beavers have had a profound impact on the ecology of the West. They are what biologists call a keystone species, one that increases biodiversity in the areas it occupies and

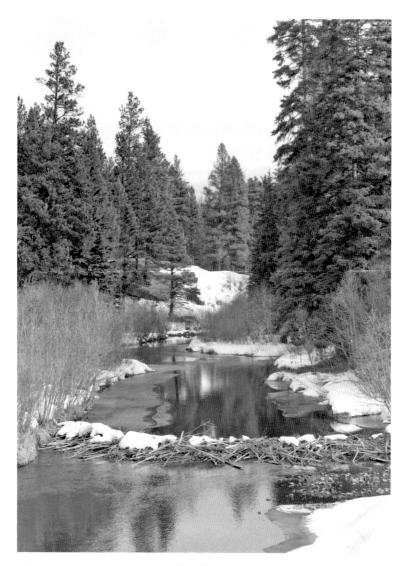

A beaver dam in winter, Lewis and Clark National Forest. The pond behind the dam provides secure habitat for multiple aquatic species. *Photo by Don and Lori Thomas.*

impacts apparently unrelated components of the surrounding ecosystem in ways disproportionate to its own population density.

Beaver dams create crucial habitat for waterfowl, including geese and swans. Ice-resistant open areas behind beaver dams allow waterfowl to nest earlier in the spring, increasing the chances of a successful brood. Streamside trees drowned by flooding create nesting sites for avian species varying in

size from flycatchers to wood ducks, raptors and owls. By creating open transition zones between forest and water, beavers make a wider selection of food sources available to birds in the area.

Fish also benefit from beaver dams, as anyone who has cast a fly line out across a beaver pond knows. Beaver dams allow an increase in both size and number of all native salmonids. Although many people once accused beaver dams of interfering with trout and salmon spawning runs, the opposite turns out to be true. Upstream-bound adults have no trouble crossing beaver dams, and beaver ponds create ideal habitat for out-migrating juveniles. In southeast Alaska, where I live part of the year, spawning coho salmon have proven capable of jumping beaver dams two meters high, and the greatest densities of young, outbound smolt are found in streams containing beavers. In Montana, the deep water found in beaver ponds provides resident fish with refuges from ice during bitterly cold winters.

In low-flow mountain streams, the crucial period for aquatic wildlife of all kinds is late summer and early autumn, when heat or drought can lead to critical de-watering. Beaver dams provide reservoirs that help maintain stream flow throughout the year. They also act as settling basins for silt, resulting in decreased erosion and cleaner water flowing downstream. Seasonal flooding of beaver ponds disperses nutrients into the surrounding soil, creating a richer environment for streamside vegetation and the birds and animals that depend on it as a food source. Standing water in beaver ponds acts as a natural fire barrier during burns.

Given all these beneficial impacts beavers have exerted on western terrain and the wildlife that lives here, it's remarkable to think how closely we came to wiping them out.

Beaver fur was a popular fashion commodity in Europe and Russia long before trade with North America began. A century before Columbus sailed, Chaucer described a beaver hat on the head of the Merchant in *The Canterbury Tales:*

> *A MARCHANT was ther with a forked berd,*
> *In mottelee, and hye on his horse he sat;*
> *Upon his head a Flaundish bever hat…*

Here, Chaucer used the image of the beaver hat to establish the character's position as a man of means and social stature.

These furs came from the Eurasian beaver. The demand for its hides had nearly led to that animal's extirpation by the early 1700s, just as exploration

in the New World discovered an abundant alternative. Unfortunately for the beaver, its fur was particularly well suited for making felt by a process first developed in Russia. Hats made of beaver felt were an important fashion statement in Europe by the time of the American Revolution. Neurological symptoms due to poisoning by the mercury essential to the felt-making process gave rise to the phrase "mad as a hatter." During the eighteenth and early nineteenth centuries, furs, especially beaver pelts, drove much of the North American economy.

Trade between Native Americans and Europeans and rivalry between British and French interests for control of the fur trade played pivotal roles in the early history of the northeastern United States and Canada. Beaver hides became such an important component of the backwoods economy that they were a standard of relative value and a substitute for hard currency. Here, our attention focuses on the era of the mountain man, beginning shortly after the Lewis and Clark expedition and ending three decades later, by which time competition from the well-organized Hudson Bay Company in Canada had nearly decimated the American fur trade and the beaver on which it depended.

The arrival of the legendary American mountain men was driven almost entirely by demand for beaver pelts. In Montana, notable mountain men included Lewis and Clark expedition veterans George Drouillard and John Colter, the latter remembered for the escape from the Blackfeet that became famous as "Colter's Run." Colter was also the first non-native to enter and describe what is now Yellowstone Park. John "Liver Eating" Johnson, who earned his gory name during a personal vendetta against the Crow after members of the tribe killed his wife, also spent much of his trapping career in Montana. Virginia-born Jim Bridger began his remarkable career as a trapper, trader and explorer of the Mountain West when he joined General William Ashley's Upper Missouri Expedition at age seventeen in 1822. He was among the first white men to visit Yellowstone and the first (probably) to discover Great Salt Lake. Despite the popular image of the mountain man as an independent loner (as some of them certainly were), many worked together for businesses, including John Jacob Astor's American Fur Company. Despite a well-known enthusiasm for drink and violence, the mountain men utilized their wilderness skills to continue the exploration begun by Lewis and Clark and made substantial contributions to the opening of the West. They also brought the beaver near the brink of extirpation.

The historic range of the North American beaver covered the continent from the Atlantic to the Pacific and from sub-arctic Canada and Alaska to

parts of northern Mexico. Estimates of their numbers prior to European contact range from 100 to 200 million. Demand for their pelts had already imperiled the beaver population east of the Mississippi by the time Lewis and Clark headed up the Missouri, but the brave new world they described seemed to offer the resource in limitless quantities just as trends in European fashion placed it in even higher demand. That assumption proved false. By 1842, Astor's American Fur Company was bankrupt and the West was running out of beaver.

Regrettably, we humans often take an *us* and *them* attitude toward wildlife. Hardly any species profiled in this book hasn't managed to offend someone, sometime. Farmers dislike pronghorns that roll in their winter wheat and damage fences. Ranchers object to elk when they raid winter haystacks. Politicians get twitchy when sage-grouse or paddlefish raise the specter of listing under the Endangered Species Act, and the easiest way to start a barroom brawl in Montana may be to initiate a discussion of bison or wolves. But viewed across the entirety of its range, I doubt that any wild animal accounts for more complaints to animal control officers and game wardens than the beaver.

One concern about the beaver is easily addressed. The term "beaver fever" may make good poetry, but it is inaccurate on two counts. The gastrointestinal illness caused by *Giardia lamblia* usually does not cause fever, and a wide range of temperate zone mammals in addition to the beaver serve as reservoirs for the parasite. Should you develop giardiasis after a camping trip in Montana, don't automatically blame the beaver as the responsible vector of the disease.

The beaver's tenacious instinct to obstruct the flow of moving water is another matter. Some nearby friends reach their ranch house in the foothills by way of a gravel road that crosses a creek running through a large culvert. Every spring they eventually awaken to a flooded road after beavers dam the culvert, usually in a single night's work. Our friends clear the culvert. The beavers dam it up again. This goes on and on like an endless rerun of an old Roadrunner cartoon until the beavers decide to erect their dam downstream or the creek freezes. Variations on this theme play out every year wherever beavers and people occupy the same space, from coast to coast, in environments ranging from rural to urban. While it's hard not to feel sympathy for affected humans, it's also important to remember which species got here first.

We humans have at least tried to make symbolic amends for the excesses of the fur trade era. The beaver is Canada's national animal and the state

animal of Oregon and New York. The beaver appeared on Canada's first postage stamp. Even though its engineering prowess turns out to be based more on myth than scientific fact, the highly respected engineering schools Cal Tech and MIT have both adopted the beaver as their mascot.

All these honors seem the least we could do after we nearly wiped the beaver off the continent so that European gentlemen could wear fashionable hats. Montana and its wildlife just wouldn't be the same without the beaver.

Chapter 9

ROCKY MOUNTAIN ELK

Cervus canadensis nelsoni

September is a time of transition in Montana. In the sunbaked eastern part of the state, temperatures can reach triple digits early in the month, but around the equinox, one can expect the first snowfall of the season. A magical interlude of two or three weeks lies in between, with cool, clear nights and daytime temperatures low enough to allow hiking comfortably but high enough to obviate the need for heavy clothing—in other words, just right.

But I would be out in the hills then no matter what the weather, for mid-September marks the onset of the annual elk rut. There's never a better time to spot a big bull doing interesting things—shredding aspens, horning pines, carrying brush in its antlers to make itself look even bigger and more imposing than it already is or locking horns with a rival for the attention of nearby cows, to initiate a battle that might become as casual as an exchange of insults or as serious as a knife fight.

The visual elements of the elk rut represent just one part of the drama. Elk are highly vocal animals, and cows and calves communicate with bird-like chirps and mews throughout the seasons. But this is the time of year when the hills start to ring with one of nature's strangest and most dramatic sounds as bulls bugle to announce their presence, claim their territory and warn off potential rivals. Recognizing the near impossibility of conveying the full impact of an elk bugle on the printed page, I will try nonetheless for the sake of unfortunate readers who have never heard the real thing. A bugle usually begins with a low, snarling

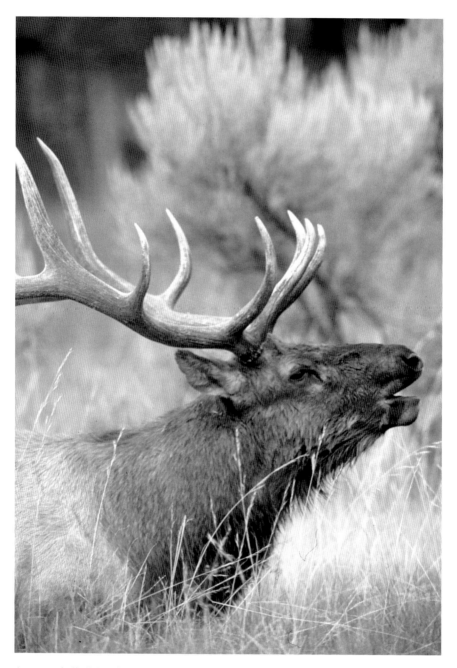

A mature bull elk bugling during the September rut. At this time of year, bugling can make the hills ring in elk country. *Photo by Don and Lori Thomas.*

growl that might be coming from a tiger. Then the sound clarifies—think Wynton Marsalis on the trumpet—and slurs its way upward through a series of semi-distinct notes until it reaches a penetrating whistle or an outright scream before yowling its way quickly back down the scale into silence.

Different bulls bugle in different ways, and once you become familiar with an area and the elk it contains, it often becomes possible to identify individual bulls by sound alone. Spikes—year-and-a-half-old bulls whose antlers have not yet started to branch—often sound high pitched and squeaky, with a bugle that is little more than a one-note squeal. It's the big old bulls that really get the low notes to reverberate, often ending a bugle with a series of guttural coughs that sound like a diner about to need a Heimlich maneuver. However, some of the least impressive bugling I've ever heard has come from huge old bulls, possibly because they're suffering from voice fatigue after weeks of battling intruders bent on cutting out some of their cows. And some of the best bugling in the woods comes from human hunters who have mastered the art of imitating elk vocally.

No matter whether you are carrying a rifle, bow, camera, binoculars or nothing more than your own eyes and ears, this is where you need to be and when you need to be there. There is no more dramatic experience to be enjoyed anywhere in the natural world.

Elk ancestors arose in Eurasia and crossed the Bering Sea land bridge. Our elk are so closely related to the European red deer (*C. elaphus*) that biologists once considered them members of the same species, although DNA studies have now proven that idea incorrect. However, elk and red deer will hybridize in areas where both have been introduced, such as New Zealand. The elk's name can be a source of confusion, since it derives from German and Scandinavian names for the moose, which is called an elk in Europe today. Elk still inhabited our eastern seaboard when the first European colonists arrived, and since they were so much larger than their familiar red deer, they assumed it was a variety of moose and named it accordingly. The alternative name "wapiti" derives from Native American words whose meaning I first heard rendered simply as "white rump." My friend Mike Hoffman, an enrolled member of the

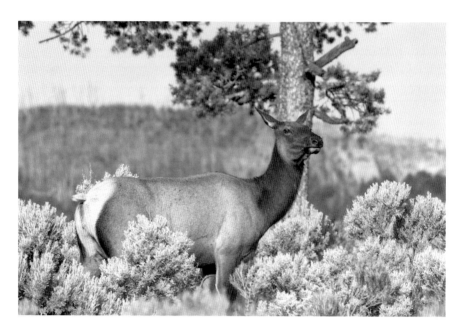

A mature cow elk in early autumn. *Photo by Don and Lori Thomas.*

Menomonee tribe and an authority on native languages, explained that the original form of the word *wapesketiyaew* is of Algonquin origin and best translates as "shows white at the rear." Light-colored hindquarters are indeed a distinguishing feature of the elk, although the actual hue seems more yellowish than white to me. Once the eyes have learned to recognize that color, it is often the first visual cue that alerts the observer to the presence of elk moving away through the dark timber.

Biologists recognize six original subspecies of North American elk, two of which are now extinct. Once an inhabitant of the eastern United States, the Eastern elk (*C. c. canadensis*) faced tremendous subsistence hunting pressure during colonial times and finally disappeared when the last one was killed in Pennsylvania in 1877. The Merriam's elk (*C. c. merriami*) has also vanished from its original range in our desert Southwest. In addition to the Rocky Mountain elk, surviving subspecies today include the Roosevelt elk (*C. c. roosevelti*) in the Pacific Northwest, the Manitoban elk (*C. c. manitobensis*) of the Canadian prairie provinces and the Tule elk (*C. c. nannodes*) in California.

Rocky Mountain elk are large animals, as anyone who has packed one out of the bottom of a canyon knows. Cows weigh around five hundred pounds on the hoof, while bulls average two hundred pounds more. The

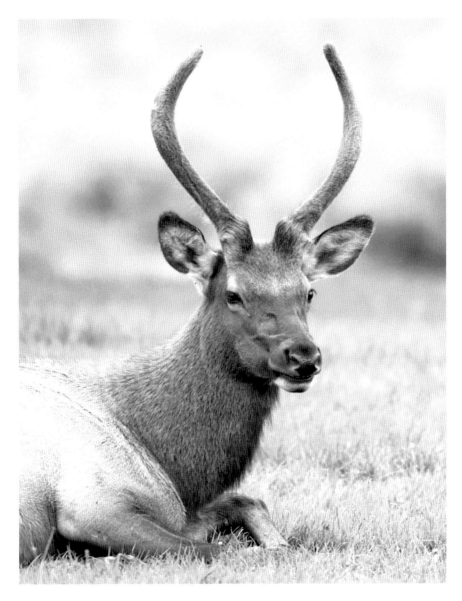

Spike elk in Mammoth. *National Park System photo by Jim Peaco.*

Roosevelt subspecies is even larger, while Tule elk are slightly smaller. Elk are powerful animals. A rancher friend once reported watching aggressive bulls push thousand-pound round bales of hay around in his pasture during the rut. (He also saw one die when a bale fell from the top of a stack the bull was attacking and broke its neck.) Bull elk carry

spectacular antlers whose primary function is to impress cows and deter rivals during the rut, although elk can also use them in defense against predators. Antlers can be so wide that one sometimes wonders how big bulls can navigate through the dense stands of lodgepole pines they like to lie up in during the heat of the day. But when alarmed, a bull can lay its antlers back along its flanks and tear through the woods as if the trees weren't even there. Like all deer, elk shed their antlers during the winter, an event initiated by a fall in testosterone levels after the completion of the breeding season.

Elk social dynamics are complicated. Bulls and cows with calves stay separated for most of the year. During the rut, bulls round up cow harems that vary in size from two or three to over twenty depending on the status and aggressiveness of the dominant herd bull. Most herd bulls are between six and ten years of age. Those younger or older become "satellite" bulls, spending their time on the periphery of the harem while hoping to cut out an occasional cow. When a satellite bull approaches, the herd bull begins the defense of its harem by posturing and displaying its antlers, which are usually (but not always) larger than the intruder's. The herd bull will walk parallel to the route taken by the satellite bull, shielding his cows with his body. If the intruder persists, the herd bull confronts him head-on and lowers his antlers—a glove thrown, if you will, at the beginning of a duel. If the satellite bull doesn't retreat, the two may lock horns and begin to fight.

I have witnessed many of these encounters and remain surprised by their usually docile nature after all the noise and posturing that precedes physical contact. Most often, fighting bulls engage their antlers carefully, as if they are trying to avoid hurting each other, and the fight itself seldom consists of anything more than pushing and shoving. Sometimes though, two bulls will really go after each other seriously enough to result in the injury or even death of one participant. Rarely, fighting bulls manage to push their horns into a locked position from which the two contestants cannot free themselves, an unfortunate event that often results in the death of both animals. It is my observation that serious fights are most likely to occur when the satellite bull is close to the herd bull in age and size.

Until recently, the elk's most significant predators in Montana were bears, cougars and people, with coyotes occasionally taking down a very young calf. Mature elk can often defend themselves successfully against solitary attackers with their antlers or, in the case of cows, by kicking with their front feet. The reintroduction of the pack-hunting gray wolf

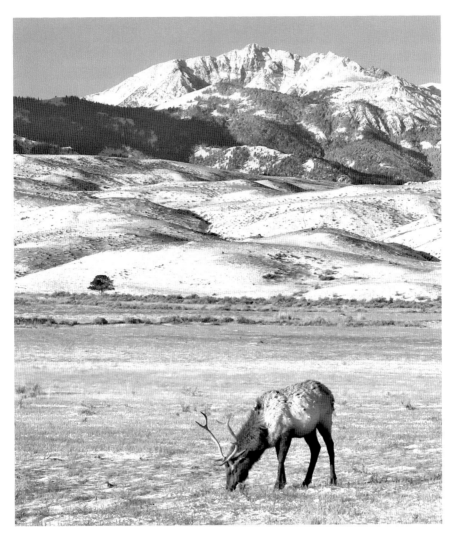

Bull elk near North Entrance and Electric Peak. *National Park System photo by Jim Peaco.*

to western Montana affected a considerable change in this dynamic. The degree to which the Montana elk population has been reduced directly by wolves remains a highly controversial and politicized subject, and absent better objective data, I do not intend to argue the matter here. The numbers cited are usually a direct reflection of the source's attitude toward wolves and, at their extremes, range from "negligible impact" to "decimated." As a matter of general principle, the truth likely lies somewhere in between.

Estimates of the continental elk population at the time of European contact range from 2 to 10 million, and they were abundant east of the Mississippi. Lewis and Clark first recorded them in what is now Nebraska, where Clark put to shore and tried to kill one for camp meat. (He missed.) Their journals cite frequent contact with elk throughout the expedition with no further comment or attempt to describe them, suggesting that they were familiar with the species even though neither of them had been west of the Mississippi previously. The elk they encountered as they made their way across Montana through the foothills of the Rockies were likely Manitoban elk. During the long, hard winter they spent on the Pacific in 1805–6, elk likely saved them from starvation. The reliable Sergeant Gass reported that the expedition's hunters killed 131 coastal elk between December and March. Naturalist C. Hart Merriam later named this coastal subspecies the Roosevelt elk in honor of our greatest conservation president.

Lewis and Clark were hardly the first to appreciate the elk's value to humans. The vanished Anasazi people of the Southwest depicted elk in petroglyphs some two thousand years before Europeans arrived in the New World. High in protein and widely regarded as delicious, elk venison was a Native American diet staple, especially for tribes that lacked access to bison. Elk skin is thick and difficult to work with, but it makes beautiful, durable leather that was an important part of ceremonial dress for many native tribes. The elk was an especially important animal in the traditions and lore of the Lakota Sioux.

Meanwhile, subsistence hunting was relentlessly pushing the eastern margins of the elk's range farther west. The last elk in Wisconsin was killed in 1866. Matters grew worse for the elk when a social group called the Jolly Corkers changed its name to the Elks and created a commercial demand for the animal's unique ivory teeth, which may be remnants of long tusks carried by primitive elk ancestors. By the end of the nineteenth century, elk were gone not only from the East but also from the Great Plains where Lewis and Clark had noted them in such abundance. By then, the country's total elk population had fallen from millions to around fifty thousand, most of them living in Montana.

The state created its first regulated hunting season in 1872 and its first annual limit of elk (two) in 1895. At that time, elk and other game animals were still being killed for the commercial meat market, a practice the state outlawed in 1897. The annual bag limit on elk was dropped to one in 1910, the same year state wardens and sportsman

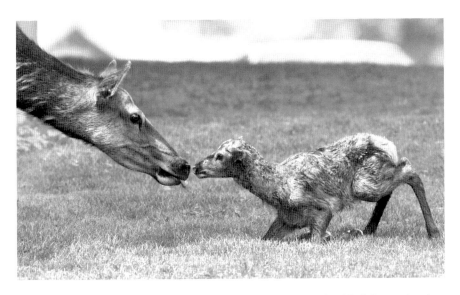

Twenty-five-minute-old elk calf in Mammoth Hot Springs. *National Park System photo by Jim Peaco.*

volunteers began to reintroduce elk to parts of the state from which they had been extirpated by market hunting. These transplanting programs continued for years, usually with elk captured in Yellowstone National Park, and resulted in the restoration of healthy elk herds in all of the island mountain ranges described in the first chapter of this book. One of the transplant program's most spectacular successes began in 1951 when elk were released along the Lewis and Clark expedition's route through the Missouri River Breaks, finally restoring elk to the prairie. The Breaks herd eventually became one of the country's most robust. Similar reintroductions have now taken place across the nation, including states the eastern elk once inhabited. Many of the recent transplants, not to mention habitat conservation programs around the West, have taken place with substantial assistance from the Rocky Mountain Elk Foundation, headquartered in Missoula. With help from groups like this, North America's population of elk has now risen to around 1 million—not what it once was, but a lot better than it used to be.

Montana's official state animal is the grizzly bear, a choice with which it is difficult to argue. Nonetheless, given a voice in the discussion, I might well have lobbied for the elk, a spectacular, widely distributed animal that has fed, clothed and intrigued Montanans and visitors for generations. (In fact, the elk came in second to the grizzly in a vote

taken among Montana schoolchildren to determine the state animal in 1982.) Certainly no other animal can turn the hills into a symphony like the elk in September, an event that every wildlife enthusiast deserves to experience at least once.

Chapter 10

MOUNTAIN GROUSE: SPRUCE, RUFFED AND DUSKY

Falcipennis canadensis, Bonasa umbellus and *Dendragapus obscurus*

It is impossible to understand spring in Montana until you have understood winter in Montana. Spring would feel meaningless without the months of tire chains and heavy woolens that precede it. After endless mornings of repetitive four-word road reports—snow-packed and icy, snow-packed and icy—followed by front window views that look like Russell Chatham landscapes painted in shades of white, desperation begins to creep into even the most winter-hardened Montanan's heart. T.S. Eliot may have declared April the cruelest month in the opening line of *The Waste Land*, but he'd never spent a winter in Montana.

On the very last day of that allegedly cruelest month, I was hiking casually through a foothills meadow dotted with the first pasque flowers of the year. These relatives of the anemones are the initial bloom of the new season at the elevation where I live, often appearing right next to the last of the corn snow. I have long considered them a personal token of survival. We call them turkey flowers around our house because those purple blossoms usually begin to erupt right in the heart of Montana's spring wild turkey season. On this particular morning, I hadn't heard a single gobble even after miles of hiking, and I'd practically forgotten about the light wooden longbow balanced lightly in my hand. My original mission forgotten, I had started to scan the ground for morels even though I knew they were a week or two away by the time I heard the ruffed grouse.

Puttt-putt-putta-putta-putta...the sound that a drumming male ruffed grouse makes with its wings as it tries to attract a hen during the spring mating season bears an uncanny resemblance to a balky two-stroke engine coming to life on a cold morning. The sound resonates in my memory as surely as it does in my ears, for I spent my early childhood in northern New York, and the ruff was the only familiar game bird waiting for me when my family moved West. Intrigued that spring morning, I dropped my daypack, rested my bow against an aspen and began a cautious descent into the brushy draw where I thought the drumming had originated.

After making a bit more noise than I intended to picking my way downhill through the brush, I stopped and listened until I heard another drumming sequence. From there, it was easy to work my way across the quiet, winter-dampened carpet of old leaves on the bottom of the draw until I spotted the grouse. Like most drumming males of the species, it had taken a position on a log to obtain a better perspective from which to spot the tentative approach of a hen—or a coyote. I was a bit surprised that it hadn't seen me, but I held still and kept my distance until the bird drummed again. Then I retreated back up the draw to my gear, with one more spring milestone behind me.

Grouping several gallinaceous birds together in this chapter may seem arbitrary, but these three have a lot in common. They are all grouse. All occupy slopes between prairie and the alpine in central and western Montana, although their habitat preferences differ sufficiently so that I seldom find any two of them together. The Montana Department of Fish, Wildlife and Parks recognizes no distinctions among them and lumps them all together as "mountain grouse" when it writes the hunting regulations every year. All three are good to eat, and one—the dusky—is my favorite among all the state's upland game birds on the table. Finally—no surprise by now—Meriwether Lewis identified all three of them, on the same day and in the same sentence, no less.

In the Bitterroot Valley on September 20, 1805, after separating temporarily from Clark, Lewis recorded an encounter with "three species of Phesants, a large black species, with some feathers irregularly scattered on the neck and belley—a smaller kind of a dark uniform colour with a

Grouse occupy slopes between prairie and the alpine in central and western Montana, like the Big Hole Valley. *U.S. Forest Service photo.*

red stripe above the eye, and a brown and yellow species that a gooddeel resembles the pheasant common to the Atlantic States."

The first of the three was Richardson's blue grouse (now the dusky, after recent taxonomic splitting), and the second was the Franklin grouse (now the spruce, after some taxonomic lumping). His comparison of the third to "the pheasant common to the Atlantic States" was accurate enough for his time even though it wasn't really a pheasant. The bird was a version of the ruffed grouse he and I both knew well from East Coast childhoods, although this was a new subspecies, the Oregon ruffed grouse.

Biologists formally divided the blue grouse into two separate species in 2006, based on DNA studies and differences in range and appearance. The darker sooty grouse (*D. fuliginosous*) occupies a coastal range in the Pacific Northwest and Southeast Alaska, while the dusky is native to the Rocky Mountains. These are the country's second-largest grouse, exceeded in size only by the sage-grouse (see chapter 15). Mature male dusky grouse often weigh over two pounds. The plumage of both sexes is generally dark but nondescript, although the male has a solid gray breast that really does look blue in good light. The most reliable key to identification other than size is a gray band across the very tip of the tail. Males also have a yellow stripe over the eye and a purplish throat sac that inflates during spring mating display.

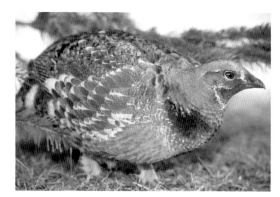

Left: The dusky grouse—formerly the blue grouse—is the largest of the mountain grouse species. In sunlight, its gray plumage really does look blue. *Photo by Don and Lori Thomas.*

Below: A male dusky grouse showing his throat sac and plumage. *National Park Service photo.*

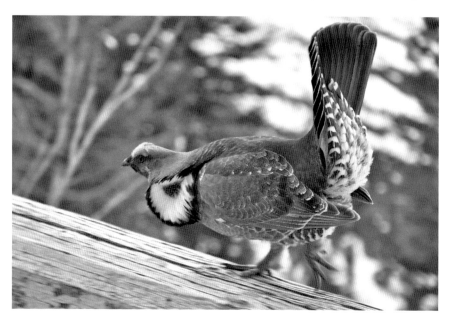

The dusky grouse is primarily a bird of coniferous mountain habitat, where it depends heavily on fir and pine needles as a food source, especially during winter. However, during the fall I often find them (with some help from my bird dogs) in brushy foothill terrain just below the level of the pines. It is one of the few species in Montana—bird or animal—that frequently moves from lower to higher terrain in the winter.

While a strutting cock in spring is a spectacular sight—tail fanned out like a turkey's, inflated throat sac surrounded by a white collar, golden eye patch aglow—like most boreal species, it also depends heavily on sound to attract potential mates. In the case of the dusky grouse, this consists

of a short, low-pitched series of hooting noises that sound somewhat like an owl calling. Birds can be located then by imitating this sound, best accomplished by blowing into a beer bottle. (The brand does not appear to matter, although I prefer one of Montana's excellent microbrews.) While this sound, usually delivered from high in a tree, carries for a surprising distance, dusky grouse are remarkable ventriloquists and calling birds can be hard to locate. I've spent hours walking around the woods and peering up into trees trying unsuccessfully to spot an invisible grouse that I know is up there somewhere.

In the obverse of the way the blue grouse was split, the spruce grouse was lumped, suffering additional taxonomic confusion along the way. For much of the twentieth century, the spruce grouse and Franklin's grouse were regarded as separate species. Then they were grouped together and included with the blue (now dusky and sooty) grouse in the genus *Dendragapus*. But the spruce grouse lacks a throat sac and most closely resembles an Asian grouse of the genus *Falcipennis*, which explains how it became *F. canadensis* today.

The spruce grouse's range extends widely across Canada and Alaska (where I have encountered them countless times), south into northern Maine in the East and down the Rockies through Colorado in the West. The spruce grouse is also a resident of coniferous habitat, as its name implies, and it, too, depends primarily on needles and buds in its diet. However, whereas the dusky prefers deep woods and tall trees, the spruce grouse prefers thinner taiga and rarely perches far above the ground.

The spruce grouse is the classical "fool hen," relying on camouflage to evade predators. If and when it does flush, often at very close range, it usually flutters a short distance and settles onto a low-lying branch—high enough to be safe from terrestrial predators like foxes and coyotes, but not from human hunters even if they are armed with little more than a rock or a stick. This makes the bird an excellent source of survival food, and it has fed many wilderness camps, including a number of my own. It is quieter than most other grouse, although it sometimes purrs softly when alarmed. Courting males make a noise that sounds like hands slapping by bringing their wings together sharply behind their backs.

The final member of our mountain grouse trio—the ruffed—is the only one likely to be familiar to visitors from east of the Mississippi. Its natural range spreads south from central Alaska (where it is less common than spruce grouse and ptarmigan) and Canada across the Northern Tier of the lower forty-eight states from Washington to Maine wherever

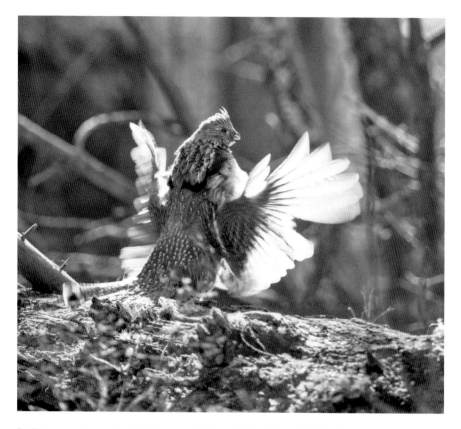

Ruffed grouse drumming in Yellowstone National Park. *National Park Service photo by Neal Herbert.*

suitable habitat is available. In contrast to the previous two species, it prefers deciduous habitat to conifers. In Montana, the ruffed grouse does well in canyon bottoms and foothills, particularly those in the island ranges in the central part of the state.

The ruffed grouse occurs in both gray and rufous color phases. Like the spruce grouse, it weighs barely half as much as the dusky. Its crested head and dark tail band readily distinguish it from the other Montana mountain grouse. The most striking difference between Montana ruffed grouse and those I knew while growing up in the East is not a matter of appearance but behavior. Eastern ruffs are notoriously wily game birds, perhaps as a result of generations of human hunting pressure, despite which they remain abundant. It's possible to flush a dozen of them during a morning in typically thick cover without getting a good look at any of

them. In the mountain West, however, they often act more like spruce grouse, waddling along the ground in plain sight at close range before flushing in the open. We have a small but stable population of ruffs on our property, but as much as I have always enjoyed them on the table, I leave them alone save for occasional training exercises for my bird dogs that result in no harm to the grouse.

In contrast to Eastern ruffed grouse, all of Montana's mountain grouse species receive little human hunting pressure, largely due to the abundance of more glamorous game birds—ring-necked pheasants, sharp-tailed grouse, Hungarian partridge—in gentler terrain. That doesn't mean that it's easy for any of them to make it through the year.

The winter following my encounter with the drumming ruff in the spring, I was following a cougar track through the same draw when an explosion of wings erupted from the barren brush ahead. My ears told me at once that the bird was a ruffed grouse. Could it be the same one I had seen earlier in the year? I didn't even have time to consider the possibility until after the fact. The instant I saw the bird clear the brush, something knocked it out of the air as quickly as a lightning bolt. Opportunities to observe predators taking prey are surprisingly rare and always require a combination of time in the field and luck. By the time I realized what had happened, a Cooper's hawk was standing over the dead grouse's body surrounded by feathers and crimson snow.

The attack had been surgical, to employ current military parlance—no noise, no struggle, just death as pure and quick as it comes. The hawk began picking delicately at the grouse's meaty breast with the tip of its beak, demonstrating all the precision of an experienced server filleting a sole at the side of a restaurant table. Could it have been the same bird I had seen that spring? Did it matter?

Now there was one less grouse in the woods and room for one more in the season ahead.

Chapter 11

MORELS

Morchella esculenta and
Morchella angusticeps

Early May is one of my favorite times of year to be afield in Montana. Much of the month's appeal derives from the nature of the season that precedes it, when the landscape sometimes looks as if it has just plain given up. Every year I remind myself that winter has its place, that this is the season that sorts the survivors' genes from all the rest, that the reservoir of moisture in the mountain snow will see the streams I love through the long, hot summer ahead. But I'm still always ready for May.

The Merriam's subspecies of wild turkey, a nonnative bird first introduced to the state in 1954 at a location visible from my front porch, usually provides what little excuse I need to rise in the dark and head to the hills. Because I enjoy hunting turkeys more than I enjoy killing them despite my enthusiasm for wild turkey on the table, I have limited myself to the traditional longbow as a means of take for the past three decades, putting the smart money squarely on the birds. But there is more to the spring woods than the siren call of distant gobbles and the challenge of coaxing a wary tom into longbow range. The snow remaining in the draws provides a final opportunity to read about the local wildlife's comings and goings in the white pages. Last season's shed antlers and cougar kills lie exposed, awaiting discovery. The eerie warble of courting snipe overhead confirms the return of migratory birds from the south. And if you take the time to look down as well as up, you might just find one of Montana's choicest wild culinary delights waiting to be gathered, taken home and eaten.

On one such morning a few years back, Lori and I were returning from a long hike through the hills that had produced nothing but exercise and scenery. Perplexed by the absence of turkeys, I was thinking about where they might be rather than paying attention to my surroundings even though I knew better. We were barely ten minutes from the truck when Lori whispered, "Stop!" in her soft hunting voice. I obeyed and turned slowly toward her for clarification. "You just stepped right over one!" she continued softly. Even after I looked down, it took me nearly a minute to notice what I'd missed.

"Why are we whispering?" I asked, whispering myself.

"There's probably more, and I don't want them to get away!"

Since the object of this sudden attention was a wrinkled fungus three inches tall and lacking all five cardinal senses, such precaution might seem absurd. But when Euell Gibbons titled his classic foraging guide *Stalking the Wild Asparagus,* he made a valid point. The terms "hunter" and "gatherer" are joined by a hyphen in the anthropology literature for a reason. Each borrows elements from the other, never more so than in the gathering of morels. Lori had continued to hunt that morning while I had not. Without her sharp eyes and awareness of her surroundings, we likely would have reached the truck empty-handed.

<center>⸻ ◦◦◦ ⸻</center>

The first rule of safe hunting is to make a positive identification of the target. This principle applies to foraging as well, never more so than in the case of wild mushrooms. Many are safe and delicious, some can induce adverse effects ranging from vomiting to hallucinations and a few can prove fatal. The latter possibility makes many outdoor travelers avoid them completely. With all due respect to the better-safe-than-sorry principle, that's unfortunate. Many of our tastiest wild mushrooms are easy to identify and enjoy with just a bit of knowledge, and the morel is one of them. Common advice encourages beginning mushroom pickers to stick to a few readily identified species at first and expand their scope slowly with the aid of an experienced mentor.

In 1943, mycologist C.M. Christensen of the University of Minnesota identified what he called the "Foolproof Four"—a quartet of edible mushrooms so distinctive that even beginners could gather them with confidence. One was the morel. (The other three: giant puffballs, shaggy

manes and chicken-of-the-woods.) True enough, but even the "foolproof" morel requires a bit of explanation.

There are actually multiple varieties of morels in North America, many of which cannot be distinguished in the field. For practical purposes, mushroom hunters in Montana can reduce that number to two: the common morel *M. esculenta*, also known as the white or yellow morel,

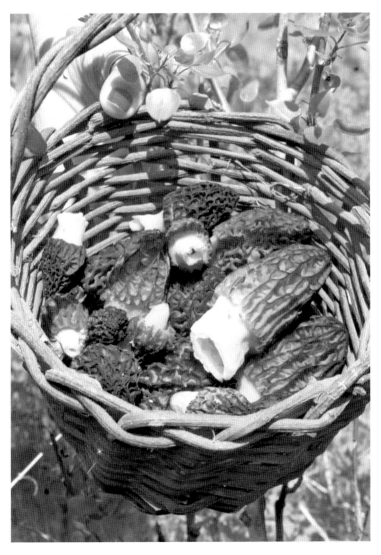

A basketful of fresh morels picked in early May. Collecting morels in baskets rather than closed containers allows their spores to disperse. *Photo by Don and Lori Thomas.*

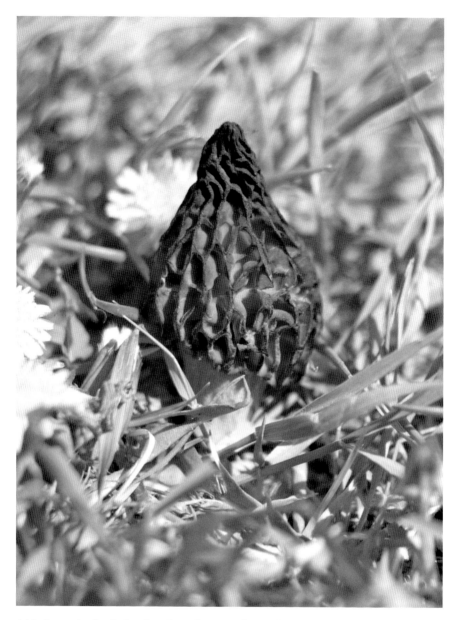

A black morel pokes its head up through a green layer of new grass. Morels have never been successfully cultivated. *Photo by Don and Lori Thomas.*

and the conic morel *M. augusticeps*, or black morel. Both are spongy mushrooms one to three inches tall, hollow inside and lacking gills, with caps covered with furrows and ridges in an irregular honeycomb pattern.

M. esculenta is lighter in color, and *M. augusticeps* has a more sharply tapered cap. In the field, the distinction is moot, since both are safe and delicious.

However, two caveats apply. First, several "false morels" of the genus *Helvella* can cause moderate to occasionally severe poisoning. Distinguishing these mushrooms from the true morels is easy once one becomes familiar with them, but beginners should be sure to understand the differences in appearance between true and false morels. The cap of the true morel is joined seamlessly to the stalk, and the inside of the cap and stalk forms one continuous hollow cavity. False morels lack these features. Second, even the true morels contain heat-labile compounds that can cause mild to moderate gastrointestinal symptoms in some people. Fortunately, cooking breaks them down. Never eat morels raw even in small quantities.

Morels are found throughout Montana. While usually associated with moist but well-drained soil in open wooded areas in the western part of the state, they also appear in mountain foothills and river bottoms farther east. They occupy a variety of habitats at all elevation levels except true alpine. Recently burned areas are classical places to find black morels, and they attract a lot of mushroom hunters, both recreational and commercial. I usually look for morels near cottonwood trees. They erupt in the same areas year after year, and serious morel enthusiasts guard their favorite locations closely. When I lived in Alaska, a good friend with a house across the Kenai River from my own confided that his famously productive morel patch was on my side of the river and close to where I lived. Every spring he fed us morels and gave us morels generously, but he would never tell me exactly where he found them. I can't say that I blame him.

In contrast to most edible fungi, morels appear in the spring, usually after a few days of warm sunshine. Warming soil (forty-two degrees Fahrenheit seems to be the magic number) is the most specific trigger for eruption, but I just watch for pasque flowers in full bloom and listen for ruffed grouse drumming. Yellow morels usually appear before blacks, and both species lag well behind the receding snow line as it advances up the mountainsides. Morels seldom appear right next to old snow.

The morels we pick are not individual entities but the fruiting bodies of an organism composed of a vast underground network of thread-like mycelia. This is one reason why productive areas for morels tend to remain constant from season to season. An individual morel is just

Morels thrive in moist but well-drained soil in open wooded areas in the western part of the state as seen along the Nez Perce National Historic Trail in the Bitterroot Valley's Lee Metcalf National Wildlife Refuge near Stevensville, MT. *U.S. Forest Service photo by Roger Peterson.*

the tip of a very large iceberg. Mycologists theorize that morels appear when mycelia expanding beneath the ground reach an impenetrable obstruction such as rock or a seam of clay. Then spores released by the mushrooms can disperse through the air and jump the barrier.

Mushrooms of the genus *Morchella* occur widely around the world, and they are culinary favorites in Europe and Asia as well as North America. Finding them may be the hard part of the process, but you still have to know what to do with them. Like most mushrooms, they deteriorate soon after they appear. Fresh specimens taste best, and morels that are dry or brittle should be left in the field. Snipping or pinching the stem of the morel just below the cap will minimize the amount of dirt in your collecting basket. (Seasoned mushroom hunters like to carry their harvest in baskets rather than impermeable bags, allowing spores to disperse as they walk.) While worms imbedded in the flesh of any wild mushroom can render them unappetizing, don't let the superficial presence of a few small insects bother you. Once you reach home, rinse your haul thoroughly under cold running water and let them drain on paper towels.

At this point, the forager faces several options, but it's important to exercise one of them soon. Morels don't dissolve overnight in the refrigerator like shaggy manes, but they should still be eaten or processed within a day or

two. The simple, classical way to prepare morels is to slice them in half longitudinally, sauté them in butter with a dash of salt and pepper and serve them as a side with venison or, better yet given the season, freshly roasted wild turkey. The result is a spectacular meal best shared with friends, although I'm not above sneaking a few of the morels out of the pan and eating them myself while I'm cooking.

But even I can only eat so many morels in one sitting, and if the search has been truly productive, the successful gatherer will need to deal with the surplus—a classic example of a nice problem to have. The two basic approaches consist of freezing or drying, and everyone seems to favor a different method for accomplishing either. After years of experimentation, here's how we do it.

Separate the morels into portions that will just cover a plate in a single layer, with no overlap. Microwave the plate of morels at a medium setting while observing constantly until the mushrooms have reduced to about half of their original size. Depending on microwave settings this usually takes about one minute, but don't overdo it. Remove the morels from the plate and carefully save the liquid on the bottom. Repeat the process until you have reduced all the morels, then let them air-dry, divide them into appropriate portions, vacuum pack them, label and date each package and put them in the freezer, where they will keep for a year in the unlikely event that you don't eat them first. Then put the liquid you've reserved into an ice cube tray and freeze it. When the liquid has frozen solid, pop out the individual cubes and return them to the freezer in a bag. These "morel cubes" can then by removed one or two at a time and used as the base for savory mushroom sauces, with or without the actual morels.

While I always look forward to that first gluttonous meal of fresh morels in the spring, I prefer to think of them the way chefs think about truffles, as a source of flavor rather than a stand-alone dish. The taste is distinct, rich and nutty, and a little bit goes a long way. Used sparingly in sauces and as a supplement to dishes like wild rice, the product of one morel season can extend all the way to the next one.

The popularity of morels on the table has made them an expensive delicacy for those who don't gather their own. Growers have made numerous attempts to cultivate them, but since all such efforts have failed, wild morels remain the only commercial source. The high price morels command has drawn large numbers of commercial pickers to western Montana, especially following recent burns on public land. Managers at the Beaverhead and Bitterroot National Forests have had to devise

An open wooded area ideal for morels below the Bitterroot Valley's Trapper Peak, near Sula, Montana. *U.S. Forest Service photo by Roger Peterson.*

increasingly complex regulations to manage the swarms of mushroom pickers who arrive each spring nowadays. The rules change every year depending on conditions and demand, but even private mushroom pickers need to check current regulations. The Forest Service generally requires recreational pickers to obtain permits, which are issued free or at nominal cost. Commercial pickers are more strictly regulated. The demand for morels is so high that unpleasant confrontations, especially among commercial pickers, have started to take place, illustrating the inevitable problems that arise whenever wildlife acquires a commercial value. The area where I live has fewer morels than the western part of the state, and we have to work harder to find them, but I'll gladly accept hiking farther in exchange for solitude in the woods when I'm searching for morels—or anything else.

I can still remember when hardly anyone in eastern Montana knew what a morel was, but that naiveté was subject to unexpected surprises. One day in May years ago, I cut across a bend in a local creek on my way back to my rig after a morning of fly-fishing. There in a grove of towering cottonwoods, I noticed a morel peeking its head up through the new grass. In no time, I'd stuffed all the pockets in my fishing vest with fresh, plump morels.

Back at my truck, I ran into the landowner, a gruff and crusty old rancher with whom I'd enjoyed a surprisingly cordial relationship for years. After the usual jawing about the weather and beef prices, I decided as a matter of courtesy to obtain formal permission to do what I'd just done. "You wouldn't mind if I picked a few of those little black mushrooms down by the creek, would you?" I asked politely.

To my surprise, he fixed me with a glare as if I were a rabid coyote. "If I ever catch you picking any of my morels," he growled, "I'm throwing your ass off my property for life."

Doing my best to keep my arms fixed across my bulging vest pockets, I sidled around to the driver's side of the truck, thanked him for the fishing and departed. On all future visits I kept to the creek and avoided the cottonwood grove as if the ground beneath the trees held landmines. The best way to defeat temptation is usually to avoid it.

<center>———◦◦◦◦———</center>

North America is home to dozens, if not hundreds, of edible mushroom species. Among gatherers, morels enjoy a unique status that is a bit difficult to explain. Morels are wonderful on the table, but so are a number of mushrooms, including chantrelles, agarics, boletes and the rest of the "Foolproof Four." Many casual mushroom hunters pick nothing but morels, which have acquired a cult-like following in many parts of the country. Enthusiasts regard the month of May the way others regard the hunting or skiing season. To some extent, popularity eventually becomes self-fulfilling. Is the morel, like certain celebrities, simply famous for being famous?

I would argue otherwise. The morel has a truly unique flavor, and nothing but a truffle can liven up a dish the same way in such small quantity. The morel is easy to identify, with no really dangerous look-alikes. It appears in the spring, when most Montanans are eager for excuses to get back in the woods after the long winter. Looking for morels is challenging and just plain fun.

Morels are surprisingly difficult to see. Short and inconspicuous, they blend in readily with the grass and duff on the forest floor. Seeing them requires looking for them, a process I describe as "finding my morel eyes," as I have to do all over again every spring. Lori is much better at it than I am, and she frequently spots morels I've walked right by. Morel hunting is

an activity to enjoy with family and friends, including children (although kids should always be strictly cautioned against eating any wild mushroom until an adult has examined it).

Above all, morels are an annual reminder of nature's capacity to give. Nowadays, we should appreciate such reminders more than ever.

Chapter 12

LEWIS'S WOODPECKER AND CLARK'S NUTCRACKER

Melanerpes lewis and
Nucifraga Columbiana

*I*was near the end of a morel-gathering expedition in the mountain foothills east of my home one spring day when the sight of an unfamiliar bird perched on a nearby fence post brought me up short. Spotting an unfamiliar avian species on my home turf is an unusual event after all these years in the field, but I knew I'd never encountered this one before. The bird appeared undisturbed, and I had time to dig my binoculars out of my daypack for a better look. Its vertical perch on the post identified it as a woodpecker, and it was a large one, approximately the size of a flicker. The bird looked black overall, but its face was dark red and its belly was an unusual rosy pink. As I watched, it performed a very uncharacteristic maneuver for a woodpecker, flapping away from its perch to pluck an insect from midair just like a flycatcher, although with considerably less grace. Finally, it headed across the meadow toward the pines, flying crow-like as if it were towing a heavy weight. What the…?

By the time I reached home, I had correctly decided the bird was a Lewis's woodpecker, although I had to confirm my hunch by consulting a reference book. The reason I'd never seen one before is likely just that I live on the extreme eastern edge of the species' range. That encounter occurred over twenty years ago, and I've never seen one since.

In addition to being superb woodsmen, navigators and hunters, the two officers who led the Corps of Discovery across the continent to the Pacific and back were remarkable naturalists. Their observations and records have

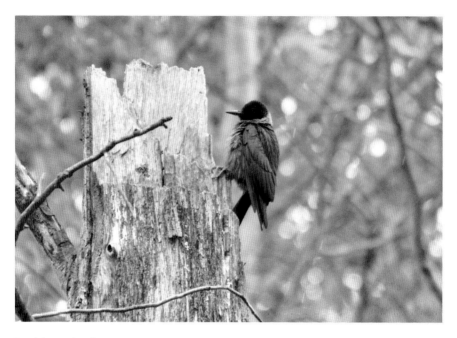

Lewis's woodpecker. *Photo by Andy Reago & Chrissy McClarren.*

withstood the test of time, and I've referenced them often in this book. It has always struck me as strange that their names are not attached to more of the two-hundred-plus species they first described for western science, since the nineteenth century was the era of biological eponyms. From auklets (Cassin's) to wren's (Bewick's), modern guides to birds are chock full of kudos to those who first described many of them. Some of those early naturalists rode with Audubon on his collecting expeditions. Many have their names attached to multiple species. But despite all their accomplished descriptions of new representatives of both the plant and animal kingdoms, Meriwether Lewis and William Clark each have just one, Latin scientific names excepted—the birds identified in this chapter's title.

On May 27, 1806, while the expedition was in what is now Idaho, Lewis recorded the following:

> *The Black woodpecker which I have frequently mentioned and which is found in most parts of the roky Mountains as well as the Western and S.W. Mountains, I never had an opportunity of examining until a few days since when we killed and examined several of them...The beak is black, one inch long, rather wide at the base, somewhat curved and sharply pointed; the chaps*

are of equal length. Around the beak and the base of the eye and a small part of the throat is of a fine crimsons red. The neck and as low as the croop in the front is of an iron grey. The belly and breast is of a curious mixture of white and blood red which has much the appearance of having been artificially painted or stained of that color. The red feather predominates.

The description goes on for two more paragraphs in a wonderful example of its author's keen eye for detail.

After the conclusion of the expedition, those specimens wound up in a Philadelphia museum, where the American ornithologist Alexander Wilson (of the snipe, phalarope and others that now bear his name) examined them and named the bird *Picus torquatus.* In 1831, British zoologist William Swainson (of Swainson's hawk and thrush) reclassified the bird and named it for Lewis.

Lewis's woodpeckers are migratory and don't spend a lot of time in Montana, arriving in April or early May and usually heading south by the end of August. While they occupy a variety of open forest habitat, mature ponderosa pines and old burns are favorite locations. They also nest along creeks and other water sources. They are less adept than most woodpeckers at excavating nest

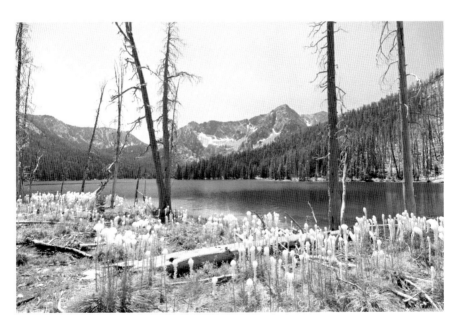

Johnson Lake's burn site represents the habitat preferences of old burned trees, a water source and easily foraged holes in the dead trees. *Courtesy of Pete Ferranti.*

A stand of mature trees in an open forest in the Lee Metcalf National Wildlife Refuge represents ideal habitat for the woodpecker. *U.S. Forest Service photo by Roger Peterson.*

cavities and prefer natural holes in dead trees or nest sites abandoned by other woodpeckers. They are also different from most other woodpeckers in their feeding habits. Instead of pecking holes in trees to extract beetles and larvae, they prefer to forage in the air or on open ground.

Visitors to open pine or riparian habitat in western Montana have a reasonable chance of seeing one, but they will still have to look closely to find the only species whose common name includes a tribute to Meriwether Lewis.

Although an equally capable leader, William Clark lacked some of Lewis's capacity for minute and accurate biological observation. His notes of May 22, 1805, demonstrate this point: "I saw to day a Bird of the woodpecker kind which fed on Pine burs it's Bill and tale white the wings black every other part of a light brown, and about the size of a robin."

The following year, Lewis had time to expand on this description in his meticulous way, while correcting Clark's original error in classification:

I have killed several birds of the corvus genus of a kind found only in the rocky mountains and their neighborhood. [It] has a loud squawling note something like the mewing of a cat. The beak of this bird is 1½ inches long, is proportionably large, black and of the form which characterizes this genus…the head and neck are also proportionably large. the eye full and rather prominent, the iris dark brown and puple black. it is about the size of the Jaybird.

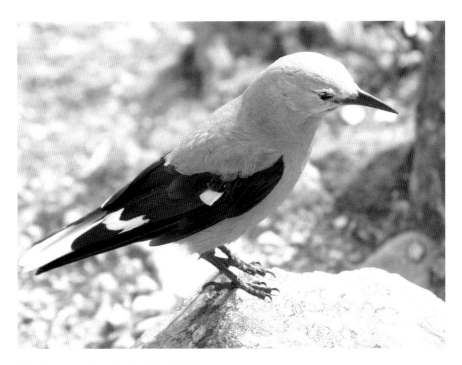

Clark's nutcracker. *Photo by Wing-Chi Poon.*

Again, considerable additional detail follows. All of Lewis's observations have proven accurate, as well as his belief that the bird is not a woodpecker but a member of the corvid family of crows and jays.

In Montana, the nutcracker occupies high, forested mountainsides in the western third of the state. The only bird it might be confused with is the gray jay (familiar as the "camp robber"), but the striking white markings on the nutcracker's wings and tail are distinctive in flight even at a distance. The bill that Lewis commented on is indeed remarkably long and pointed, and its form defines both the bird's feeding habits and the unique ecological role the nutcracker plays in the Mountain West.

While the nutcracker will occasionally eat insects, berries and even carrion, pine seeds are its principal food source. The long, sharp bill allows it to pluck seeds from pinecones while perched on them, and a pouch beneath the tongue provides a place to store them during transport. The bird then caches seeds for future use, dispersing them over a remarkably wide area and deliberately hiding more than it will likely need as insurance against an unusually hard winter. Some nutcrackers deposit up to ninety thousand seeds in more than ten thousand caches in a single season. These caches

can be distributed over a distance of ten miles and three thousand feet of elevation change. Nutcrackers demonstrate a remarkable ability to relocate these caches even when they are buried under layers of snow, apparently by using a combination of memory and landmarks.

While nutcrackers will feed on many varieties of pine, their preferred food sources are the higher-elevation five-needled pines of the genus *Pinus*, which in Montana includes the limber pine and the whitebark pine. Populations of both, especially the whitebark, have been in rapid decline due to infestation with mountain pine beetles. Fire suppression has resulted in overgrowth by other more shade-tolerant, fire-intolerant species of spruce and fir. In 2011, the United States Fish and Wildlife Service listed the whitebark pine as "threatened but precluded."

Whitebark pinecones will not open on their own. They require active dispersal by one of two species: the red squirrel and the Clark's nutcracker. Squirrels stockpile seeds in middens, of great value as a food source for foraging grizzly bears but of little use to the pines since seeds heaped into piles seldom germinate. On the other hand, nutcracker caches, each of which usually contains just a few seeds buried in the soil, commonly produce

When the mountain pine beetles that killed these trees infest whitebark pines, they can initiate a ripple effect detrimental to species as diverse as the Clark's nutcracker and the grizzly. *Photo by Don and Lori Thomas.*

Spraying ponderosa pine tree with Carbaryl in Bitterroot National Forest campground to prevent mountain pine beetle mortality. *U.S. Forest Service photo.*

growing pine trees over a wide area. In this way, the nutcracker and the whitebark pine have enjoyed a symbiotic relationship as long as they have coexisted on the continent. In fact, some biologists believe that the nutcracker introduced the whitebark pine to North America by carrying its seeds across the Bering Sea land bridge thousands of years ago. The uncertain future of the whitebark pine has important implications for species other than the nutcracker, particularly the grizzly bear (see chapter 29).

Given the volume and quality of the biological knowledge Lewis and Clark compiled on their journey, the fact that each of their names is attached to just one modern species seems something of a snub. But this is it: one distinctive-looking woodpecker, one jay on whose shoulders rests the future of many species and the health of Montana's sub-alpine habitat. However, Lewis and Clark were both modest men. I doubt they would have asked for anything more.

PART III
PRAIRIE

Chapter 13

SAGEBRUSH: A DEFINING FLORA

Artemisia spp.

*I*first moved to eastern Montana in 1973. I had just completed a medical internship in Montreal, and after meeting my old high school friend Dick LeBlond, who had just completed an internship in New York, we set out for our first real jobs as physicians. Although the draft had just ended, we enlisted as commissioned officers in the Indian Health Service, a branch of the Public Health Service, which in turn is a branch of the Coast Guard, and headed for the Fort Peck Reservation in northeastern Montana. We knew we faced a challenge—cross-cultural medicine in a remote setting with the nearest support facilities many long miles away. But after all those grueling years of higher education, loading our meager possessions into our trucks and pointing them west felt so liberating that neither of us worried about what might lie ahead.

We had been warned, however, not about the professional difficulties we might face at Fort Peck but about the terrain. The Billings Area Office administered healthcare on reservations in Montana and northern Wyoming, and virtually all the physician applications it received were from young doctors who wanted an assignment in or near the mountains. Fort Peck hardly met this description. It lies surrounded by prairie, with the nearest mountains hundreds of miles away. That, it turns out, was the principal reason the administration had difficulty finding physicians willing to work there.

We drove across Canada faster than we needed to, just because we were so eager to see the place we'd call home for the next two years. After we

entered American soil at the Port of Raymond and headed south on State Highway 16 toward Culbertson and U.S. Highway 2 (or the Hi-Line, as Montanans call it), I realized I'd been there before. Every summer when I was growing up, my family would load fishing rods and camping gear into our station wagon and head for Montana in what felt more like a religious pilgrimage than a vacation. After two days of round-the-clock driving by my parents, I always began to grow desperate for a sight of the mountains where the trout lived. Now I was driving through the area where that childish desperation had once begun to overflow in an endless series of questions. *How much longer? Are we there yet?* The eastern Montana prairie had always been the place I wanted to put behind me as fast as possible, and now it was about to become my home.

But I had already begun to notice things I'd missed as an impatient kid eager for a trout stream. The dimensions of the huge blue sky seemed endless. For mile after mile, the only evidence of human habitation came in the form of occasional isolated ranch houses, none of them the least bit pretentious, some looking like leftovers from the homestead days. Lush sage—this was early July in an exceptionally wet year—covered the prairie in a gentle blanket of silvery gray, and when I rolled down the window, its pungent aroma filled the truck. Like white balls of cotton blowing across the landscape, the antelope were easy to see. The deer required a bit more looking, but they were there, too.

I had arrived at my new home on the range.

———◦◦◦———

Despite popular misconceptions to the contrary, most of Montana is prairie rather than timbered slopes and alpine peaks. To appreciate Montana and its wildlife, one must learn to respect the two-thirds of the state that doesn't make it to the postcard racks, the calendars or the coffee table books (with occasional welcome exceptions). But in temperate-zone ecosystems, savannah habitat supports more biomass and wildlife diversity than any other. It's all there in eastern Montana, just waiting for observers patient enough to look.

Many habitats support one dominant flora that largely determines what varieties of fauna will thrive there, as we have already seen in this book. It's hard to think of a better example of this principle than sagebrush in eastern Montana. The prairie there *is* sagebrush and vice versa. Several

Sagebrush below Ear Mountain in the Lewis and Clark National Forest. *U.S Forest Service Northern Region photo.*

An example of a mountain big sagebrush steppe (*Artemisia tridentata* subsp. *vaseyana*)–dominated plant community near Cabin Gulch in the Big Belt Mountains near Townsend, Montana. *U.S Forest Service Northern Region photo.*

of the species profiled in this section, notably the pronghorn and the sage-grouse, simply cannot survive without it. Trying to imagine the prairie without sagebrush is like trying to imagine France without wine.

What we commonly refer to as sagebrush is not one plant species but many closely related members of the genus *Artemisia*. Lewis and Clark described five of these species on their journey—admirable botany but little more than a good start. Scientists now recognize forty-eight species of sagebrush native to our western plains. Tarragon and wormwood are both derived from Old World *Artemisia* species. Twenty-seven varieties of sage are found in Montana, of which sixteen are of the woody form particularly important as wildlife habitat. Sagebrush is not confined to the prairie, and several species occur in western Montana's mountains.

Montana's most widespread and abundant *Artemisia* species is also the most important to wildlife: the big sagebrush, *A. tridentata*, so named for its three-lobed leaves. Four subspecies of big sagebrush occur in the state, each favoring slightly different soils and precipitation levels. This is a remarkably long-lived shrub, and if undisturbed, individual plants may live over a hundred years. Big sagebrush is indeed big, capable of growing ten feet tall in favorable conditions. It also has a very long taproot

Healthy sagebrush is a crucial habitat component for numerous species of Montana wildlife. *Photo by Don and Lori Thomas.*

Because sage retains its leaves year round, it provides both food and shelter for multiple species of wildlife during the winter. *Photo by Don and Lori Thomas.*

that can reach twelve feet below ground level. This structural feature benefits prairie habitat in two major ways. Big sagebrush helps prevent erosion, and it draws subsurface moisture upward where vegetation with short root systems can utilize it as well. Like many other varieties of *Artemisia*, big sagebrush retains its leaves year round, making it an important source of nutrition for many birds and animals during harsh Montana winters.

The pungent oils that give sagebrush leaves their characteristic smell have an acrid taste that presumably evolved to deter browsers from feeding on the plants. While most large mammals avoid eating sagebrush, pronghorns regularly consume it and depend on it as a source of nutrition, particularly during the winter. Sage-grouse do the same throughout the year. Some sage leaves are at least mildly toxic to humans, so resist whatever urge you might feel to nibble on them. One of the hundred tales in Boccaccio's *Decameron* describes two doomed lovers who die after nibbling sage during a tryst in a garden. (However, the ultimate source of the lethal intoxication proves to be a toad living beneath the plant, proving that old Italian literature does not necessarily provide a reliable guide to the natural history of plants or amphibians.)

In addition to its role as a food source, sagebrush provides shelter habitat for a number of prairie species, including songbirds, sage-grouse and

sharptail grouse and the diminutive pygmy rabbit (whose range in Montana is limited to the southwest corner of the state). The big sagebrush is the most important of the *Artemisia* species as a source of shelter because of its size and the strength of its sturdy trunk, which make it resistant to wind and snow loads.

Sagebrush is remarkably hardy, capable of surviving wind, bitter winters and drought—another reason for its importance to wildlife during periods of environmental stress. It does have an Achilles heel, however: fire. Sagebrush burns hot and can take decades to regrow after a prairie wildfire. In order to convert sagebrush habitat into cropland, homestead-era farmers simply needed to burn it and start breaking up ground. Sagebrush is threatened further by the introduction of invasive species like cheat grass, which has a much shorter natural fire cycle. Additional threats include structural damage by domestic livestock, herbicides and competition from other invasive plants that compete for moisture. Montana has lost approximately half of its original sagebrush habitat. Federal, state and private organizations such as the American Prairie Reserve (see www.americanprairie.org) are actively working to preserve what's left in conjunction with voluntary efforts by private landowners.

———◦◦◦———

Many Americans living east of the Mississippi received their introduction to the *Artemisia* species through Zane Grey's 1912 western classic *Riders of the Purple Sage*. Depending on many factors, including rainfall and the angle of the light, I've seen sage look gray, silver, green and even a light shade of blue, but I can't remember it ever looking purple. Even the cover of the Grosset & Dunlap first edition of the book shows the sagebrush looking bluish-gray. The only purple I've noted anywhere in the book or its subject matter is the color of Grey's prose.

This confusion is indicative of a larger issue—the prairie's chronic public relations problems. Visitors to Montana rarely come to see the prairie. If they are driving from the east as we were during the 1950s, the first response to those lonely miles of sagebrush is usually to step on the gas pedal, secure in the assumption that there isn't a cop within miles (as there usually isn't). Too often, the result of the impression that the prairie is a barren wasteland is to overlook one of the most interesting wildlife habitats in America.

Bowdoin National Wildlife Reserve near Malta. *Public domain.*

In fact, sagebrush country is anything but monotonous and empty, at least for those willing to look. A number of the wildlife species profiled elsewhere in this book, notably including elk, bighorn sheep and bison, have been successfully reintroduced on their original range there, and the prairie may be one of the best places in the state to observe them. And there are plenty of opportunities to do so, no matter what your specific interests. Encompassing large sections of the spectacular Missouri River Breaks, the Charles M. Russell National Wildlife Refuge (NWR) (www. fws.gov/cmr) is the country's largest. The Bowdoin NWR near Malta supports one of the most diverse concentrations of water birds anywhere in the West. A float trip down the Wild and Scenic section of the Missouri allows visitors an opportunity to see Montana much as Lewis and Clark did, with remarkably little change. The American Prairie Reserve always welcomes visitors.

All one needs to do in order to appreciate this beguiling country is to visit it with open eyes and an open mind.

Chapter 14

AMERICAN PRONGHORN

Antelocapra americana

\mathcal{A}lthough they lie half a world apart, the eastern Montana prairie and the southern African veldt have more in common than one might imagine. Both areas are arid, with short trees and thorny brush scattered across flat, grassy terrain that provides a surprisingly rich forage base for ungulates. Both locations offer vast horizons, and Africa's overhead space can feel just as overwhelming as A.B. Guthrie's iconic Big Sky. Apparently barren at first glance, both are home to a remarkable diversity of wildlife. Not surprisingly, much of the fauna occupying these ecological niches is similar in both appearance and habit.

One spring day, Lori and I were returning home from the Billings airport with our old friend Alan Cilliers, who had come all the way from Africa for a visit. For years, Alan served as chief ranger in Namibia's Etosha National Park, one of Africa's largest and best-preserved expanses of wilderness south of the Zambezi River. In addition to providing support and local expertise for countless biological field studies, he is one of the few white Africans to have made himself at home with the Bushmen, southern Africa's legendary trackers and subsistence hunters. His idea of a vacation is to shed his western clothing and go walkabout through the Kalahari for a week or two with his Bushman friends. He understands wildlife as well as anyone I know.

Halfway home, Alan pointed out across the sagebrush and shouted, "Those look like springbok!" Of course, the critters he'd spotted weren't the South African national animal but our very own pronghorn antelope. The resemblance, however, was striking. Both species are medium-sized

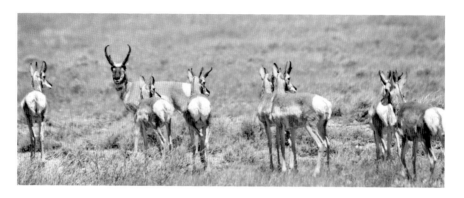

A pronghorn buck tends its harem of does in September. *Photo by Don and Lori Thomas.*

ungulates, light in color, alert and ready to explode across the plain in a burst of speed the instant their keen eyes detect a hint of danger, often from remarkable distances. The springbok and the pronghorn represent a fine example of parallel evolution as a result of adaptation to life in dry, open terrain shared with a host of potential predators. There is an interesting catch though. The springbok is a gazelle, a true member of the antelope family. Our pronghorn isn't, even though Montanans have been calling it one for generations.

This misclassification received widespread popular support in 1876 courtesy of one Brewster Higley, an often married, alcoholic failed physician who moved to the plains to escape his past and wound up writing the Kansas state song, whose opening lines eventually became a music class staple in grade schools all across America: "Oh, give me a home where the buffalo roam, where the deer and the antelope play." It's hard for biologists to follow an act like that.

Keener observers than Higley have had similar difficulties classifying the animal. Lewis and Clark began to encounter the pronghorn in September 1804 in what is now Nebraska, and they soon became an expedition food staple. The *Journals* sometimes refer to them as goats and at other times as antelope, occasionally on the same day and even the same page. On September 14, Clark offered the following observations:

I killed a Buck Goat of this Country, about the hight of a Grown Deer, its Body Shorter the Horns which is not very hard and forks $^2/_3$ way up one prong Short the other round & Sharp arched and is immediately above its Eyes the Colour is light gray with black behind its ears down its neck, and its face white round its neck, its Sides and rump around its tail which

*is Short and white: Verry actively made, has only a pair of hoofs to each
foot, his brains at the back of his head, his Nostrals large, his eyes like
a sheep he is more like the Antelope or Gazella of Africa than any other
Species of Goat.*

As usual, Clark's description is accurate, his spelling imaginative. In this
case, his confusion about the animal's classification seems forgivable since
scientists have wrestled with the same problem for the last two centuries. The
proper form would be to call it the pronghorn, as I shall do here.

The pronghorn's immediate ancestors arose in the New World. It is the
only surviving member of its family, which included twelve *Antelocapridae*
during the Pleistocene. Like the mountain goat described earlier, the
pronghorn has no close biological relatives anywhere in the world. To the
extent that it resembles members of any other family, it is a goat. Sort of.
Since goats are known scientifically as *Capridae*, the pronghorn's schizoid
generic name splits the difference and gets it about as right as possible.

Like many sole survivors, the pronghorn demonstrates a number of
unique anatomic features and abilities, all ideally suited to the habitat niche
it occupies. The pronghorn's large eye sockets are located unusually high
and far apart on the skull, providing a field of vision of around 320 degrees,
roughly twice our own. The distance between the eyes affords excellent
binocular vision, which is particularly important in detecting motion. The
pronghorn's long-distance vision is a matter of western legend, as generations
of native subsistence hunters and hungry settlers armed with rifles learned
the hard way. Many claim that the pronghorn views its world through the
equivalent of eight-power binoculars, although that statement is largely a
matter of conjecture.

While their vision is certainly acute, years of personal experience have
taught me that the pronghorn's eyesight has some weaknesses. They are
poor pattern-recognizers that often stumble right into harm's way at close
range. They really excel at seeing just two things: movement and changes in
horizon contour. They also don't see particularly well in low light, which is
likely one reason they move and feed during the day more than most western
ungulates. While pronghorns certainly can hear and smell, their ears and
noses aren't as sensitive as those of deer and elk, probably because they
evolved to detect predators from longer distances at which hearing and smell
would be less useful.

Seeing predators accomplishes nothing absent the ability to elude them,
which the pronghorn achieves with speed rather than stealth. It is the world's

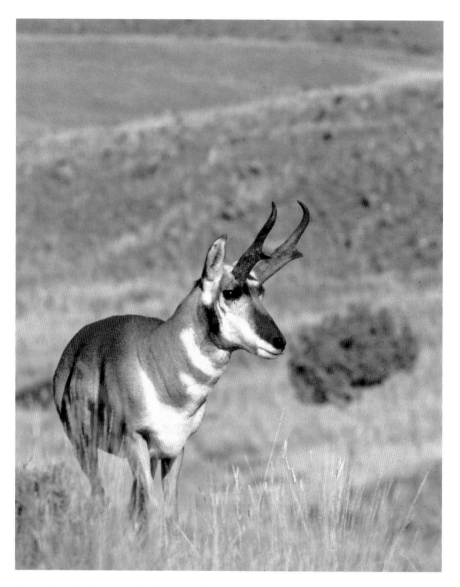

A pronghorn buck surveys its chosen territory at the beginning of the September rut. *Photo by Don and Lori Thomas.*

second-fastest land mammal, capable of speeds exceeded only by the African cheetah. Like most cats, the cheetah is a sprinter. A cheetah can accelerate from zero to sixty miles per hour in three seconds and hit top speeds over seventy. But the cheetah cannot sustain its pace for long, while the pronghorn's robust heart and lungs allow it to run for hours with little evidence of fatigue.

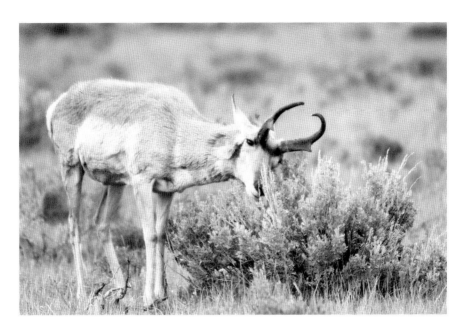

This mature pronghorn buck is scent-marking its territory on sagebrush. *Photo by Don and Lori Thomas.*

The pronghorn's top speed is around fifty-five miles per hour, but it can sustain that pace for several minutes and can cruise at forty-five for miles. Since no predator within the pronghorn's range can come close to those standards of speed and endurance, one wonders why the animal developed such cardio-pulmonary reserves in the first place. The fossil record shows that the North American plains were once home to a now extinct relative of the cheetah, so the pronghorn likely evolved to give itself a chance to outrun our own version of the world's fastest mammalian predator.

The best way to appreciate the pronghorn's remarkable ability to eat up ground is to hike out into the prairie with a pair of binoculars and observe a herd of antelope during the last two weeks of September when the annual rut is in full swing. By this time, dominant bucks will have gathered harems of does numbering a dozen or more depending on local population dynamics and the fitness of the buck. The herd buck typically spends the morning tending its does, nudging them back if they try to wander off, and confronting the smaller satellite bucks that inevitably lurk at the perimeter of the harem.

The show really starts when a doe becomes receptive to breeding. Talk about playing hard to get! Her first act is usually to break away from the herd and tear across the prairie at blistering speed with the herd buck in hot

pursuit, often matching her stride for stride for miles across broken terrain. The lovers' ability to run these high-speed courtships without breaking legs is amazing. The herd buck may or may not catch the doe and breed her, but no matter how the race concludes, it will usually face an immediate problem once it turns back toward the rest of the does. The herd buck's departure provides the cue the satellite bucks have been waiting for, and they will take advantage of its absence by trying to cut a doe or two out of the harem to breed themselves. Thus, as soon as the weary herd buck concludes the original chase, it has to race back to the herd, lower its horns and start chasing away the competition. The herd buck often ends these episodes in a state of near collapse, lying in the dirt with sides heaving, waiting for its body to metabolize the lactic acid accumulated during the run and preparing to repeat the process all over again at the first sign of another receptive doe.

At first glance, this ritual hardly appears adaptive to the species. Bucks and does sometimes injure themselves during the course of these wild runs. An exhausted buck is inevitably susceptible to predators, and I've watched coyotes spend all day lurking at the margins of a pronghorn rutting area just waiting to capitalize on a broken leg. But in the long game, all of these antics appear much more logical. The does' wild runs ensure that the swiftest, fittest bucks' genes will be passed along to the next generation. The satellite bucks' careful plotting introduces genetic diversity into the herd and allows selection for craftiness as well as raw speed. Since today's pronghorn is the only one of its dozen original family members to survive, something must be working.

For complex social and anthropological reasons, humans often define ungulates, particularly males, by their horns and antlers. Horns are hollow and remain in place for the life of the animal, while antlers are solid and shed annually. The pronghorn's "horn" structure is unique. The interior contains a permanent bony blade. This structure is covered by skin, which acquires a hard, tough coat of keratin that is shed annually, usually in November. Thus the black structures atop the antelope's head have features common to both horns and antlers. Unusually, pronghorn does also carry horns, although theirs are smaller than the males' and rarely fork.

Wild inhabitants of wooded areas with limited visibility usually communicate using sound and hearing, while open country species depend on visual cues. The pronghorn's primary means of communicating alarm to other members of its herd is by flaring the erectile white hairs on its

rump, a signal visible from considerable distance that will quickly bring all animals in the area to a state of alert. (They also issue a distinctive alarm wheeze in response to perceived threats.) Another unique feature of pronghorn behavior is the species' proclivity to migrate. While many pronghorns remain within a limited home range most or all of their lives, others don't hesitate to travel. In northeastern Montana, bitter winter conditions along the Canadian border sometimes send antelope streaming south across the frozen Missouri and Fort Peck Lake in herds of thousands, with disastrous results if the ice hasn't thickened sufficiently to support their weight. As winter approaches in Wyoming, large herds of antelope follow traditional migration routes south from Grand Teton National Park to the upper Green River Valley, a distance of nearly two hundred miles. The caribou is the only North American ungulate that migrates farther.

There were probably around 20 million pronghorns on the Great Plains at the time of European contact. By 1900, that number had fallen to 12,000. Unregulated subsistence hunting and habitat losses to agriculture certainly contributed to that decline, but a unique weakness in pronghorn behavior may have been even more significant. A friend who has spent a lot of time with antelope once accurately described them as talented rather than smart. In fact, they really only do two things well, although they do them very well: see and run. They are not shrewd intellects, and one concept they just don't seem to grasp is the wire fence.

I have seen a pronghorn jump a fence only once, although they are certainly capable of doing so at will. When pronghorns have to cross a fence, they usually drop to their knees and crawl awkwardly beneath the lower wire, a process that can be hard on fences and pronghorns alike. Often, they will walk or run parallel to a fence for miles rather than attempting to cross it. I once watched a large group of pronghorns racing across the prairie ahead of some perceived danger I never identified. When they reached the first fence, the does and fawns dropped down and crawled beneath it at the same spot, single file. So far so good, but the mature buck following them never even slowed down. After hitting the fence at top speed, he catapulted backward like a professional wrestler hurtling off the ropes at the edge of the ring. Obviously eager to rejoin the herd, he backed off and hit the fence again. And again. The animal just couldn't grasp the presence of the wire strands separating him from his companions. I finally hiked down off the rise I was watching from and gently herded the buck down the fence line to an open gate. The ubiquitous appearance of wire fences in the prairie disrupted

pronghorn movement patterns and may have altered their behavior more than any other human activity.

Fortunately, appropriate hunting regulation and habitat preservation, much of it initiated by the great hunter-conservationist George Bird Grinnell in his leadership roles in the fledgling Boone and Crocket Club and National Audubon Society, began to reverse the pronghorn's downward population trend by the early 1900s. Pronghorns now number between 500,000 and 1 million animals. Their populations are currently stable or expanding in most western states, including Montana, although hard winters and outbreaks of bluetongue disease can cause sharp declines in local populations. Only three geographically isolated Mexican subspecies (*A. a. sonoriensis, A. a. peninsularis* and *A. a. mexicana*) are currently endangered.

My favorite thumbnail sketch of the species comes from a familiar source. On September 17, 1804, Meriwether Lewis recorded:

> *We found the Antelope extreemely shye and watchful insomuch as we had been unable to get a shot at them; when at rest they generally seelect the most elivated point in the neighborhood, and as they are watchful and extreemly quick of sight…in short they will frequently discover and flee from you at the distance of three miles.*

All these years later, this journal entry still accurately describes the essential features of the American pronghorn, a talented survivor and iconic representative of eastern Montana's prairie.

Chapter 15

GREATER SAGE-GROUSE

Centrocercus urophasianus

*F*ew places on earth consistently produce sunrises as spectacular as those that appear on the Montana prairie's eastern horizon during the spring. Pinks, reds, golds and oranges—even those who expect them all will sometimes encounter hues they've never seen before. April can still be cold even toward the end of the month, and the beauty spread across the sky behind us that day didn't prevent me from wishing I'd worn an extra layer of clothing. Lori and I had glassed a few birds here the night before. After spending the night in our sleeping bags, we'd crept in under the cover of darkness and set up our portable blind. Since I had never visited this lekking ground before, we had engaged in a bit of a gamble, but that's hardly unusual in the world of wildlife.

As light spread across the sky, we waited. Lori was using her headlamp to read, and I had actually drifted off into a catnap when a low, booming sound suddenly aroused me. Elbowing Lori gently, I peered out the portal in the front of the blind to see what looked like white popcorn beginning to pop up and down in an opening in the sage a hundred yards away. To my chagrin, I realized that our blind location was just far enough astray to keep us from obtaining the close-up pictures we'd hoped to obtain. But sometimes it's best to stop hunting with whatever you've chosen to hunt with and simply enjoy the show, and few spectacles in nature justify that decision like a morning on a sage-grouse lek.

Eight or ten cocks were calling and displaying. The male in the center of the activity was the dominant bird according to status and prime breeding rights, although it was physically indistinguishable from all the rest. Sage-grouse, even the males, are drab birds that rely on their excellent camouflage plumage to avoid predators for most of the year. You'd never know that on a lek, though,

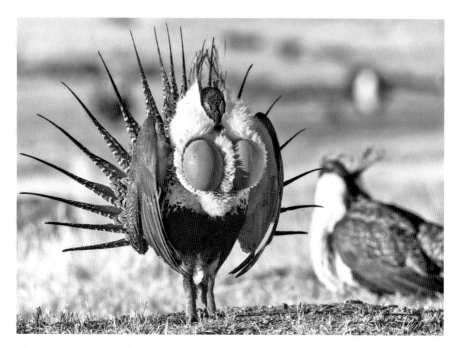

The greater sage-grouse's puffed throat sacs are a vital part of the lek's goal of attraction. *Bureau of Land Management photo by Bob Wick.*

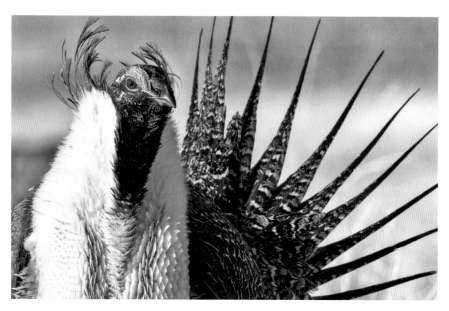

The grouse's filamentous black hackles protruding above snow-white neck ruffs with every tail feather extended in a perfectly symmetrical fan and tapered to a sharp point. *Bureau of Land Management photo by Bob Wick.*

for these guys were dressed to kill—filamentous black hackles protruding above snow-white neck ruffs, yellow throat sacs inflated, every tail feather extended in a perfectly symmetrical fan and tapered to a sharp point as if the bird had just left a beauty salon. Each cock was trying to attract one of the brown, profoundly disinterested hens nearby into its established territory, but none was having much luck. The males' pale ruffs bounced up and down as their eerie hooting calls made the air vibrate. The hens lingered like shy girls at a seventh-grade dance. After an hour or so, the magic spell suddenly broke as if in response to an inscrutable cue. The gaudy males turned back into sage-grouse, and the lek emptied. If reproduction of the species was the goal of all that effort, it would have to wait for another day.

───◦◦◦◦───

The sage-grouse is the largest grouse in North America. Among all our gallinaceous birds, only the wild turkey exceeds it in size. Mature cocks weigh around six pounds. The bird's range is limited to sagebrush prairie habitat from southern Canada south to Colorado and Nevada, and it was unknown to western science prior to the Lewis and Clark Expedition. Lewis noted the bird near the mouth of Montana's Marias River on June 10, 1805, and initially called it the "mountain cock," although he subsequently referred to it as both the "Prairie Cock" and the "Cock of the Plains." For some reason he did not record his usual meticulous description of a new species, and he did not receive full credit for his observation until years later.

Sage-grouse vary considerably in the amount of physical space individuals occupy. When they can find food, shelter and water nearby, some hardly travel at all. (Sage-grouse do not require surface water if succulent plants are abundant in the area, but they will utilize it if it's there.) Some degree of seasonal migration is common, though, usually in response to varying levels of snow depth during the winter. Some sage-grouse have home ranges of up to two hundred square miles. The longest-known sage-grouse migration occurs when birds leave Saskatchewan's Grasslands National Park and head for the Charles M. Russell National Wildlife Refuge in central Montana, a distance of over one hundred miles. That may not be much of a trip for a speedy, high-flying duck, but on the wing, sage-grouse are heavy, ponderous birds that barely seem capable of flight. On this long-range trip, they walk almost as much as they fly.

The spring courtship ritual certainly represents sage-grouse behavior at its most conspicuous, but the term *lek* introduced above requires clarification. The

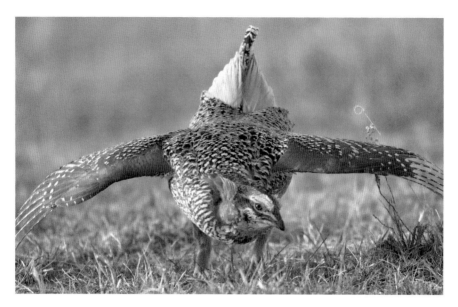

A male sharptail grouse engages in its own form of spring mating display on the Charles M. Russell National Wildlife Refuge. *U.S. Fish & Wildlife Service photo.*

word is of Swedish origin. Many people use it as I did earlier, to refer to the physical location where the breeding display takes place. More accurately, it refers to the entire process in which males congregate and display for females in order to establish breeding rights. Lekking is most familiar to us as practiced by several game birds of the open plains, including prairie chickens and sharp-tailed grouse, as well as sage-grouse. However, many unrelated avian species around the world engage in lekking, as do some species of antelope, seals and bats.

Sage-grouse need sagebrush—it's as simple as that. Since they lack the muscular crop other grouse possess, they cannot digest hard seeds the way their relatives do. While the bird's diet includes various other kinds of forbs and grass during the summer, sagebrush leaves almost always predominate even then. Alfalfa is a favorite in areas where it has been cultivated. During the winter, sage-grouse are entirely dependent on sagebrush as a food source. The bird's natural range correlates almost exactly with the distribution of the big sagebrush (see chapter 13). They will utilize other sagebrush species as food, however, sometimes preferentially. Like the young of many other gallinaceous birds, newly hatched chicks feed primarily on insects for several weeks before transitioning to forbs and finally to sagebrush. The insect-dependent period in a young chick's diet is brief but critical. One study showed that if insects were eliminated from an otherwise healthy diet, newly hatched chicks died within ten days.

Sage-grouse also depend heavily on sagebrush for cover. Field studies conducted in Montana show that the majority of male sage-grouse occupy habitat in which the sagebrush canopy covers 30 to 50 percent of the ground. Sage-grouse rarely occupy areas with less than a 10 percent sage canopy. After breeding, hens are particularly fastidious in their selection of nesting cover, the quality of which is the principal factor in determining brood survival. Field studies have yielded conflicting results regarding the optimal thickness of preferred ground cover, but the median seems to be less dense than the numbers cited above for males. Sagebrush height is important, and hens will often nest under the tallest bush in the area. As young birds mature, they seek out areas of different sagebrush density at different times so that optimal habitat for young birds may be found in areas that offer them a range of choices. During the winter, when sage-grouse often form large flocks, snow depth becomes the major habitat factor, and birds will often move considerable distances to find areas with little or no snow cover. While they usually prefer level terrain, during hard winters they sometimes move onto gentle south-facing slopes where direct sunlight has reduced the snow cover.

Sage-grouse were simply sage-grouse until 2000, when genetic studies confirmed that the Gunnison sage-grouse (*C. minimus*) is a separate species. Since the Gunnison grouse is some 30 percent smaller than the rest of the West's population, others, including those in Montana, became the greater sage-grouse. In addition to the size difference, the Gunnison species has more distinct white bars on its tail feathers and longer, denser black head plumes. It would still take an experienced observer to tell the two apart if they occupied the same range, which they don't. After losing nearly 90 percent of its historic range, the Gunnison sage-grouse is now found only in isolated parts of southwestern Colorado and southeastern Utah, and the total population has dropped to around five thousand birds. The geographic isolation of these populations encourages inbreeding and threatens the genetic diversity important to species survival.

Policy decisions addressing the declining number of Gunnison sage-grouse reflect similar controversy facing the more widely distributed greater sage-grouse and the diverse parties with an interest in the bird's future. Recognizing the worrisome status of the Gunnison grouse, a loose coalition of state and private interests voluntarily began working on conservation policies and habitat protection during the 1990s, partly motivated by genuine concern for the bird and partly to forestall official listing by the Fish and Wildlife Service under the Endangered Species Act and all the complex regulation that would entail. In 2000, the Service listed the Gunnison sage-grouse as "threatened," a compromise that left many parties on both sides of

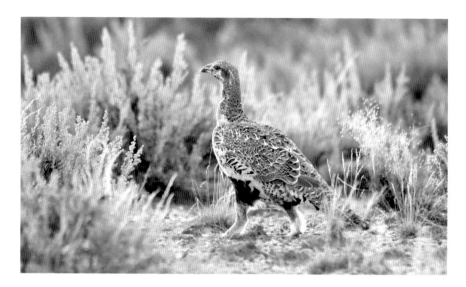

Greater sage-grouse. *U.S. Fish & Wildlife Service Mountain Prairie photo by Tom Koerner.*

the debate unsatisfied. While some conservationists were glad to have the bird receive this degree of protection, others were disappointed that it had not received the more restrictive designation "endangered." Stakeholders who had already been active on behalf of the sage-grouse felt that this decision negated much of what they had already accomplished on the ground, which included real progress with habitat improvement. One can argue that a decision that leaves people on both sides of an argument unhappy probably represents a reasonable compromise—or a disaster.

While the decision to list the Gunnison sage-grouse as threatened affected a small number of birds in a geographically limited area, the greater sage-grouse faces many of the same problems. Whatever policies eventually enacted on its behalf will affect far more birds, landscape and people. The issue is undeniably real. The western population of sage-grouse a century ago was around 15 million birds, a number that has dropped to between 200,000 and 500,000 today. Its range is also contracting, as the bird has disappeared from British Columbia, New Mexico, Kansas, Nebraska, Oklahoma and other areas of prairie habitat where it once thrived. As is so often the case, predators assume the role of "the usual suspects," as termed by Claude Raines's character in the classic Bogart film *Casablanca.* Adult sage-grouse have always faced a variety of predators, including coyotes, foxes, bobcats and raptors. Nest mortality is an even greater factor in annual population losses, which vary considerably by location, range condition and the availability of

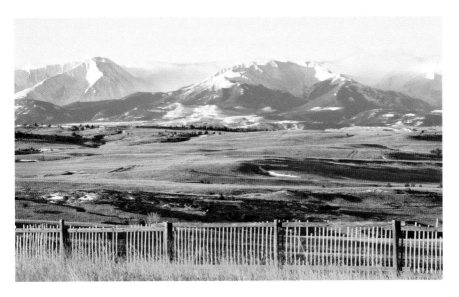

The eastern side of the Crazy Mountains. *Photo by Don and Lori Thomas.*

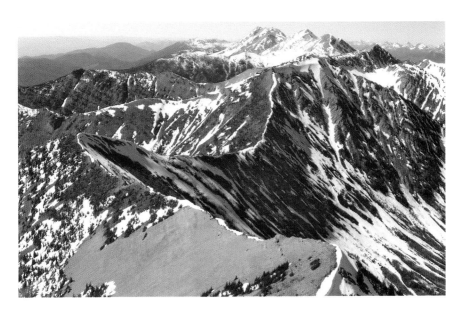

Mount Grant in the Great Bear Wilderness. *Courtesy of Blake Passmore.*

The Centennials. *Bureau of Land Management photo by Bob Wick.*

Great Northern behind Stanton Lake in the Great Bear Wilderness in the Hungry Horse Ranger District. *U.S. Forest Service photo by Chantelle Delay.*

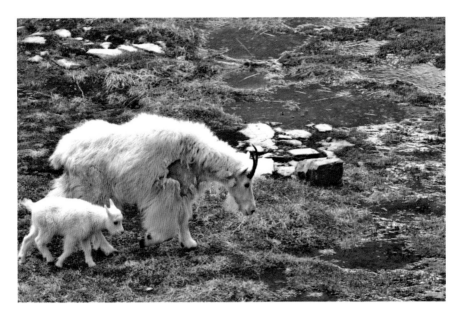

A newborn baby goat following its mother seen from Hidden Lake view point, Hidden Lake Nature Trail, Logan Pass, Glacier National Park. *Photo by Wingchi Poon.*

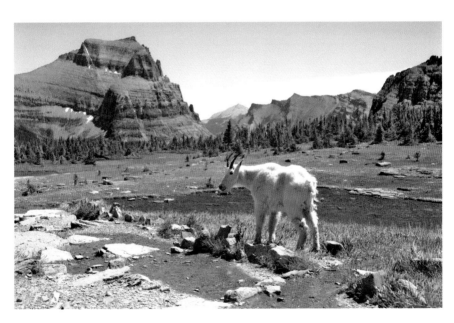

A mountain goat near the Hidden Lake Overlook Trail at Logan Pass. In the background are Going-to-the-Sun Mountain and the St. Mary Valley. *National Park System photo by David Restivo.*

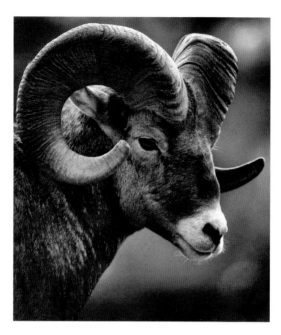

Bighorn in Glacier. *Photo by Jeremy Weber.*

Effective conservation of the greater sage-grouse and its habitat requires a collaborative, science-based approach that includes strong federal plans, strong plans for state and private lands and a proactive strategy to reduce the risk of rangeland fires. *Bureau of Land Management photo by Bob Wick.*

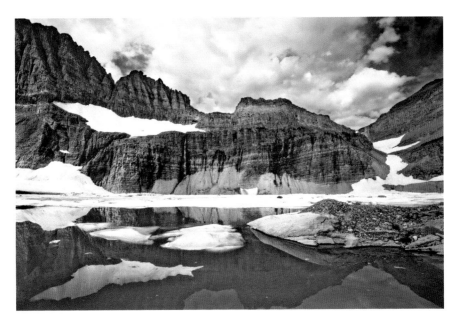

Upper Grinnell Lake, Glacier National Park. *National Park Service photo by Tim Rains.*

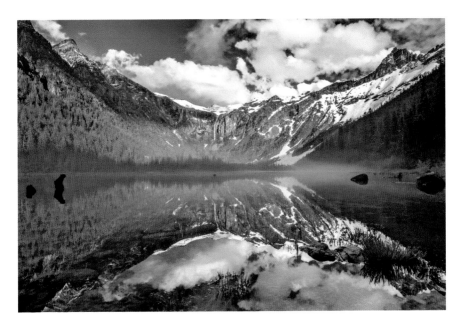

Avalanche Lake, Glacier National Park. *National Park Service photo by Tim Rains.*

Bitterroot River near Darby, Montana. *U.S. Forest Service photo by Roger Peterson.*

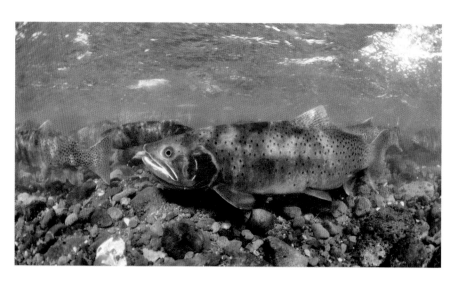

Spawning cutthroat trout in Yellowstone National Park. *National Park Service photo by Jay Fleming*

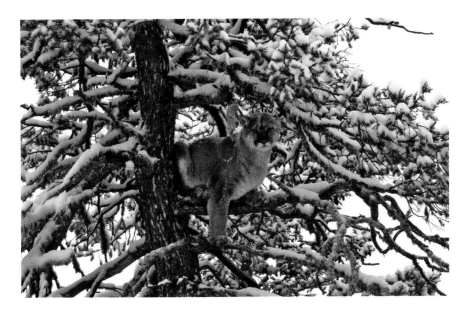

A male mountain lion in Judith Basin County. Cougars can now be found in virtually every corner of the state. *Photo by Don and Lori Thomas.*

Stunning coniferous yellow larch in the Bitterroot National Forest dotting the slopes of St. Mary's Peak in the distance and striking cottonwoods in the foreground. *U.S. Forest Service Northern Region photo by Roger Peterson.*

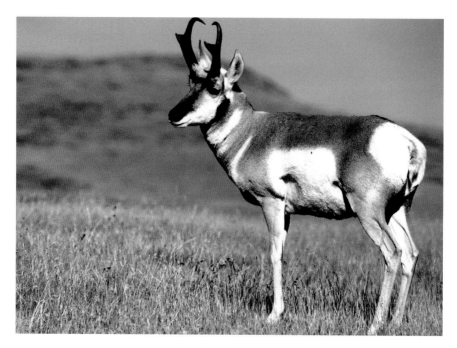

Charles M. Russell National Wildlife Refuge was established, in part, for pronghorn antelope. *U.S. Fish and Wildlife Service.*

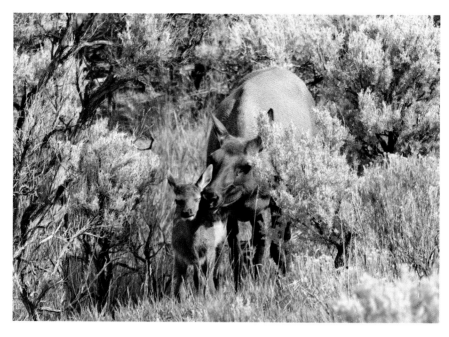

A cow elk tends her calf in late June. The scene appears peaceful, but cows with calves can act aggressively toward perceived threats. *Photo by Don and Lori Thomas.*

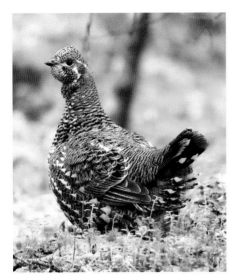

Left: A spruce grouse in early autumn. Spruce grouse are the definitive "fool hens," frequently allowing approach to close range before flushing into nearby trees. *Photo by Don and Lori Thomas.*

Right: Post-fire rebirth in the Anaconda-Pintler Wilderness. *Courtesy of Pete Ferranti.*

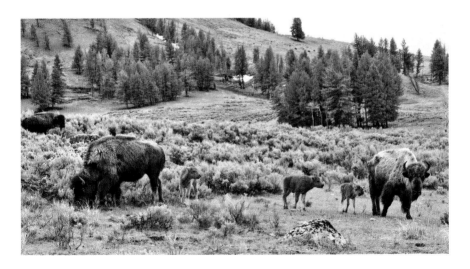

Bison in the Lamar Valley. *Courtesy of Val Schaffner.*

A panorama of the Judith Mountains, one of Central Montana's island ranges and the former site of the Maiden mining camp. *Courtesy of Jim Shulin.*

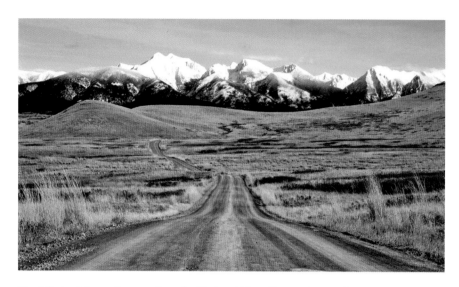

The Mission Mountains seen from the National Bison Range. *Photo by Jaix Chaix.*

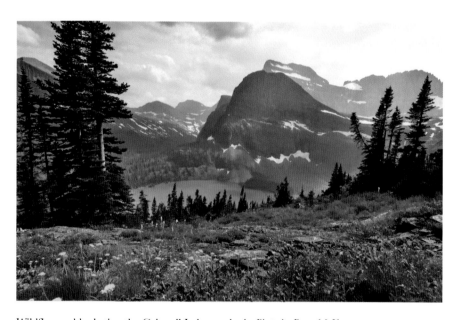

Wildflowers blanketing the Grinnell Lake overlook. *Photo by Ryan McKee.*

The Middle Fork of the Flathead River at the old West Glacier Bridge, home to both the cutthroat and bull trout, as well as the location of the grizzly encounter described in chapter 30. *National Park Service photo by Tim Rains.*

After providing biologists from the Montana Fish and Wildlife Conservation Office with important data, this threatened bull trout returns home. *U.S. Fish & Wildlife Service photo by Michael Josh Melton.*

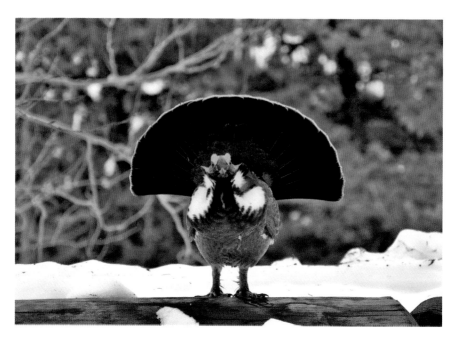

Dusky grouse. *National Park Service photo.*

Salmon fly hatch on Rock Creek. *Courtesy of Missoulian Angler.*

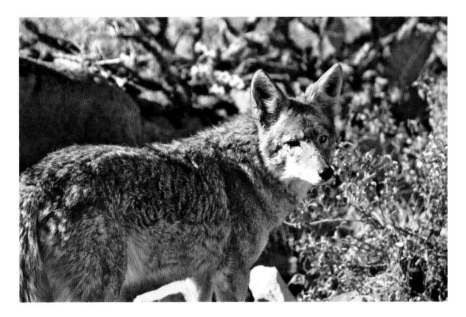

Montana's most adaptable large predator, the coyote occupies virtually every habitat in the state. *Photo by Don and Lori Thomas.*

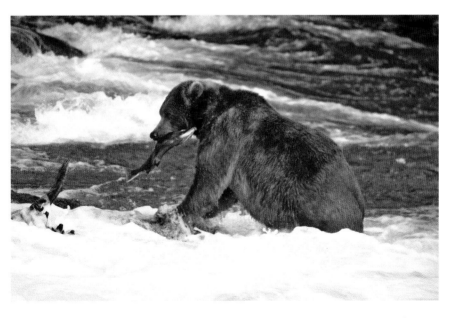

Unlike these coastal Alaska bears, their cousins in Montana rely primarily on vegetation rather than fish in their diet. *Photo by Don and Lori Thomas.*

Wolves in Lamar Valley. *National Park Service photo by Dan Stahler.*

"The Hole in the Wall" white sandstone formation along the Lewis & Clark Historic Trail in the Upper Missouri River Breaks National Monument of central Montana. *Bureau of Land Management photo by Bob Wick.*

alternative prey species. In addition to the predators just mentioned, magpies and ravens play an especially important role in the loss of eggs and chicks (see chapter 5), as do seagulls in areas where man-made dams have provided them with suitable habitat in the prairie (see chapter 19).

Humans certainly belong on that list of predators. An Assiniboine friend with strong ties to his traditional tribal community told me that sage-grouse were virtually the only upland bird his ancestors hunted, which they did by using throwing sticks on the lek. Most biologists feel that modern hunters have an insignificant effect on sage-grouse population numbers. However, all eleven states with sage-grouse populations today have either eliminated hunting for them or markedly reduced seasons and bag limits in the face of growing concern about the birds' future. (Those states are Oregon, Washington, California, Nevada, Idaho, Montana, Wyoming, Colorado, Utah and North and South Dakota.)

However, those predators have been there all along, and they are unlikely to explain a recent sage-grouse population decline of 90 percent on their own. While predators may indeed be killing more sage-grouse than they once did, habitat degradation appears to be the ultimate culprit. Studies show that nest survival correlates directly with the height and density of sagebrush in the area, which also reflects the quality of the food source available to the birds (as well as the quality of the escape habitat available to help the birds elude those predators). The biggest threat to sage-grouse today is loss of that critical habitat. Healthy sagebrush once covered a huge section of the American West, but today well over half of that habitat has been lost to agriculture, invasive species, unwise grazing practices and development.

Most parties involved in the issue agree that something must be done if the sage-grouse is to avoid the fate of the passenger pigeon and the Carolina parakeet. The question is: what? Attempts to provide answers are complicated by the number and diversity of stakeholders potentially affected by policies focused on the sage-grouse and the organizations that represent them, including farmers, ranchers, conservationists, bird-watchers, biologists, hunters, energy development interests, state game departments, the Theodore Roosevelt Conservation Partnership, the American Prairie Reserve, the Fish and Wildlife Service, the Natural Resources Conservation Service, the Bureau of Land Management and multiple state wildlife agencies, among others. One point almost all parties agree on is that addressing the habitat needs of the sage-grouse proactively is preferable to having the species listed under the Endangered Species Act. Everyone seems to have learned something from the lesson of the Gunnison sage-grouse. One important result of that knowledge began in 2010 with the Sage Grouse Initiative (www.sagegrouseinitiative.com), a cooperative

effort involving several of the above agencies and voluntary efforts by members of the ranch community to improve habitat, benefit sage-grouse and prevent listing under the ESA. The initiative is complex and multifaceted—I suggest a visit to the website for details.

In September 2014, Montana governor Steve Bullock announced the state's new sage-grouse management plan, which includes a fund to help private ranchers offset the costs of habitat improvement. (The federal NRCS has a similar program in place.) Existing land use policies on state land will continue, but there will be restrictions on new development in core areas of habitat. Most involved parties greeted the plan favorably, although some members of the environmental community felt it did not go far enough to ensure protection of the birds.

Although it is likely impossible to satisfy everyone in wildlife issues of this sort, the Sage Grouse Initiative is already producing tangible results on the ground and no one is suing anyone (yet). Events in Montana will play a key role in the future of the species—Montana is second only to Wyoming in the number of sage-grouse it contains. A final decision regarding the USFWS petition to list the sage-grouse has not been made at the time of this writing, but it is due in September 2015. One can only hope that the decision will be made on the basis of best available science, that emotions and politics can be held in check and that all involved can continue to work on behalf of a unique representative of the Montana sagebrush habitat that remains today.

I recently spoke with my friend Ed Arnett, a biologist who has worked extensively on sage-grouse habitat issues for the Theodore Roosevelt Conservation Partnership. Ed shared his thoughts on the bird and its habitat as follows:

Sage-grouse truly are an iconic species of western landscapes that represent the uniqueness of the American West and its vast, open spaces. Thriving populations of sage-grouse are an indicator of healthy sagebrush ecosystems, which means there is also good habitat for both game and non-game species. However, the sagebrush ecosystem is one of the most threatened in the world. The sage-grouse is a modern-day canary in the coalmine, and right now the canary is telling us something. The fact that a once abundant, widely distributed bird is now at population levels low enough to consider listing as threatened or endangered should be cause for concern among all stakeholders. All species—plants, animals, humans—that utilize sagebrush landscapes will benefit from improved management of these landscapes, but getting there will require strong collaboration. Conservation plans are only as good as they are implemented and sustained in order to convert "paper birds" into real birds on the ground.

Well put, Ed.

Chapter 16

AMERICAN BISON

Bison bison

*I*t is hard to appreciate the sheer mass of a bison until you have been close to one, and there's no better place to do that than Yellowstone National Park.

A caveat before proceeding: Yellowstone visitors sufficiently aware to recognize the potential danger of proximity to any wild animal almost all worry most about bears. Fair enough, but other Yellowstone wildlife deserves equal respect. During a lifetime spent close—sometimes too close—to dangerous animals ranging from grizzlies in Alaska to elephants in southern Africa, I have faced only two situations in which I felt I was about to be injured or killed. Neither involved an animal I expected to threaten me seriously. One was a cow moose in my Alaska front yard, and the second was a cow elk on the banks of Yellowstone's Firehole River. The point of this observation is that attacks by wild animals don't always come from the sources we expect. Statistical records confirm that bison are Yellowstone Park's most dangerous animal. They are responsible for significantly more human injuries than bears. Several of these encounters proved fatal, and most were the result of human stupidity. Most Park bear attacks occur in the backcountry, but incidents involving bison usually take place in congested areas near campgrounds and roads, where I have witnessed tourists touching bison, trying to get them to pose for photos at close range and provoking them by shouting and pelting them with debris. This all represents ignorant, thoughtless behavior, and when a bison finally decides it has had enough and charges, it's hard not to feel sympathy for the animal.

While I am not advocating deliberate close contact with bison (and actually recommend strongly that it be avoided), sometimes it just happens. One summer day I was photographing mule deer in a small, grassy basin surrounded by burned lodgepoles left over from the 1988 fire. Suddenly a small herd of bison walked over a nearby rise, and before I knew it, I was standing in the middle of the herd. I slowly edged behind a tree and tried to make myself invisible as the animals passed by.

I'd been close to a lot of large ungulates before, including Alaska moose, African Cape buffalo and Australian water buffalo, but the mature bulls traveling with the bison herd looked as big as any of them—formidable as army tanks, with power concentrated in their necks and forequarters after countless generations of natural selection for ability to defend themselves against large predators, including wolves and bears. Dust rising beneath their hoofs as they passed furthered the impression of an army on the march. Even though it was late summer, the shaggy hair on their forequarters made each animal look as if it were wearing a shag rug like a poncho. (This unique adaptation allows bison to face into rather than away from the wind during a blizzard.) Cows and calves vocalized constantly in an endless series of low, murmuring grunts. The rich, musky aroma permeating the air suggested a stockyard full of cattle. Although

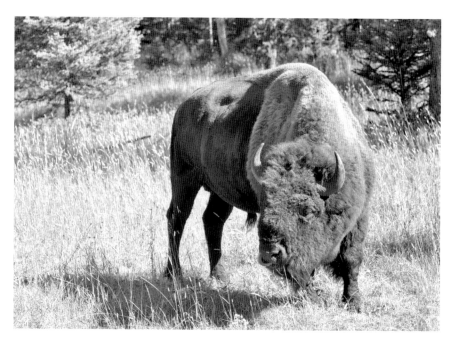

Bison in Yellowstone National Park. *U.S. Forest Service photo by Joni Packard.*

I never felt threatened, I recognized the tension in my muscles relaxing as the last of the herd finally wandered over the rise behind me and disappeared. Among all that cacophony of impressions—visual, auditory, olfactory—the ones that remained foremost were the size of the animals, their indifference to the possibility that anything nearby might harm them and the raw power those forequarters contained. They looked indestructible.

But they weren't. One hundred years earlier, we'd nearly wiped the species off the face of the earth.

———◦◦◦◦———

The bovine family of buffalo, bison and their relatives diverged from common ancestors in Eurasia during the Pleistocene. From then the family tree becomes confusing, as many bovids interbred with one another. The steppe bison (*B. priscus*) began crossing back and forth across the Bering Sea land bridge around 500,000 years ago. It gave rise to the giant bison (*B. latifrons*) in North America, which disappeared during one of the great megafauna extinction events around 30,000 years ago. The smaller *B. antiquus* replaced the giant bison, only to be replaced by the even smaller *B. occidentalis*, which was eventually replaced in turn by the smallest of them all, our American bison. The American bison's closest relatives are the wisent (European bison) and the Asiatic yak. The true buffalo, including the African Cape buffalo and the Asiatic water buffalo, represent a different branch of the family. Many of these species interbred along the way and some still can, significantly including domestic cattle.

Our bison may be the smallest in a long line of bovid predecessors, but it is still a massive animal. Bison are the largest wild ungulates in North America. Bulls not infrequently weigh one ton, and the largest wild bison ever recorded tipped the scales at 2,800 pounds. Scientists currently recognize two subspecies of bison in North America: our familiar plains bison (*B. b. bison*) and the wood bison of Alaska and northwestern Canada (*B. b. athabascae*), which is actually a bit larger than those of our own northern plains.

Are these animals bison or buffalo? Proper scientific usage argues for bison—to emphasize the legitimate distinction from the true buffalo of Asia and Africa. The term buffalo apparently originated with French fur traders as a corruption of *boeufs* (or cattle), and "buffalo" was in use in the New World long before "bison." Lewis and Clark described the animals as buffalo in their journals, and that is certainly the way Indians and most other locals in eastern Montana refer to them today. Although biologically incorrect,

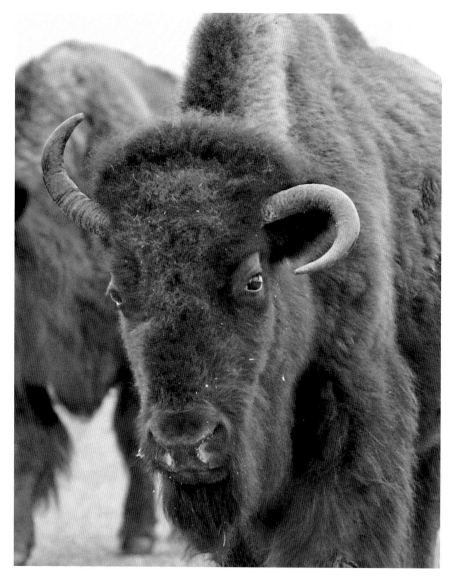

Cow bison with unusual horn on Northeast Entrance road. *National Park System photo by Jim Peaco.*

the word "buffalo" has become ubiquitous in our language. There was no Bison Bill Cody and no bison nickel. David Mamet did not write a play titled *American Bison*, and one does not become "bisoned" when facing tough negotiations. Some consider both terms acceptable, but I will stick to "bison" in this chapter for the sake of consistency and scientific accuracy.

Bison occupied almost all of the Great Plains and Midwest at the time of European contact and even ranged as far eastward as New England at one point. Estimates of their population size then range from 30 to 60 million animals. Bison were an indispensible resource to Plains Indian tribes for thousands of years. The oldest example of the distinctive Folsom-style stone point was found embedded in a bison bone shown by carbon dating to be nearly ten thousand years old. Native Americans relied on bison meat for food and bison hides for clothing and shelter and utilized virtually every other part of the animal in various ways. Because of the low human population of the West and the limited effectiveness of Paleolithic hunting tools, their impact on bison herds was initially limited. However, evidence suggests that bison numbers began to decline even before white men settled the West, likely as the result of the introduction of the horse during the 1600s. The horse changed Plains Indian life as much as the automobile changed our own, and over the next several centuries, Indians became much more efficient predators as a result. Feral horses (an estimated 2 million roamed the plains by 1800) also competed directly with bison for food and water.

Even so, bison remained abundant, and early visitors encountered them in staggering numbers. On a westward journey by train in 1859, journalist Horace Greeley described a bison encounter thus:

> *What strikes the stranger with most amazement is their immense numbers. I know a million is a great many, but I am confident that we saw that number yesterday. Certainly, not all we saw could have stood on ten square miles of ground. Often the country on either side seemed quite black with them. Consider that we have traversed more than one hundred miles since we first struck them, and that for the most of this distance the buffalo have been constantly in sight.*

Similar descriptions appear in the notes of other well-known early commentators, including Washington Irving, Wyatt Earp and John James Audubon, who had the foresight to note in 1843 that "before many years, the buffalo, like the Great Auk, will be gone." As late as 1870, the great conservationist George Bird Grinnell, who would play a crucial role in saving the bison from extinction, faced a three-hour delay during a trip west while a vast herd of bison crossed the tracks in front of his train.

A key event in the collapse of America's bison population occurred just two years later when a young commercial meat hunter named J. Wright

Mooar shipped fifty-seven buffalo hides to his brother in New York with instructions to introduce them to the European leather market. They proved a tremendous commercial success, and by the following year, thousands of commercial hide hunters were already spread out across the plains.

Nothing drives innovation like money, and hide hunters quickly developed means to increase their efficiency. Designed specifically for this purpose, the Sharps rifle delivered previously unheard-of long-range accuracy and killing power. Hide hunters learned to wound a herd's dominant old cow and pick off the rest while they milled about in confusion. The arrival of the Northern Pacific Railroad in Montana allowed prompt shipment of hides from an area that had previously received light hunting pressure because of its distance from markets. In 1883, the railroad shipped 200,000 hides east from Miles City. The following year, that number fell to 40,000. The entire haul in 1885 fit inside a single boxcar, and that was the last hide shipment ever made from the area. The newly published *History of Montana* (which was still four years shy of statehood) announced that the bison was now "almost an animal of the past."

By 1902, the nation's population of free-ranging bison consisted of one herd of twenty-three animals in the northeastern corner of Yellowstone National Park. The species likely would not have survived at all save for a determined effort on the part of men like Grinnell and Theodore Roosevelt. The story of the bison's return from the brink is fascinating but too complex to relate here. Interested readers can refer to the titles by Punke and Thomas listed in the bibliography provided at the end of this book for further details. Now it is time to fast-forward to today, when the biologic status of the bison is more secure than it was one hundred years ago, even if the politics surrounding the species are no less controversial than when Grinnell and Roosevelt were campaigning to save the animal from extinction.

Montana's current bison controversy arises largely from an organism at the opposite end of the size spectrum from the bison itself: the microscopic bacterium *Brucella abortus*. In domestic cattle, brucellosis—the chronic disease the bacteria causes—leads to infertility, abortion of first pregnancies, weight loss and decreased milk production. Related bacteria can cause an indolent disease in humans characterized by recurrent fevers and a wide range of vague symptoms that make it notoriously difficult to diagnose. The human disease is usually acquired by drinking unpasteurized milk, but brucellosis control measures in

cattle and widespread pasteurization have made it rare. In animals, the infection is spread primarily through contact with birth products from infected animals.

There is no effective treatment for the disease in cattle, but decades ago the American livestock industry began an aggressive program of serologic testing and culling that proved both costly and effective. Montana cattle herds have been certified brucellosis free since 1985, a status now shared with cattle from every other state. Loss of brucellosis-free certification would have a serious impact on the state's livestock industry, and ranchers do not take that threat lightly.

Yellowstone Park is now home to the largest and one of the few genetically pure bison herds in the country. (Almost all other bison, both wild and domestically raised, carry traces of domestic cattle DNA in their genes.) The Yellowstone herd was infected with brucellosis in 1917, when some Park bison were artificially fed infected milk from domestic cattle. Bison carrying brucellosis show no evidence of the disease, which can be demonstrated only through blood testing or culture. There has never been a documented case of brucellosis transmitted from bison to cattle outside experimental conditions in laboratories. That is the basic microbiology, presented with as much fact and as little opinion as possible—always an important consideration in wildlife issues as polarizing and controversial as this one.

An understanding of the issue requires appreciation of the ecology. The Park's historic winter carrying capacity for bison is unknown and subject to disagreement. As snow accumulates on the high Yellowstone Plateau, bison have always migrated to lower elevations to feed, principally northward into Montana. In 2000, the secretary of agriculture and the governor of Montana signed a court-mediated bison management agreement with multiple provisions. State and federal parties to the agreement concurred that bison migrating north out of the Park fell under state rather than National Park Service (NPS) jurisdiction once they crossed the border. The management plan gave the Montana Department of Agriculture authority over those animals and allowed for natural dispersion of bison in certain portions of the Gallatin National Forest, where there were no cattle at that time of year. It also called for a cap on the total Park bison population of 3,000 animals. As of 2014, there were 4,900 bison in the Park.

The NPS and state agencies have tried various means to reduce the Park bison herd. Recreational hunting by private parties inside Park boundaries is forbidden by federal law and likely always will be. Montana allows a carefully regulated bison hunt outside the Park that rarely produces a harvest of over three hundred animals annually. One rationale for the reintroduction of wolves

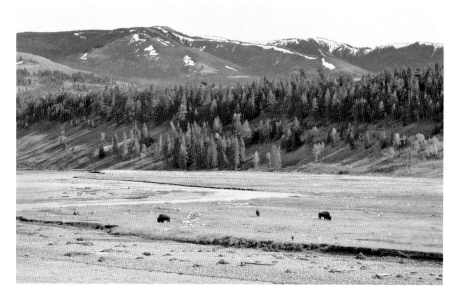

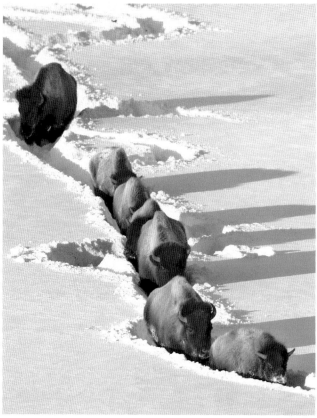

Above: Bison grazing in Yellowstone's Lamar Valley during the summer. *Photo by Don and Lori Thomas.*

Left: Bison walking through deep snow near Tower Junction in Yellowstone National Park. *National Park System photo by Jim Peaco.*

to the Greater Yellowstone area was that increased predation would lead to a reduction in bison numbers. But wolves quickly learned (if they didn't know already) that buffalo are large, aggressive animals and it was a lot easier for them to take down elk. Wolves have had a negligible impact on the bison population. As of 2014, the NPS plans to trap around nine hundred bison near the northern boundary of the Park and ship them to meat-processing facilities and Montana Indian reservations under the authority of agreements with the InterTribal Buffalo Council. Without such efforts, biologists predict that the Park bison population could rise to six thousand by the end of 2016, in which case a harsh winter would result in widespread starvation and mass migration outside the Park leading to intense social conflict or both.

And so bison present a classical example of a wildlife management dilemma, with emotions running high on all sides and no ready solution likely to leave all (or any) parties satisfied. Many Americans view the bison as a persecuted symbol of the American West and greet the idea of killing them under any circumstances as an outrage. Others would like to see Montana bison managed according to best-available science and are willing to use most reasonable means to attain biologic goals. Many ranchers view all bison as a potential calamity capable of destroying family ranches that have been operating for generations.

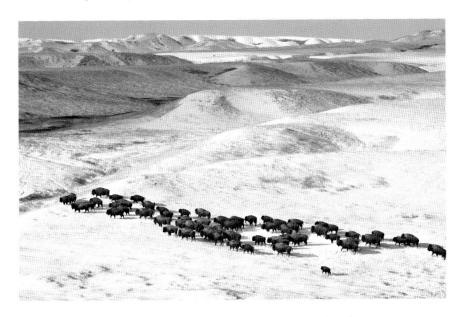

Bison grazing on the Fort Peck Reservation. *Photo by Ted Wood, the Story Group.*

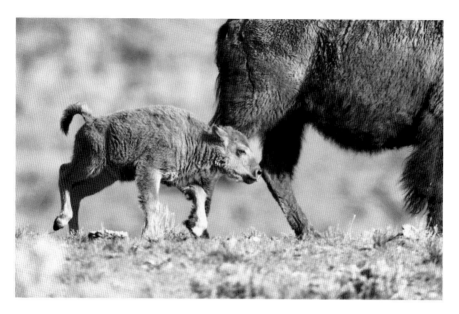

Bison calf following cow in Little America Flat. *National Park System photo by Jim Peaco.*

While the conflicting interests among these stakeholders sometimes sound reminiscent of Middle Eastern politics, there are glimmers of hope. Native American groups, notably on the Fort Peck and Fort Belknap Reservations, feel a special cultural relationship with bison and are actively working to reestablish their own herds from Yellowstone stock. The American Prairie Reserve, using land in central Montana north of the Missouri obtained from willing sellers, has successfully established a brucellosis-free, self-sustaining bison herd using transplanted animals. Many of their neighbors have vociferously opposed these efforts despite the extraordinary lengths these groups have gone to in order to eliminate any threat to nearby livestock.

The unfortunate reality today is that discussions of wildlife cannot be isolated from discussions of wildlife politics, to the regret of many, including me. But it is impossible to profile bison in Montana now without reviewing the controversies surrounding them. Readers old enough to remember the old television cop series *Dragnet* may recall Sergeant Friday's constant plea when interviewing witnesses: "Just the facts, ma'am." That is what I have tried to provide here. Readers are encouraged to explore the issue further on their own, with one final observation. It is my experience that the data presented in issues of this sort often conflict, and the numbers almost invariably reflect the original bias of the presenting party.

MOUNTAIN PLOVER

Charadrius montanus

I was glassing a remote, windswept stretch of prairie for antelope one hot August day when an unfamiliar bird appeared incidentally in my field of vision. At first glance, it appeared to be a shorebird, but there was no shore for miles around. Observing its behavior—standing rigidly upright and motionless, then darting quickly ahead to peck at the ground—supported this initial impression, as the bird's behavior reminded me of a sandpiper on a beach. Further study revealed a rounded, robin-sized bird, tan on top and white on the belly, with a small black crown and short bill like a plover but none of the black neck markings of other Montana plover species. I was stumped. Only when I returned home and consulted my reference books did I realize that I'd seen a mountain plover, an uncommon bird that in its own way defines eastern Montana prairie habitat as surely as the antelope I didn't see that day and the sagebrush through which I'd walked for miles.

Six species of plover occur in Montana, of which only the familiar killdeer can be considered common. With their piercing call and conspicuous territorial behavior, killdeer are easy to spot and identify almost anywhere in Montana, often, but not necessarily, near low-lying standing water in marshes and ponds. Observers will also likely encounter the tiny semipalmated plover—a bird not much bigger than its name—on shorelines or mud flats throughout the state. The rest will require some serious looking to locate, none more so than the mountain plover.

The bird's name is misleading. In 1838, naturalist John Townsend (of the Townsend's solitaire) observed a new species of plover in the Rocky

Mountains. When the birds appeared at the same location the following year, he assumed the species preferred mountain habitat and misnamed it accordingly. In fact, the mountain plover is a bird of dry, flat, open short-grass prairie, atypical habitat for members of the shorebird family. Recent studies have shown that when selecting nesting sites, mountain plovers prefer nearly barren ground with grass no more than three inches high and no more than 5 percent slope in elevation.

Such habitat was once typical of prairie dog towns and areas grazed by bison. Today, the bison are largely gone, but the mountain plover still prefers to nest near prairie dogs when possible, especially in Montana. One population study in north-central Montana showed that 74 percent of the mountain plovers in the area resided in prairie dog towns. There are several reasons for this affinity. Abandoned prairie dog holes offer shelter from weather and predators. Although mountain plovers feed predominantly on insects, they also eat seeds and forbs commonly found in open areas that prairie dogs have grazed. Predators may be the prime consideration. Eggs and chicks sustain a mortality rate of 50 percent during their first summer, primarily due to coyotes and foxes. Nesting birds and their eggs are well camouflaged on open ground, which also provides predators less stalking cover. To counter the high mortality rate among their young, mountain plovers produce several broods between June and August.

The conservation status of the mountain plover might best be described as a muddle. The United States Fish and Wildlife Service proposed listing the bird as threatened or endangered by authority of the Endangered Species Act in 1999. It withdrew that request in 2003, reinstated it in 2010 and then determined that the bird was not threatened or endangered in 2011. USFWS biologists estimated the continental population of mountain plovers at 20,000 birds, although others have put that figure between 5,000 and 12,000. (Estimates of Montana's breeding population range from 750 to 2,000.) In making its last determination, the Service cited the birds' widespread range, ability to utilize multiple habitats including crop fields and areas grazed by livestock and their overall ability to adapt to human activities. Some data support these positions. The association between plovers and prairie dog towns noted in Montana is less pronounced elsewhere. In Oklahoma, 90 percent of surveyed mountain plovers were found on land cultivated for crops.

Most biologists feel that the futures of the plover and the prairie dog in Montana are intertwined. Black-tailed prairie dog populations have declined

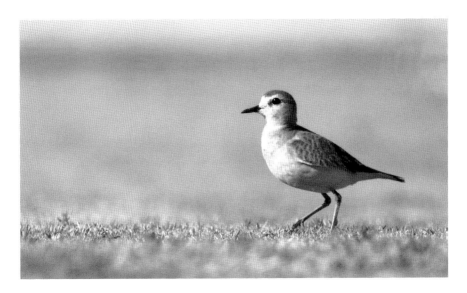

Mountain plover. *Photo by Tim Lenz.*

considerably in the last one hundred years due to a combination of factors, including disease (especially plague), predation and human activity. The prairie dog is listed as a Species of Concern, and the health of its populations is critical to other species that depend on it, notably including the mountain plover and black-footed ferret.

The mountain plover's breeding range has contracted during the last century. While it once occupied suitable habitat throughout the Great Plains, most breeding populations now occupy Montana, Wyoming and Colorado. Birds usually appear in solitary pairs during the summer, but they often form large flocks during migration south to California's Central Valley, where most of the continental population spends the winter. Such large flocks rarely, if ever, form in Montana.

This is a little chapter about a little bird, but despite its small size and nondescript appearance, the mountain plover warrants the amateur naturalist's attention for several reasons. Plovers are usually associated with water, but this one positively seems to avoid wetland habitat, demonstrating the capacity for error that generalized assumptions about wildlife always introduce. The relationship between the plover and the prairie dog in Montana illustrates again (as did the Clark's nutcracker and whitebark pine in chapter 12) the intricate ways in which apparently unrelated species can depend on and sustain one another. Finally, the mountain plover offers a reminder that eastern Montana's apparently

barren prairie is anything but. An attentive walk there may provide an opportunity to observe a bird most Montanans have never even heard of, much less seen.

Chapter 18

PRAIRIE RATTLESNAKE

Crotalus viridis

*I*t was late July, and I could already feel summer irrigation beginning to suck the life out of the Big Hole River as we slid the raft into the water. We had deliberately timed this visit to avoid the fabled salmon fly hatch and its attendant swarms of bugs, boats and visiting anglers. All we wanted from the day ahead was a quiet float trip and a few trout.

The last decision I needed to make before I climbed behind the oars and shoved off involved my choice of footwear. At this time of year, I'm usually happy wading wet in cutoffs and running shoes, even if this sartorial style doesn't meet the official dress code on Blue Ribbon Montana trout streams anymore. But the high country morning chill doesn't give up easily in this country, and since I was already shivering, I rummaged through the back of the truck for some chest waders. All I could find was a pair of insulated boot-foots left over from duck season that I knew would leave me sweltering by noon. After a moment of consideration I wriggled into them anyway, an impulsive decision that proved fortuitous indeed a few hours later.

By mid-morning, we'd caught a few fish and didn't really care that we hadn't caught more. As we floated past an inviting run on the river-left side, I decided to pull over below it, hike back up the bank and fish it from shore. As soon as we left the water, I realized how high the temperature had climbed and promised myself I'd shed the cumbersome waders once we returned to the raft. The short hike upstream required us to pick our way across a jumble of scree that had tumbled into the river from a nearby cliff. The combination of blazing sun overhead and rock underfoot triggered a sudden

mental association, and I stopped and turned to my wife. "Watch out," I cautioned. "This would be a great place to run into a snake."

No kidding. Moments later, distracted by the current and the search for the next place to put my foot, I heard a loud slap as if someone had struck the back of my calf with a stick. Despite the sound cautionary advice I'd just offered, it took me longer than it should have to recognize its source. When I finally turned and looked back, there was the snake coiled on top of a flat rock, its body turning in an infinite series of S-curves, its menacing head moving back and forth slowly as if in search of the right spot to target its next strike and its tail buzzing the warning that might have prevented the encounter had I been paying more attention.

I shouted a warning and pointed out the snake. Then we began to back slowly away. After regrouping on the far side of the rocks, I shucked off my boots and examined the point of attack. Two tiny pinpricks overlay the back of the right ankle, but the heavy construction of the boot had kept the snake's fangs from penetrating further.

I am not recommending insulated waders as protection from snakebite in the Montana outdoors. I am recommending reasonable vigilance.

Despite its admirable biological diversity, Montana is home to just ten species of snakes, only one of which is venomous. North America's poisonous snake species—there are several dozen—fall into one of two general families. The elapids—represented elsewhere by the cobras and their relatives—produce venom predominantly composed of neurotoxins that cause death quickly. The coral snakes are our continent's only elapids. Shy and retiring, they rarely bite humans and live nowhere near Montana.

Rattlesnakes are crotalids, or pit vipers, as are copperheads and cottonmouths of the related genus *Agkistrodon*. Pit vipers are distinguished from other snakes by the single row of scales on the abdomen behind the anal vent, vertical elliptical pupils in the eye, a pit in the facial bone between the eye and nostril and a triangular head distinct from the body. If you're looking for any of these features but the latter, you're too close to the snake. In Montana, these points are largely academic, since the rattles on the end of the prairie rattler's tail usually make it hard to confuse with anything else. (Note that rattles can sometimes be missing as a result of trauma, and that rattlers don't always rattle prior to a strike.)

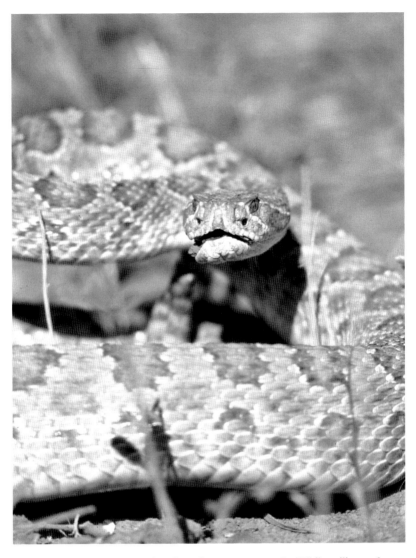

The prairie rattler is Montana's only native venomous snake. While coiling and rattling behavior is largely a threat display that usually doesn't result in a strike, it should always be taken seriously. *Photo by Don and Lori Thomas.*

A marvel of evolution, rattlesnake venom is a complex mixture of proteins and peptides designed to immobilize, kill and help digest the small mammals and birds the snakes feed on. The venom's effect on the human body is as complex as its composition. Injected through the snake's two hollow upper fangs, which act like hypodermic needles, the venom acts both

locally at the site of envenomation and elsewhere throughout the body as the toxins are absorbed. While components of some rattlesnake venoms affect nerves, neurotoxicity is not as prominent as in elapid bites. At the site of envenomation, crotalid venom produces pain, bruising and swelling that can sometimes interfere with the blood supply to local tissues. As venom absorbs into the circulation, it compromises the body's blood-clotting mechanism, which can lead to bleeding and shock.

Among rattlesnakes, the prairie rattler is a middleweight in terms of its threat to humans. With some exceptions, the severity of envenomation correlates with the size of the snake. Prairie rattlers, which rarely grow more than three feet long, are small compared to the eastern diamondback, which can exceed eight feet in length. The precise composition of rattlesnake venom varies among species. Drop for drop, prairie rattlesnake venom is not nearly as toxic as that of the southwestern Mojave rattler. Nonetheless, any snakebite in Montana should be treated seriously until proven otherwise. This is not the place to discuss the medical details of snakebite management in a hospital. Suffice it to say that it is important to seek medical attention immediately in case envenomation proves severe, which is often not apparent for some time after the bite.

As with most wildlife species potentially harmful to humans, the lore surrounding rattlesnakes exceeds the sum of its parts. Rattlesnakes really don't want to waste their venom on things they can't eat. Most human snakebites involve some degree of provocation, intentional or accidental. Around 30 percent of rattlesnake bites don't produce envenomation at all. (It can be difficult to make this distinction in the field soon after a strike, which is why prompt medical evaluation is always important.) The medical management of snakebite has advanced tremendously since my childhood, when victims were advised to incise the bite with a knife, suck out the venom and apply a tourniquet and ice. (Hint: Don't do any of those things!) Proper field care of a rattlesnake bite is easy to summarize: 1. Stay calm and identify the snake if you can do so safely. 2. Immobilize the extremity (where 90 percent of snakebites occur) as if it were fractured. 3. Remove potential causes of constriction, like tight clothing and rings. 4. Seek medical care. With modern treatment including the use of anti-venin derived from the laboratory instead of from horses, even severe envenomation rarely leads to death (although the bill may prove fatal to your pocketbook).

Statistics confirm this optimism. On average, one or two people die of snakebite every year in the entire United States. In Montana, five or six people are treated for rattlesnake bites annually. There have been only seven

fatal snakebites reported in Montana over the last fifty years, and modern medical management, which has improved dramatically since many of those incidents, likely would have prevented some of those deaths. The purpose of this discussion is to establish the appropriate median position in attitude that should apply whenever people share the outdoors with potentially dangerous wildlife. Visitors to Montana should be aware that venomous snakes may be present, take reasonable precautions to avoid snakebite and know what to do in an unlikely worst-case scenario. But they should not let the possibility of a snake encounter ruin their enjoyment of the outdoors.

In fact, if people accorded rattlesnakes as much respect as the snakes show us, many of these unfortunate incidents would never take place. Montana's last fatal snakebite occurred when an allegedly experienced outdoorsman spotted a snake in the road, stopped his truck and picked it up to take a better look. The first snakebite I ever treated as a physician further illustrates the point, fortunately with a less tragic outcome. This was one of just two snakebites I treated during a long medical career, much of which I spent in a rural community of farmers and ranchers in the heart of prairie rattler country—another confirmation of just how little interest rattlesnakes have in biting people.

One summer afternoon, a local cowboy got off his horse to open a gate and spotted a small rattlesnake on the ground. He caught it, picked it up and put it in a jar he found in his saddlebag. He never could explain just what he had in mind, but it must have seemed like a good idea at the time. That night, a couple of his friends stopped by to play cards and drink beer. After several hours, our by then well-lubricated cowboy remembered his afternoon catch, retrieved the jar and dumped the justifiably irate snake out on the card table for everyone to see. The snake must have remembered how it got there. It went straight for its captor and bit him in the finger. The bite was for real, and the cowboy eventually lost the tip of his pinkie. Nonetheless, that seems a small price to pay for a Darwin Award.

The range of the prairie rattler includes almost all of Montana except the extreme northwest corner. Preferred habitat includes some rocks, ground cover adequate to hold small rodents and isolated water sources to concentrate prey. Even in suitable habitat, rattlesnakes are not distributed randomly. I've never seen one on our central Montana property even though they are common nearby. Other areas are known for their concentration of snakes. One such location is the Highwood Mountains east of Great Falls, where I once enjoyed a golden opportunity to garner a Darwin Award of my own.

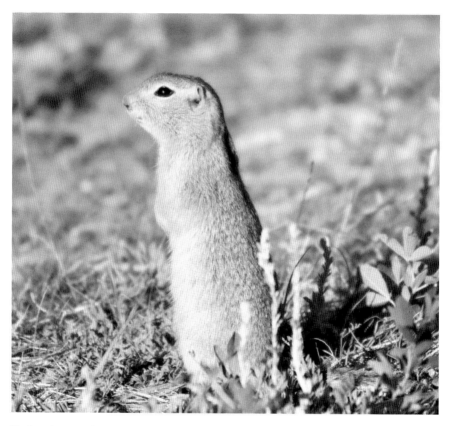

Rather than wasting venom on people, rattlesnakes would rather save it for prey like this ground squirrel. *Photo by Don and Lori Thomas.*

New at the time to that particular island mountain range and unaware of its reputation as snake country, I'd arrived to hunt elk with my longbow one September weekend. Camp was the first order of business. I put my freestanding backpack tent together and began looking for a flat piece of ground that would hold it. After selecting a likely spot in the grass, I set the tent down, crawled inside and lay down to make sure there weren't any rocks underneath me that would interfere with sleep.

I didn't feel any rocks under the floor of the tent, but I did feel something soft beneath my shoulders. After I wiggled around some more it seemed to disappear, and I blew it off as a clump of grass that I'd compressed with my weight. But then it came back—something I did not expect a flattened clump of grass to do. Turning over and rising to my knees, I realized it was moving. As lights began to go on in the dim recesses of my brain, I bolted

out of the tent and picked it up, only to discover that I'd tried to pitch my shelter right on top of a prairie rattler as thick around as my forearm. At least I'd figured this out during daylight, before I'd pounded the tent stakes in. Those mountains eventually became the only location in Montana where I routinely wore snake chaps in the field.

I don't routinely kill rattlesnakes for the same reason I don't kill anything else just because it's there, although I might make an exception if I really needed a snakeskin backing for a bow. Other Montanans, particularly of earlier generations, haven't always shared that view. A friend once showed me a faded black-and-white photograph of his ancestors back in the homestead days. The image showed every member of the family holding a pitchfork loaded with charred rattlesnakes. Prairie rattlers share communal dens during the winter, and those denning sites remain constant from year to year. If you suddenly encounter a high concentration of snakes during the fall, they're almost certainly headed for one. My friend's family had belatedly realized that they'd just finished building their new home right on top of such a den, and they responded with kerosene and matches. With lots of little kids running around, it's hard to blame them. No one wants to watch *Snakes on a Plane* meets *Little House on the Prairie*.

Human beings have enjoyed an edgy relationship with snakes since the Book of Genesis. Lori, who is comfortable close to potentially dangerous animals ranging from grizzly bears to elephants, admits being terrified of snakes. My mother, who grew up on a ranch south of San Antonio, used to tell me how my grandmother wouldn't let her leave the house in the morning until she'd gone through the yard killing the overnight accumulation of rattlesnakes with a hoe. During the time I spent tracking with the Bushmen on the edge of the Kalahari, I found them the kindest, gentlest people I'd ever met. Hence my surprise one day when I watched three of them stop and begin to shout as they flailed furiously at the ground with their sticks. The object of their anger proved to be a horned adder, a venomous but not particularly aggressive pit viper. When I asked for an explanation, the elder replied through the usual multiple levels of translation the region requires: "We might walk this path again one day."

Since venomous snakes still kill thousands of people in Asia and Africa every year, there's a certain adaptive logic in that reply. I prefer to regard the sole venomous snake species that occupies my own home ground with a mixture of healthy respect and biological admiration. The prairie rattlesnake is marvelously adapted to fill the niche it occupies. The venom in the glands above its fangs is so complex that scientists still don't know the

precise chemical structure of everything it contains. Those fangs anticipated the invention of the hypodermic needle by millennia. The depression in the maxillary bone that makes the rattlesnake a pit viper contains temperature receptors sensitive to changes of tiny fractions of a degree—an ideal sensory organ for a predator hunting warm-blooded prey at night.

Yes, we might walk this path again one day, and in Montana, a prairie rattler might by lying there. Do what you must to ensure the safety of yourself and your companions. (I worry more about one of my bird dogs getting bitten by a snake than I worry about getting bitten myself.) But let's not lose track of *C. viridis*'s status as the marvel of evolutionary biology that it really is.

Chapter 19

PLAINS COTTONWOOD

Populus deltoides monilifera

Sometime in early October, I always take one last walk along the creek carrying my fly rod. I may find trout feeding on blue-winged olives or a late caddis hatch, but fish are seldom the point of this ritual visit. Winter lies just around the corner at this time of year, and I can always sense its lurking presence even when the air feels balmy. In a matter of a week or two, southbound geese will fill the air with their calls, whitetail bucks will start to move in search of does and Lori and I will awaken to a landscape turned suddenly white. All the riot of color along the creek's riparian corridor will be gone, and I will have to wait another year to witness it again.

The grasses underfoot and the eye-level willows offer a complex array of oranges, yellows and reds, but the real visual drama stands overhead. This is the magical week when the leaves on the cottonwoods towering above the creek have all turned to translucent gold. The canopy fills the sky, and the sunlight filtering through it makes everything beneath it glow, even the current. When a puff of breeze passes through them, the leaves shimmer and dance, making the whole creek corridor come alive as if by some cinematic special effect. If the wind freshens, the quaking leaves can make me hear the sound of the sea above me—not crashing breakers but the soft murmur of waves retreating gently down a long, sloping beach.

Winter may still lie a few weeks away, but one overnight blow from the northwest will bring all this to an end and leave the cottonwoods barren,

Translucent gold cottonwoods along the Nez Perce National Historic Trail riparian area, Florence, Montana. *U.S. Forest Service photo by Roger Peterson.*

standing like lonely sentries along the creek. That's why I always take this walk even though I hardly ever catch many fish. That's probably because I hardly ever try.

The boundaries of the Great Plains may be arbitrarily defined, but the first waves of western settlers—those who came by covered wagon instead of by rail—certainly knew when they were there. During the travel season, the plains appeared vast, hot, barren and dry enough to be called the Great American Desert even though that term is not technically accurate. Coming from the boreal forests of the eastern seaboard and the upper Midwest, the absence of trees left these pioneers deeply distressed. No trees meant no shade from the relentless sun, no good fuel for fires and often no water. So, they baked in the sun, cooked over buffalo chips and plodded on. No wonder they fell in love with cottonwoods wherever they found them, eventually making the cottonwood the official state tree in Kansas, Nebraska and Wyoming.

Three species of cottonwood inhabit Montana. The black cottonwood (*P. trichocarpa*) and the narrow-leafed cottonwood (*P. angustifolia*) occur from the western part of the state down the Columbia drainage toward the Pacific.

Cottonwoods along the banks in Upper Missouri River Breaks. *Bureau of Land Management photo, by Bob Wick.*

The Lewis and Clark expedition collected specimens of both, and Lewis provided the first written description of the narrow-leafed cottonwood based on trees he encountered near Great Falls. But when Montanans east of the Continental Divide refer to cottonwoods, the tree in question is usually the eastern cottonwood (*P. deltoides*). There are three subspecies of eastern cottonwood in America, of which Montana's is known as the plains cottonwood (*P. d. monilifera*). These trees grow in riparian corridors in the Missouri and Yellowstone drainages throughout eastern Montana. In this chapter, I will simply refer to the trees that so spectacularly illuminate October walks near my home as cottonwoods.

If they survive lightning, beavers and humans, cottonwoods can live a long time—as long as 150 years— and become large trees, over 100 feet tall and 6 feet thick. At the time of this writing, the country's largest known plains cottonwood grows in Ravalli County, Montana, and measures 112 feet tall and 32 feet in circumference around the base. The bark of a mature tree is light, thick and brittle. (The Lakota name for the cottonwood translates as "peel off wood.") The leaves have flat stems that make them flutter in the breeze like those of another well-known member of the *Populus* family: the quaking aspen.

Cottonwoods became a foundation of commercial enterprise in eastern Montana once steamboats replaced human-powered watercraft on the

"Men on the bluffs overlooking the Missouri River and the boat," circa 1912. *U.S. National Archives and Records Administration.*

Missouri River. During the first half of the nineteenth century, steamboats didn't venture past the confluence of the Missouri and the Yellowstone because of difficulty navigating shallow water between shifting sand bars. In 1860, the side-wheelers *Chippewa* and *Key West* made it all the way upstream to Fort Benton, establishing the river as a viable commercial trade route for the eastern half of the state. The boats that followed all needed fuel, and the cottonwoods along the river provided the most convenient source. A vintage Missouri River steamboat could consume thirty cords of cottonwood per day. Workers called woodhawks felled cottonwoods in the dense stands along the river and organized the logs into piles along the banks so they could sell them to steamboat captains. A segment of land along the river downstream from Great Falls and north of Winifred is still known as Woodhawk Bottom today. As was so often the case then, the woodhawks regarded the resource as inexhaustible, but—again as was so often the case—that assumption proved false.

Despite the cottonwood's importance to early settlers and steamboat captains, the species has a number of drawbacks from a utilitarian point of view. The wood is soft and difficult to work with, although Lewis and Clark, who were already familiar with the eastern cottonwood when they first headed up the Missouri, used it to make dugouts and wagon wheels. They also discovered that the bark made surprisingly good winter fodder for their horses. As important as these trees were historically as a source of steamboat

Cottonwood bottoms provide prime habitat for many Montana wildlife species. *Photo by Don and Lori Thomas.*

fuel, cottonwood burns weakly and has a very low BTU rating. Furthermore, mature cottonwoods rot from the inside out, making large, apparently sound branches vulnerable to wind. These branches have flattened more than their share of tents, corrals and homesteads. The fact is that early enthusiasm for cottonwoods largely arose from the lack of alternatives on the prairie.

Whatever the weaknesses of the cottonwood from a practical human perspective, the tree is a boon for wildlife. Half the bird species in Montana utilize riparian cottonwood habitat. Dead, hollow cottonwood branches provide nesting sites for numerous species of birds and small mammals. Large ungulates use cottonwood stands for shelter. One study showed that over 80 percent of eastern Montana's white-tailed deer used riparian bottoms for cover.

Cottonwoods have a complex life cycle that is intimately connected to the dynamics of the streams they live beside. In the spring, female cottonwoods (each tree is one sex or the other) release huge numbers of tiny seeds attached to buoyant, cotton-like strands that allow them to disperse on the wind. These puffy airborne particles, which can practically turn the air white at times, give the cottonwood species their name.

Water current aids in the seed dispersal process as well. Ideally, seeds become airborne as spring high water is starting to recede, leaving sand

and gravel bars that have recently been bathed in fertile silt exposed to the blowing and drifting seeds. Only a small percentage of seeds arrive at a resting place suitable for germination, and those that do require a precise combination of moisture and temperature to sprout once they get there. Cottonwood seeds are short lived, and if those conditions are not satisfied when the seeds arrive, a whole year's crop may be lost. This combination of factors means that only a tiny percentage of cottonwood seeds ever grows into trees.

Some years, young cottonwood shoots crowd the sandbars along the Missouri, but they still aren't home free. If they stand too far above the fluctuating waterline, they receive insufficient moisture, but if they are too low, they will likely be scoured away by current and drifting ice the following spring. Meandering streams and rivers provide ideal cottonwood habitat, since periodic floods provide moisture and nutrient rich soil without exposing young trees to the potential trauma they would face right next to riverbanks. This combination of environmental factors explains the trees' proclivity for old oxbows and deep river bends.

The propagation of cottonwoods depends on the cycles of high and low water that free-flowing rivers provide. Naturally occurring variations from season to season and year to year provide seeds and seedlings a range of environmental options from which nature can select the survivors. Unfortunately, a variety of human activities represent potential threats to Montana's cottonwoods that could be more destructive than the woodhawks' saws and axes.

Dams disrupt a river's natural rhythms in several ways. Reservoirs act as settling basins and prevent the downstream dispersal of silt. They disrupt natural seasonal cycles of high and low water. While the Yellowstone itself remains free flowing, several of its major tributaries do not, and several dams stand between the headwaters of the Missouri and its confluence with the Yellowstone at the North Dakota border. Thus far, cottonwoods have largely withstood this environmental disruption. Land managers with the Missouri River National Monument have been pleasantly surprised to see little significant change in today's cottonwood density in comparison to vintage Army Corps of Engineers drawings and photographs from the early 1900s. However, that's not a long period of time in biological terms, and the trees' future remains uncertain.

Biological threats to the cottonwoods may prove more significant than physical alterations in river flow. Two exotic invasive plant species are particular causes of concern. Tamarisk (*Tamarix spp.*), also known as salt

Cottonwoods lining a reservoir in eastern Montana, where they are often the only trees for miles around. *Photo by Don and Lori Thomas.*

cedar, was introduced to the Midwest from the Mediterranean region in the early 1800s as an ornamental shrub and a component of windbreaks. This invasive plant began to appear in Montana during the 1960s. Salt cedar is fire resistant and tolerates more highly saline soils than most native river bottom flora. It inhibits the growth of cottonwoods and other plants by using its long tap root to transport salt from deep soil to the surface. As its name implies, Russian olive (*Elaeagnus angustafolia*) is an Asiatic species that was widely introduced around the west in the late 1800s, again largely for use in shelterbelts. It proved extremely tenacious and has overwhelmed many native plants in its preferred riparian habitat, including young cottonwoods. Unfortunately, Russian olive supports a far less dense and diverse wildlife population than cottonwoods and other less competitive plants it has displaced.

Then there are the bugs. A member of the longhorn beetle family and one of the largest insects in North America, the cottonwood borer (*Plectrodera scalator*) looks like an extra from one of the Ridley Scott *Alien* movies about to begin a rampage through a space ship. Its oversized antennae and mandibles make it appear particularly malignant when viewed close up. In real life, it is

The invasive Russian olive behind this rising flock of ducks threatens to displace native cottonwoods in many of Montana's riparian corridors. *Photo by Don and Lori Thomas.*

the cottonwood tree rather than Sigourney Weaver that the borer threatens with infestation. After an adult female borer penetrates a cottonwood's bark, the eggs she lays grow into larvae that spend two years worming their way around the inside of the tree before they pupate, chew through to the surface and exit as adults to begin the life cycle anew. Larvae can sometimes kill young trees, and the structural damage they cause can weaken trunks and make them more vulnerable to wind.

Ominous as this description sounds, the cottonwood and the borer that exploits it have co-existed for ages, and the trees are clearly capable of surviving the beetles. As with the plants described earlier, the real biological threat will likely come from an alien invasive species with which the host has had no historic contact. In the case of the cottonwood, the villain could turn out to be the emerald ash borer (*Agrilus planipennis*). This Asiatic beetle first arrived in North America in 2002, when it appeared in Michigan, probably as a hitchhiker carried by infested wooden packing crates from overseas. In the Old World, populations of this brilliant green beetle were held in check by indigenous insect predators, especially wasps. Absent this natural system of checks and balances, the ash borer spread rapidly, decimating multiple

species of ash trees across the Midwest. At the time of this writing, the ash borer has not reached Montana, but it has been found in North Dakota. Ash trees are its preferred hosts, and its potential impact on cottonwoods remains unknown, but foresters are concerned about the impact the beetle could have on eastern Montana's dominant deciduous tree.

And so the plains cottonwood remains something of an enigma. It is a poor source of timber and fuel, yet it played a vital role in the settling of the prairie. It collapses unpredictably on top of human structures wherever people have been attracted to its beauty and its shade. It defines wildlife habitat in riparian corridors across the state despite the one-in-a-million odds against any seed developing into a mature tree. Its complex life cycle has withstood profound alterations to its environment by dams and human development only to be threatened by alien flora and fauna from Asia and the Mediterranean.

But there it stands, a home to countless wildlife species and magically alive with color every fall, reminding people like me why we live where we do.

PART IV
RIVERS AND STREAMS

. .

Chapter 20

CURRENT AND DAMS

*M*ontana's streams and rivers separate almost too neatly into two kinds, with the division running roughly down the middle of the state from north to south. West of this imaginary line, the steep drop away from both sides of the Continental Divide provides impetus to the current while snowmelt keeps its temperatures low. The result is just the kind of cool, clear aquatic habitat favored by trout and char. As the streams on the Gulf side of the Divide reach the prairie to the east, they slow down, pick up some sediment and grow warmer as catfish and pike replace the salmonids. Sometimes the state's waters seem to flow through different worlds.

The streams that run eastward from the Greater Yellowstone area form one of the most famous angling destinations in the world. Their names read like an honor roll of western trout water: the Big Hole, Beaverhead, Madison, Jefferson, Gallatin and Bighorn, plus the Yellowstone and the Missouri Rivers themselves and numerous smaller tributaries and spring creeks. Many visiting anglers fail to realize that the fish they came for are—with the exception of the now sparsely distributed cutthroat trout—alien, invasive species. That sounds harsh—those are terms we apply to the likes of knapweed, Russian olive and carp. Since I have spent my life enjoying eastern Montana's alien, invasive brown and rainbow trout with my fly rod, finger pointing on my part would sound hypocritical. The charge is accurate, however. The rainbows came from the other side of the Continental Divide, and the browns came from the other side of the Atlantic. Now they are crowding native cutthroats out of their historic habitat.

Fly rod anglers launching drift boats below Yellowtail Dam on the Bighorn River. The dam has created a world-renowned tailwater trout fishery on the eastern Montana prairie near the site of the Custer Battlefield. *Photo by Don and Lori Thomas.*

The human urge to meddle doesn't end with the introduction of new species. Human engineers view flowing water in much the same way as the beavers described in chapter 8, especially at natural points of constriction. In both cases, the urge to build dams seems to arise from innate, primitive instinct. Today, dams span the upper Missouri, the Madison and the Beaverhead, and smaller diversion dams alter current flow here and there in most rivers throughout the state. (The Yellowstone, as noted, remains the longest free-flowing river in the lower forty-eight, not that the Army Corps of Engineers didn't consider making it otherwise a few years back.) Some of these man-made obstructions have created spectacular tailwater trout fisheries in the smooth, evenly flowing current below them, notably in the Missouri and the Bighorn River farther east. But even when I'm enjoying the fishing in one of those waters, I have to wonder if I've made a bargain with the devil, for these streams will never again flow exactly as nature intended.

Of course, one never knows just what nature has in mind, as demonstrated by events on the Madison River on the night of August 17, 1959, an upheaval that has more than once reminded me: "There but for the grace of God..."

Two man-made dams already spanned the Madison, a world-famous trout stream rising in Yellowstone National Park: one below Hebgen

The Yellowstone River east of Livingston. Today, the Yellowstone is the longest free-flowing river in the lower forty-eight states. *Louann W. Murray, PhD.*

Lake and a second that formed Ennis Lake. At 11:37 p.m. on the night in question, a sequence of events began that quickly created a third. The time marked the beginning of an earthquake that produced thirty to forty seconds of tremors that shook the area violently. The quake's epicenter was near the town of West Yellowstone, and it measured 7.5 on the Richter scale—roughly the magnitude of the quake that leveled San Francisco in 1906.

The tremors sent walls of gravel and rock crashing down the sides of Madison Canyon, burying campgrounds and totally obstructing the Madison's flow. As water began to build up behind the slide, engineers realized the rising pressure load's potential to collapse the wall of rock and produce catastrophic flooding in the valley below. By the end of September, the Army Corps of Engineers had dug two channels through the slide to allow Madison River water to continue on its way downstream.

Despite some shrewd engineering and a heroic emergency response from multiple agencies throughout the area, twenty-eight people lost their lives in Montana as a result of the earthquake. Despite the lightly populated area it affected, the quake caused nearly $100 million worth of damage in today's currency.

State Highway 287 slumped into Hebgen Lake; damage from the August 1959 Hebgen Lake (Montana-Yellowstone) earthquake. *USGS Photographic Library photo by I.J. Witkind.*

What's left of a building from the 1959 earthquake in Gallatin National Forest. *U.S. Forest Service Northern region photo.*

Eight additional fatalities attributed to the event occurred in nearby parts of Idaho. The natural dam caused by the untouched portion of the slide debris formed a new impoundment on the Madison, aptly named Quake Lake. Today, the Earthquake Lake Visitor center, maintained by the USDA Forest Service, sits twenty-seven miles northwest of West Yellowstone on U.S. Highway 287, offering a solemn lesson for those who need to be reminded of nature's raw power and willingness to exercise it without regard to human consequences.

I may not spend as much time considering the grace of God as I should, but five days before the Hebgen Quake, at the age of eleven, I was staying with my family in one of the campgrounds the rockslide buried the following week. That's why I make a point of visiting Quake Lake every few years and thinking hard about all that has happened to me since 1959 while I'm there.

Breached man-made dams have killed people in Montana as surely as natural cataclysms. The Swift Dam was constructed on Birch Creek, a tributary of the Missouri by way of the Marias River, just before the First World War. Its principal purpose was to provide irrigation water to the arid pastureland on the Blackfeet Reservation in the shadow of the Rockies' eastern front. There was nothing sophisticated about its construction—a slab of concrete on the upstream side with compressed earth behind it on the downstream side—but the dam and Swift Reservoir behind it served their purpose uneventfully until 1964. That's when local weather conditions created Montana's own version of Sebastian Junger's perfect storm.

The mountain snowpack had not been unusually high that year, but cool temperatures delayed the normal spring runoff. Most of the winter snow was still sitting in the mountains when an unprecedented deluge of warm rain began to fall in early June, producing rapidly rising water all across the Reservation. The sudden increase in water load on its upstream side proved too much for Swift Dam, which failed catastrophically on the morning of June 8. One minute it was there, according to witnesses, and the next minute it was gone. To add to the magnitude of the disaster, the dam on nearby Two Medicine Creek collapsed shortly thereafter.

These events resulted in two walls of water roaring across the Reservation at what a pilot overflying the area estimated at twenty-two miles per hour. The surge swept away livestock, utility poles, ranches and, most tragically, people, all with virtually no warning. Families were separated. People drowned despite heroic makeshift rescue efforts. By the time the floodwaters began to subside, twenty-eight people were dead—nineteen as a result of the Swift Dam failure and nine more on Two Medicine Creek. Despite media

preoccupation with the flood's possible effects downstream in Great Falls, all the deaths occurred on the Blackfeet Reservation.

The discussion up to this point has focused on some of Montana's larger, better-known dams, in sickness and in health. According to the Association of State Dam Safety Officers, Montana contains 2,899 dams subject to state supervision, most of which I've never heard of, let alone seen. Of these, 105 are rated as "high hazard potential," which simply means that if something goes wrong, a lot of people may well die. When one considers the devastation visited on the Blackfeet in 1964, one has to wonder how much time human beings should spend acting like beavers.

Like most of the state's famous trout, most of its conflicts between currents and dams are located in the mountainous western third of Montana. However, a surprising number of the dams referred to in the last paragraph lie scattered about the prairie, many little more than Depression-era Works Projects Administration (WPA) efforts meant to provide employment for hungry men and water for thirsty cows. But then there is the great-granddaddy of them all: Fort Peck.

It is a measure of this monumental project's isolation that I managed to traverse the state many times as a youth without laying eyes on the dam or the vast body of water behind it. Most Montanans haven't seen it either. One summer day, after I'd lived in the area for years, I found myself utterly lost as I tried to reach Fort Peck Reservoir's remote northern shore by vehicle. I breathed a sigh of relief when I came over a rise and spotted an old, sunburned rancher standing outside a house that looked like a relic from the homestead era. I pulled in, introduced myself briefly (a Montana license plate goes a long way in this country) and asked what the best way would be to get down to the lake.

"What lake is that?" he asked.

"Fort Peck," I replied, as if to state the obvious.

"You know," he said after a long moment of reflection. "I've spent my life here, and I can't say that I've ever been to that lake." And there we stood, less than ten miles from the largest reservoir in the state and the fifth largest in the nation.

I still remember the first time I saw that reservoir back in the 1970s, when I was headed toward the Madison from the Fort Peck Reservation in a desperate search for clear water and trout. After driving across the prairie for an hour, I turned south off the Hi-Line on Highway 24, drove for twenty more miles and there it was—a vast, unbroken expanse of water that looked like an inland sea surrounded by desert. There was virtually no vegetation

along the shore but sagebrush, which grew right down to the waterline. The contrast between the lake and the arid prairie surrounding it felt surreal.

Driving on through the tiny town of Fort Peck, which dates back to the construction of the dam and now serves improbably as the home of a vibrant summer theater, I began to look around for the dam itself. How could I miss what was then the largest earthen dam in the world? Suddenly I realized that I was driving right across the top of it, a classical example of inability to see the forest for the trees. Reasoning backward from the scope of the completed project to the amount of effort that had to have gone into its construction, under conditions that would seem primitive now, simply reinforced may admiration for the fortitude of my parents' generation.

Work on the WPA Fort Peck Dam project began in 1933 and ended in 1940. The dam runs four miles long and stands 250 feet high. During the peak phase of its construction, ten thousand workers lived on site. Because the geology of the area consists of alluvial deposits of clay, sand and gravel with little solid bedrock, building the dam required a complex hydraulic filling process, a description of which lies beyond the scope of this discussion (refer to www.fortpeckdam.com for more detail). A project of this magnitude could not go on for seven years without mishap. Tragedy struck on September 22, 1938, when a fault spread rapidly across the dam, trapping thirty-four workers in the muck. Eight men died in the accident. Only two bodies were recovered, leaving six perpetually entombed in the heart of the structure.

What little attention this remarkable project received from the nation that commissioned it came early in its history. President Franklin Roosevelt paid a visit in 1934. Margaret Bourke-White's striking black-and-white image of the dam under construction became *Life* magazine's first cover photograph on November 23, 1936. After the notoriety of the 1938 tragedy, the dam and the reservoir behind it largely vanished into the remote prairie surrounding them, save for periodic squabbles over downstream water rights.

The dam, along with most of the reservoir's coastline, lies within the boundaries of the Charles M. Russell National Wildlife Refuge, which maintains an excellent and underappreciated interpretive center near the southern end of the dam. Despite Montana's worldwide reputation as a trout-fishing destination, a growing number of people are discovering the excellent warm water fishing eastern Montana provides, and Fort Peck Lake stands at its epicenter. Some, myself included, are even enjoying this resource with fly rod tackle. The reservoir has become famous for the size and number of the walleye pike it contains. (The walleye is not native to Montana.) Northern pike and smallmouth bass (the latter also a nonnative

Fort Peck Dam spillway. *Courtesy of Arielle Seibold, Prairie Places Photography.*

species) prowl the 1,500-mile shoreline. Introduced lake trout and planted king salmon thrive in the cool, deep water in the center of the reservoir near the dam.

Even so, few Montanans and even fewer visitors to the state have even been there.

In common with many of this book's subjects, it is possible for dams to arouse widely divergent opinions from reasonable people. On the one hand, during his 1934 visit to Fort Peck, Franklin Roosevelt proclaimed:

> *Now people talk about the Fort Peck Dam as a fulfillment of a dream. It is only a small percentage of the whole dream covering all of the important watersheds of the Nation. One of those watersheds is what we call the watershed of the Missouri River, not only the main stem of the Missouri, but countless tributaries that run into it and countless other tributaries that run into those tributaries. Before American men and women get through with this job, we are going to make every ounce and every gallon of water*

that falls from the Heavens and the hills count before it makes its way down to the Gulf of Mexico.

Roosevelt's comments reflect an optimistic view of dams and human ability to tame nature that echoes the nineteenth-century American notion of manifest destiny.

However, dams have also destroyed native anadromous fish runs on both coasts, eliminated habitat for native species and allowed the introduction of others that may not belong, left countless thousands of acres of American landscape under water, displaced people when they were built and killed people when they failed. The law of unintended consequences has a long reach. To the surprise of the biologists conducting it, one eastern Montana study of sage-grouse predation exonerated most of the usual suspects and showed that the most significant nesting losses came from seagulls that had established a nonnative population on Fort Peck Lake.

As distinguished Montana writer Tom McGuane once put it: "We have used our rivers the way a junkie uses his veins." I dislike dams as a matter of principle, simply because it is difficult, if not impossible, to improve on nature. However, since I have also enjoyed some of what they have created, I can only suggest a reasonable middle ground: that dams are now part of the Montana landscape, that we should be grateful for the wildlife habitat they have created while mourning the loss of the wildlife habitat they have destroyed, that we should keep them safe and that we should think long and hard before building any more of them.

Chapter 21

CUTTHROAT TROUT

Oncorhynchus clarkii

*T*he stream, which shall remain unnamed for reasons angling readers will understand, rises high in a central Montana mountain range. The current tumbles gracefully down through a series of small, tight canyons before it finally loses steam out on the prairie and wanders toward its eventual destination in the Gulf of Mexico at an old man's pace. You can reach it by road there, but the interesting part of the creek requires a vigorous hike through some rugged terrain. There are no fly shops or queues of driftboats anywhere nearby. Since I've been around long enough to remember when Dan Baileys's place in Livingston was almost the only fly shop in the state, a hike up this stream always provides me with a welcome personal journey backward toward a quieter, more peaceful time in the world of angling.

I find the scenery here oddly reminiscent of Alaska: rugged peaks tall enough to hold snow year round, glaciers, alpine meadows carpeted in wildflowers, aspens at higher elevations, mixed coniferous woods farther below. The large mammal population is rich and varied, including elk, black bears, mule deer, cougars, mountain goats and wolves. These mountains are supposed to contain one of the healthiest wolverine populations in the lower forty-eight states, although I've never seen a track there even after countless miles of hiking.

The lower reaches of the stream contain a respectable population of rainbow trout, but I usually hike right past them. I certainly have nothing against rainbows. But they are not native to Montana waters east of the

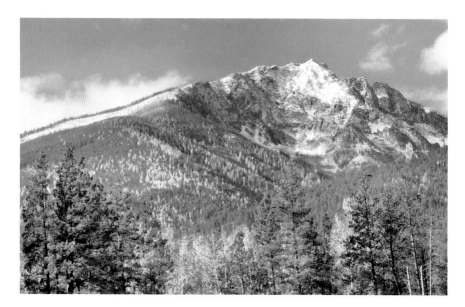

Rugged peaks tall enough to hold snow year round, aspens at higher elevations and mixed coniferous woods farther below are found along the Nez Perce National Historic Trail, Bitterroot Valley. *U.S. Forest Service photo by Roger Peterson.*

Continental Divide, and there are days when I just feel like casting flies to fish that belong here in ways that rainbows, browns and brook trout never will. Once I've made the effort required to reach the good cutthroat water, I always enjoy knowing that I've earned the privilege of pursuing Montana's official state fish.

It should come as no surprise by now to learn that the first description of the cutthroat trout to reach western science came courtesy of the Lewis and Clark expedition. Private Silas Goodrich was the fishing fool in the party, and even though the expedition's supplies included only a token amount of tackle, Goodrich made the most of it. Here's what Lewis had to say about Goodrich's catch on June 13, 1805, near what is now Great Falls:

> *Goodrich had caught half a dozen very fine trout...These trout (caught in the Falls) are from sixteen to twenty-three inches in length, precisely*

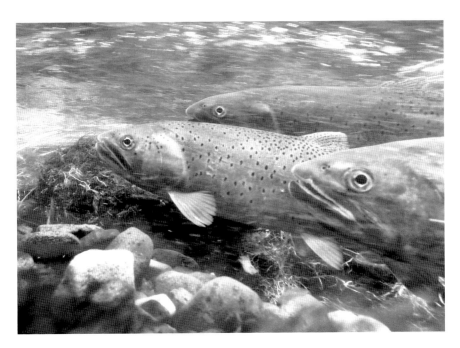

Yellowstone cutthroat trout. *National Park Service photo by Neal Herbert.*

resembling our mountain or speckled trout in form and the position of their fins, but their specs are of a deep black instead of the red or gold color of those common to the U. States. These are furnished long sharp teeth on the palate and tongue, and generally a small dash of red on each side behind the front ventral fin. The flesh is of a pale yellowish red or, when in good order, of a rose pink.

Lewis was slightly off in his anatomic placement of that "small dash of red on each side behind the ventral fin," but I doubt that Goodrich cared.

The naturalist George Suckley originally named the species for Lewis in 1853, but in 1898, David Jordan and Barton Evermann reversed course and named it *Salmo clarkii*. In 1971, after much confusion regarding the various cutthroat species, Lewis received credit in the scientific name for the westslope cutthroat he had described, *S. c. lewisi* (which actually is native to waters on both sides of the Continental Divide). The species as a whole remained, as I've always thought of it, Captain Clark's trout.

The cutthroat trout, like the rainbow, derives from salmonid ancestors native to the North Pacific. After years spent lumped in the same family as the European brown trout and Atlantic salmon, DNA studies showed

that cutthroats and rainbows are more closely related to Pacific salmon, which is why they all carry the generic name *Oncorryhnchus* today. The cutthroat's native range extends from south-central Alaska to northern California and includes a variety of habitats. The coastal cutthroat subspecies, for example, spends part of its lifecycle in salt water. Given its wide range and presence in isolated locations, the recognition of a dozen different subspecies should not be surprising. (The exact number remains controversial, and several are now extinct.) Montana is home to two: the westslope cutthroat introduced earlier and the Yellowstone cutthroat, *O. c. bouvierii*. The two are generally similar in appearance, although the Yellowstone subspecies has fewer but larger black spots on its body than the westslope. Both display the characteristic red or orange slash marks on the underside of the mandible that give the fish its name.

Cutthroats are spring spawners, although "spring" can vary from February to July depending on location and water temperature. Cutthroats require clear, cool water running over clean gravel bottoms for successful spawning. Lake resident cutthroats usually migrate up feeder streams to spawn, although they will occasionally spawn in lakes. Yellowstone Lake holds the world's largest inland population of cutthroats, which utilizes over thirty tributary streams as spawning habitat between May and August. Local predators know all about this phenomenon, and spawning cutthroats are an especially important source of protein and fat for bears after winter hibernation. Both black bears and grizzlies utilize this resource, much as bears of both species feed heavily on salmon in coastal streams farther north. Unfortunately, the illegal introduction of lake trout into Yellowstone Lake threatens native cutthroats and, by extension, the bears that feed on them. Lake trout are more aggressive and adaptable than cutthroats, and biologists predict that they may reduce cutthroat numbers by 50 percent in a few more years. Since lake trout do not migrate into streams to spawn, such a population shift would deprive bears of a traditionally important food source. Such are the consequences of "bucket biology."

Cutthroat populations are generally declining in most parts of Montana, particularly the westslope subspecies. Loss of critical spawning habitat to erosion and development is one contributing factor. But as the case of the Yellowstone lake trout demonstrates, the arrival of nonnative wildlife—no matter how "desirable" the species or well-intentioned its introduction—may pose an even bigger threat to the species. As a diehard fly-fisherman I suppose I need to shoulder some of the blame,

for my predecessors if not myself. Brown trout and rainbows, both perpetually popular with anglers, have been around Montana for so long that we tend to assume they are native species. In fact, the only rainbows native to Montana are an isolated population of the redband subspecies in the upper Kootenai drainage. Most Montana rainbows derive from California hatchery stock released widely around the state during the 1880s. Natives of Europe, brown trout were first released in Montana in 1889, into the Madison River.

Unfortunately for our native cutthroats, both rainbows and browns are hardy, adaptive species that readily displace cutthroats from food sources and spawning areas. Both, particularly the brown, tolerate a wider range of water temperature and clarity. Big brown trout just plain eat young cutthroats. Rainbows have an even more insidious way of interfering with native cutthroat populations. Rainbows and cutthroats readily hybridize, and over successive generations these "cutbows" look progressively more like rainbows and less like cutthroats. In time, rainbows seem likely to breed cutthroats out of existence wherever the two species' ranges overlap (if the browns don't devour them first).

Despite the worrisome contraction of their historical range, there are still plenty of cutthroats in Montana and ample places to fish for them. Note

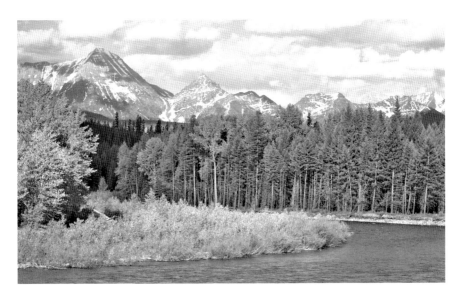

Prime cutthroat habitat along the North Fork of the Flathead River, near Ford's Cabin in the Flathead National Forest, provides the clear, cool high mountain water running over clean gravel bottoms needed for successful spawning. *U.S. Forest Service Northern Region photo.*

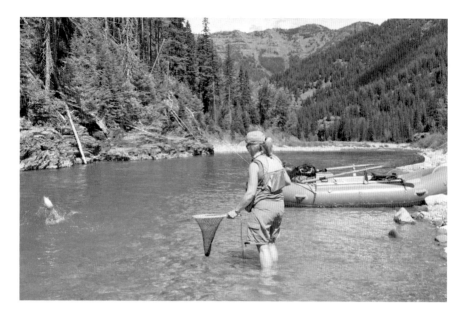

Lori Thomas brings a nice cutthroat to the net in the Great Bear Wilderness. *Photo by Don and Lori Thomas.*

that in most parts of the state it is illegal to retain cutthroats, which should be released as carefully and gently as possible (as all native trout should be for that matter, whatever the regulations say). Once you've reached the water cutthroats inhabit, which is often in high mountain streams, catching them isn't particularly difficult. While cutthroats will hit almost anything, artificial lures or flies with small barbless hooks are encouraged in order to minimize catch and release mortality, which should be negligible with proper tackle and technique.

Wherever you find them, native cutthroats are gorgeous fish, particularly in spring and summer when they are still dressed up in their spawning colors. A five-mile hike up the mountain stream introduced at the beginning of this chapter reminded me of their esthetic appeal all over again a few summers back. After we reached an inviting pool, Lori rigged up her fly rod and worked her way down through the rocks to the waterline while I remained high on the bank where I could see fish. By the time she had a dry fly—chosen for buoyancy and visibility rather than as a specific imitation of anything—attached to her tippet, I'd spotted a small cutthroat rising behind a boulder on the far side of the stream. I could accurately describe the fish as pan-sized, but that would suggest we meant to eat it, which we didn't.

There was nothing technically difficult about the presentation. The crystalline current allowed me to enjoy the sight of the fish tracking the fly's downstream progress for several feet before taking it. Cutthroats fight well for their size, and the jumble of boulders along the waterline coupled with her light tippet gave Lori a bit of a challenge as she landed the fish. By the time she had it resting quietly in the shallows at her feet, I had scrambled down the bank and landed beside her. Months had passed since I'd looked at a wild cutthroat, and I needed to refresh my memory.

Trout and char are certainly among the most beautiful of all freshwater fishes, and the cutthroat upholds that standard well: elegant proportions, greenish back, golden flanks, discreet spots as dark as drippings from a leaky ink well. Turning the fish gently on its side, I pointed out the crimson marking along the lower edges of the gill covers. The hue was lighter than blood, and nothing about the marks suggested the violence of a knife slash, but the origin of the fish's common name seemed obvious nonetheless. A quick twist of my hemostat against the tiny hook ended the physical connection. With a flick of its tail, the fish was gone. The palette of colors we'd just been admiring provided such perfect camouflage against the rocks in the streambed that the fish's disappearance seemed instantaneous and magical.

But the cutthroats were still out there somewhere, and on that day, that was all we needed to know.

Chapter 22

AMERICAN PADDLEFISH

Polyodon spathula

*T*he first time someone asked me if I wanted to go chase paddlefish, I felt as if I'd been invited on a snipe hunt. I had heard of paddlefish the way one hears of unicorns or yetis, without quite bringing myself to believe in their existence. The descriptions I'd heard from anglers around town sounded frankly preposterous. Since I had just moved to a remote Montana community in the days long before the Internet, I lacked the means to fact-check any of this suspicious local knowledge. But it was late May, and the local trout streams were so swollen with runoff that fly-fishing was impossible. Besides, there was beer in the cooler. Why not?

Farther upstream from the water we meant to fish, dams have turned the Missouri into reservoirs and stretches of clear, evenly flowing water that have become famous tailwater trout fisheries. But those dams sit a long way away from the Fred Robinson Bridge just south of the Little Rockies, and after descending the long grade downhill from home we found a wild and natural version of the Missouri that hadn't changed much since the days of Lewis and Clark. Unfortunately for angling purposes, "wild and natural" meant high and muddy, the least favorable water conditions imaginable for fishing—at least to me. But not to my companions, both veterans of many paddlefish expeditions, who pronounced the water perfect for our purposes.

I had a lot to learn, not just about paddlefish as biological oddities but also about the means Montana prairie residents employ to catch them. I had already been told—amidst no small amount of laughter—to leave my fly rod behind. It turns out that the only way to catch paddlefish on rod and reel is

by snagging them. To this end, my friends had brought along several large, broken-down surf casting rods, which they began to assemble as soon as we'd parked the truck. They had thoughtfully provided one for me. Terminal tackle consisted of a large treble hook suitable for sharks, with a heavy glob of lead molded to the shank to make it sink quickly. The long rods and heavy weight on the end of the line provided plenty of casting reach, as I discovered when I hauled back and sent my paddlefish "fly" across fifty yards of turbid water. Although I remained fascinated by the possibility of something prehistoric swimming around out there in the soup, I just couldn't match my friends' enthusiasm.

After an hour of this basically mindless exercise, I could match it even less and had started to think hard about the contents of the cooler. Suddenly I heard a whoop of excitement upstream and noticed one of my companions' broomstick rods bent double. My first thought was that he'd fouled one of the trees drifting along with the runoff, but then I noticed his line surging away upstream. Fifteen minutes later, I was staring down at the first paddlefish I'd ever seen as it slopped listlessly against the bank. A male, as subsequent dissection proved, the fish weighed around forty pounds.

"What are we going to do with it?" I asked naively.

"We're going to take it home and eat it!" someone replied. Then I began to remember snippets I'd heard about the amazing table quality of paddlefish. Locals invariably said that it tasted just like—"It tastes just like lobster!" my friend blurted out as if he'd been reading my mind.

We broke down our tackle, laid the paddlefish out in the back of the pickup and opened the cooler. Not even the beer could dampen my skepticism about the meal that lay ahead.

———∽◦◦◦∽———

Superlatives attend the paddlefish. It is the largest freshwater fish in Montana and one of the largest on the continent, exceeded in maximum weight only by the white sturgeon (to which the paddlefish is distantly related) and the alligator gar. Biologists have recorded 150-pound specimens in Montana. A contemporary of the dinosaurs, it is the sole remaining member of one of our oldest fish lineages. Fossil specimens of its immediate ancestors date back to the Cretaceous period over 70 million years ago. Most of its supporting skeleton is made of cartilage rather than bone. The only creature like it anywhere on earth is an even larger carnivorous paddlefish native to

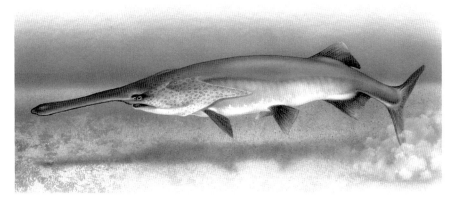

Paddlefish painting by Timothy Knepp. *U.S. Fish & Wildlife Service photo.*

the Yangtze Basin in China that hasn't been seen in the wild since 2003. Paddlefish are among the longest-lived of all freshwater fish, and individuals may exceed fifty years in age.

Even this catalogue of unique characteristics can't prepare you for your first good look at a paddlefish. The obvious morphological feature is the paddle that provides its name, a rubbery protuberance that extends forward nearly half the length of the fish's body in roughly the same position as a marlin's sword. For years, the function of the paddle remained a mystery, although some biologists reasonably hypothesized that it enabled the fish to dig out depressions in the river bottom during the spawning process. However, recent studies have shown that the paddle contains a rich supply of sensors that can detect minute changes in nearby electric fields, which help it detect concentrations of the tiny zooplankton on which it feeds. Sharks and rays have similar receptors. It is also possible that the paddle acts as a hydroplane to keep the fish stable in the flowing water column as it feeds.

The paddle may be the beginning of the fish's anatomic oddities, but it isn't the end. The elegantly shaped gill covers are long and tapering, extending backward nearly to the middle of the fish. The toothless mouth is huge, the eyes tiny and nearly useless. The skin is silky soft and smooth, with no scales. The overall impression is of a creature digitally created to populate a fantasy movie about a voyage to a galaxy far, far away.

But it turns out—and this should come as no surprise given the length of time it has been around—that the paddlefish is ideally adapted to survive in the habitat niche it occupies. The fish is a filter feeder that subsists on the base of a food chain few competing species can utilize. It eats by moving slowly upstream through the current after localizing concentrations

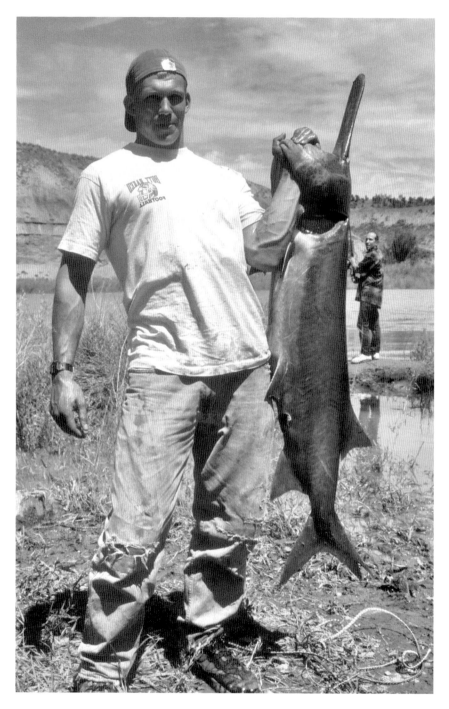

Ryan Budde with a medium-sized paddlefish from the Missouri River. *Photo by Don and Lori Thomas.*

of zooplankton with its sensory receptors. With its open maw gaping, its specialized gill rakers extract small organisms from the water as it sweeps through, a technique called ram suspension feeding that is also employed by baleen whales. The preferred food source is *Leptodora kindtii*, a nearly transparent water flea around twelve millimeters long. Better vision would be of little help locating this all-but-invisible species in muddy water, which explains the paddlefish's under-developed eyes and electro-sensitive snout. Because it spends most of its time in deep, turbid water, mature paddlefish have few natural predators.

The paddlefish lives a complex life cycle. Historically, it spent much of the year at the bottom of deep pools, a habitat now provided artificially by Fort Peck Reservoir in the Missouri and North Dakota's Sakakawea Lake, as well as numerous other reservoirs farther down the Missouri drainage. Spring spawners, paddlefish migrate upstream during periods of peak current flow produced by snow runoff hundreds of miles away. Males reach sexual maturity at nine to ten years of age, females six or seven years later. While they do not die after spawning like salmon, females only produce eggs every three years. Paddlefish are broadcast spawners, with congregations of males and females discharging unfertilized eggs and milt indiscriminately into the water with little or no interaction between individuals. So much for romance.

Despite their lack of interest in males of the species, female paddlefish are fastidious in other ways. They only spawn over silt-free gravel bars that will become shallow but not dry as the water level drops. They also require a specific combination of photoperiod, rising water and a water temperature between fifty-five and sixty degrees Fahrenheit. If they don't encounter these conditions, they back downstream to try again the following year, adaptive behavior that prevents wasted spawning effort when unsuitable water levels might impact survival of the young.

The historic range of the paddlefish extended across most of the Mississippi-Missouri drainage and at one time included parts of twenty-six states and Canada. Unfortunately, while dams provided convenient resting places for paddlefish during part of the year, they took away a lot of what the fish needed most: free-flowing water running over river bottoms that offered suitable repositories for paddlefish eggs. Today, artificial stocking programs sustain most paddlefish populations in the twenty-two states in which they remain. Paddlefish have also been introduced for commercial purposes in other countries, including Russia, China and several eastern European nations. The world's largest naturally reproducing stocks of paddlefish spawn in eastern Montana.

People have known about paddlefish—at least vaguely—for a long time. The Spanish explorer Hernando DeSoto described them in his log during his sixteenth-century exploration of the upper Mississippi. In the late 1700s, French naturalist Bernard Lacépedè and his German contemporary Johann Walbaum independently gave the fish scientific names, *Polydon feuille* and *Squalus spathula*, respectively. Splitting the difference led to the currently accepted version. Uncharacteristically, Lewis and Clark missed the paddlefish, but their patron, Thomas Jefferson, subsequently included the species in a catalogue of fishes native to the Mississippi. On August 26, 1864, James Atkinson, a soldier on the Sully Expedition, made the following journal entry while he was near the confluence of the Yellowstone and the Missouri: "Some of the soldiers shot fish from the river, some bagging spoon fish up to six feet long." Although its relative the sturgeon was a highly regarded food fish among Native Americans on both coasts at the time of European contact, the paddlefish receives remarkably little attention in traditional lore from Plains tribes.

In Montana, no one regarded the paddlefish as a source of either food or recreation until an angler accidentally snagged and landed one from the Yellowstone near Glendive in 1962. At first no one knew just what he had, but because of its size (around forty pounds, which is big for a fish of any kind on the Montana prairie) others set out to duplicate his feat and met with immediate success. Thus a unique recreational fishery was born in an unlikely place.

Inexplicably—to me, at least—the paddlefish soon acquired a reputation as great table fare. At the risk of sounding like a snob, at dinner on the night of my first (and last) paddlefish expedition, I concluded that the widely repeated comparison to lobster told more about the dearth of fresh seafood in eastern Montana than the culinary qualities of paddlefish. But someone was about to make a discovery that made paddlefish an overnight sensation on menus around the world and threatened paddlefish populations as nothing had since the damming of the Missouri. That discovery was paddlefish roe and the caviar derived from it.

Full disclosure: although I've eaten with relish sushi in its most exotic forms for decades before most Americans had ever heard of dining on raw fish, I've never been a caviar enthusiast even on the rare exceptions when someone else was covering the outrageous price tag. Caviar exists in two basic forms: red and black. Salmon and related species provide the first. When I lived in Alaska, I waded through salmon eggs by the bucketful without ever acquiring a taste for them. During the time I spent exploring in what was

then the Soviet Far East, I ate plenty of salmon roe perforce—a lot of the time we just didn't have much else to eat. Preparation was simple. I'd catch a *keta* with my fly rod. If it were a gravid female, I'd kill it and remove the egg skeins, leaving the rest of the fish for the bears. (As food fare, chum salmon is my least favorite of Alaska's five Pacific salmon, and even the hungry Russians refused to eat it.) Back in camp, we'd sprinkle the roe with salt and roll it up in a few pages of *Pravda*. Several hours later, we'd unroll the paper, break out the black bread and vodka and dine beneath the long arctic twilight. The vodka helped.

But for real connoisseurs, caviar means black caviar, traditionally derived from wild sturgeon, especially beluga sturgeon from the Caspian Sea. A number of organizations, including the United Nations Food and Agriculture Organization, Committee on International Trade in Endangered Species, and the United States Customs Service, only recognize sturgeon as the true source of caviar. As wild stocks of beluga sturgeon declined precipitously due to over-harvest and pollution, prices skyrocketed, with further impetus from the trade embargo with Iran. Then came paddlefish roe, and practically overnight, an obscure fish that Americans had ignored for centuries became a potentially valuable cash crop.

While I was in no position to judge at first, friends who were told me that paddlefish produce caviar almost as good as that from beluga sturgeon. Intrigued, a fellow survivor of the Russian odyssey and I decided we had to try some. At the time, there was no commercial source of paddlefish caviar, so we decided to make our own. I'd already decided that I'd made my last attempt to catch a paddlefish. Since we were apparently the only people in eastern Montana excited about eating raw fish eggs, we had friends deliver roe packed on ice whenever they caught a female. Because the individual eggs are enmeshed in a tenacious network of connective tissue, preparation was more complicated than for salmon caviar. A visiting Russian friend eventually taught us a lot about processing technique, and the first batch made under her supervision wowed everyone but me. Apparently I'm just not meant to enjoy caviar in any form.

When the cash value of paddlefish roe began to rise, the Montana Department of Fish, Wildlife and Parks recognized the need to exercise stricter control over the fishery. The state classified paddlers as game fish in 1963. By the time I arrived, there was an annual limit of two per year, and the department issued paddlefish tags just as it did for big game animals. The annual limit then dropped to one with an annual cap of 1,500 fish, which is likely to drop further. The impact of illegal eggs-for-

cash paddlefish poaching remains difficult to determine, although it is certainly a cause for concern.

It's depressing to think that illegal fishing in Montana could do to this ancient species what dams and pollution did to it elsewhere about the country. Because of their rigid habitat requirements and the time it takes paddlefish to reach sexual maturity and reproduce, they are inherently vulnerable to both environmental degradation and commercial over-harvest. Perhaps that's why I was never meant to enjoy caviar, even at its best: when it's tasty and free.

Chapter 23

ARCTIC GRAYLING

Thymallus arcticus

\mathcal{M}ark Twain's Huckleberry Finn endured an unpleasant, contentious relationship with his father, the vile and shiftless Pap. In contrast, I enjoyed a marvelous childhood, due in no small measure to the presence of my brilliant father, who won the 1990 Nobel Prize in Medicine for his pioneering work in the field of bone marrow transplantation. Except for fathers, Huck and I had a lot in common as we grew up: ready access to freedom, license to make adult decisions at an early age and unshakable enthusiasm for the outdoors coupled with the belief that little of importance happened anywhere else.

I first met the Montana grayling during the 1950s, when the innocence of the times reflected the innocence of my upbringing. This was the age of *Leave It to Beaver.* No one had heard of Vietnam, and September 11 was just another date on the calendar. We did have to deal with some Cold War jitters, but the worst bogeyman the Russians could produce was fat, bald Nikita Kruschev pounding his shoe on the table at the United Nations like somebody's drunken uncle at a family reunion.

The time was mid-July, and the three-month hiatus between fifth and sixth grades completed my sense of euphoria. As we did every summer, my father had packed our old Ford station wagon with sleeping bags, tents and fly rods and headed away from our upstate New York home on bearing two-seven-zero. But after three days of nonstop driving punctuated only by my mother's out-loud reading (*The Catcher in the Rye* and Boccaccio, no less), new state license plate counting contests and comparison of the roadside bird

life to the color plates in our dog-eared copy of *Petersen's*, I was ready to go fishing. Fortunately, my parents were, too.

As tangerine-colored light began to drain from the sky resting on the shoulders of the peaks ahead, we drove through Twin Bridges, where my mother pointed out the old orphanage where her stepfather had spent a childhood considerably less idyllic than my own. Settled between my parents in the front seat, I tried to keep my eyes open long enough to see some animal eyes reflected in the headlights' beams, an effort that probably lasted less than three minutes. The next thing I knew, I was crawling out of my old army surplus sleeping bag, staring at a brilliant sunrise, bracing myself against the high country chill and listening to the sound of water gurgling through a long gash in the sagebrush nearby. The stream was the North Fork of the Big Hole River, near the site of the 1877 battle between troops led by Colonel John Gibbon and the Nez Perce.

My mother could have made me stay in camp and try to be useful while she cooked the morning ration of oatmeal, but she knew better than to get between a ten-year-old with a fly rod and a trout stream. Contemporary angling technique still enjoyed a quaint innocence. There were no hatches to match, and I couldn't name a single aquatic insect in Latin. The contents of my fly box reflected Dan Bailey's observation that a selective trout was one that wouldn't hit a Royal Wulff. The box held little but a blue-collar assortment of Trudes, Goofus Bugs and Bivisibles, but back then the trout in the Big Hole drainage were just as unsophisticated as I was.

I'd already learned an important principle of childhood angling: no matter how high your waders, you will eventually go over their tops. Rather than slosh around with boots full of water, I just waded wet in sneakers. I'd barely had time to introduce my feet to the stream's chill when my dry fly disappeared in a delicate dimple. The fight, such as it was, consisted of me extending my arm and swinging the twelve-inch fish into the shallows, where I immediately faced a mystery.

Despite my young age, I'd had considerable experience with the salmonid family, including lake trout, brookies, rainbows and browns. I'd even caught a few whitefish on earlier trips out West, and that's what I initially assumed this fish to be (with a quiet sense of disappointment). But what were those subtle shades of violet dancing across the fish's flanks? And what about that billowing dorsal fin, unlike anything I'd ever seen before?

Still little more than a roll cast from the Coleman stove where my mother was making breakfast, I called up to camp and asked my father to come tell me what I'd caught. Dad never looked more thoughtful than he did when he

had his pipe in his mouth on a chilly high country morning, and he examined the fish as carefully as if it held the key to a secret code. "Congratulations," he finally said. "You've caught your first grayling."

The artic grayling is a circumpolar species whose range follows lines of latitude rather than longitude, rendering meaningless the distinction between New World and Old. Six (more or less—biological lumpers and splitters will always have their differences) representatives of the genus *Thymallus* lie spread across the upper reaches of the Northern Hemisphere from Europe and Siberia to the Canadian arctic, although *T. arcticus* is the only one found in the United States. Wilderness Alaska offers the species its last stronghold in our country, and grayling are one of that state's most widely distributed freshwater fish. During my years there, I caught them all the way from the Kenai to Bristol Bay and the North Slope of the Brooks Range. Not all Alaska gamefish hit dry flies readily, and I always appreciated the opportunities grayling provided to stop dredging streamers across the bottom and enjoy some top water purism. Grayling are also remarkably easy to catch, and they kept me from going hungry on more than one wilderness trip when the moose or caribou that were supposed to feed our camp failed to appear.

The ecology of the grayling farther south is more complicated and more concerning. Some grayling spend most of their lifespan in lakes, and some thirty Montana lakes contain small grayling populations today. Fluvial grayling—identical in appearance but genetically distinct—spend their lives in free-flowing streams. The latter variety is of special interest to Montanans since all of the fluvial grayling's remaining range in the lower forty-eight lies within the Treasure State's borders. When Lewis and Clark examined a specimen taken from the Beaverhead River on August 22, 1805, and described it as a "silvery kind of trout," grayling were widely distributed throughout the upper Missouri drainage. By 1950, the upper Big Hole contained the last remaining native population of fluvial grayling south of Canada, in less than 5 percent of its original range.

As is often the case when the population of a species declines rapidly, multiple factors were likely at play, including habitat degradation, drought and over-fishing. Grayling are notably intolerant of other fish. Even in Alaska, when salmon return to freshwater streams to spawn, grayling usually

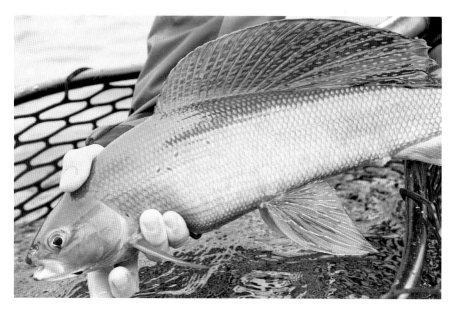

The arctic grayling's elongated dorsal fin makes the fish easy to identify at a glance. This specimen came from Alaska. Montana fluvial grayling almost never reach this size. *Photo by Don and Lori Thomas.*

vacate the water either by backing down into lakes or moving upstream to remote headwaters. (Wilderness grayling are highly migratory, with home ranges of up to sixty miles.) In Montana, grayling coexist comfortably with cutthroat trout, the only other salmonid that naturally shares their native water. The introduction of more aggressive, nonnative rainbows, brook trout and browns contributed substantially to the grayling's disappearance from much of the water it originally inhabited.

Grayling are an indicator species, with simple but strict habitat requirements including cool, clear water flowing evenly over the clean bottoms of uniformly sized gravel that they require for successful spawning. Their omnivorous diet is an adaptive trait, since grayling will eat almost anything from insects to vegetation, fish eggs and smaller fish. But to appreciate how vulnerable they can be to human meddling, one need only look back in time and east to Michigan.

During the nineteenth century, a grayling subspecies thrived in the streams that ran through Michigan's dense deciduous forests. Contemporary accounts of their abundance sound so exaggerated now that it's difficult to tell fish story from fact, although vintage photographs show recreational anglers hauling home grayling by the wagonload. The last wild native

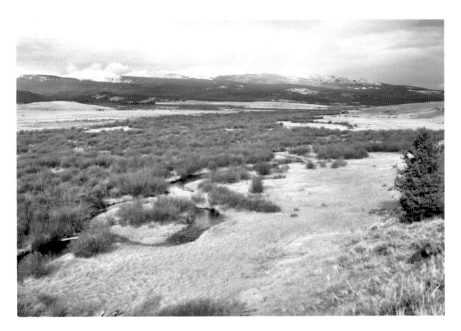

Upper Big Hole River headwaters near Jackson, Montana. *Photo by Mike Cline.*

grayling disappeared from Michigan during the 1930s. Thoughtless over-harvest by anglers certainly contributed to their extirpation. However, overzealous commercial timber harvest was likely the final nail in the Michigan grayling's coffin. The combination of riparian erosion and altered stream flow characteristics caused by logjams destroyed crucial grayling spawning habitat. Multiple attempts to reestablish a grayling population in Michigan have failed, primarily because the fish have no suitable place to reproduce. The town of Crawford, Michigan—once the epicenter of the sport fishery—changed its name to Grayling and established a hatchery in 1914, but by then it was already too late to save the Michigan grayling. Today, Montana's upper Big Hole River remains the last stronghold of the fluvial arctic grayling south of Canada, and their survival there seems anything but secure.

In Montana, state and private agencies—including, among others, the Montana Department of Fish, Wildlife and Parks; the Montana Natural Heritage Program; the American Fisheries Society; Trout Unlimited; and

private landowners working voluntarily with the Big Hole River Watershed Committee—are making a sustained effort to prevent the upper Big Hole's grayling population from suffering a similar fate. While federal efforts have involved multiple agencies, including the Forest Service and the Bureau of Land Management, the most visible have come from the United States Fish and Wildlife Service (USFWS), which oversees the Endangered Species Act. Unfortunately, much of this activity has taken place in court. A timeline reads as follows:

1991—petition to the USFWS to list the fluvial Montana grayling as endangered.

1994—USFWS determines that listing is "warranted but precluded" (Translation: It should be done, but we don't have the resources to do it because other species have higher priority.)

1994–2004—Montana fluvial grayling are identified as a "candidate" species facing a low to moderate threat of extinction.

2004—Priority is upgraded.

2003–5—Litigation to list the grayling initiated by the Center for Biological Diversity and the Western Watershed Project.

2005—USFWS agrees to reach a conclusion regarding the grayling's status by 2007.

2007—USFWS determines that listing the Montana fluvial grayling as endangered is not warranted because it does not constitute a species, subspecies or "Distinct Population Segment." After further litigation, USFWS agrees to review the grayling's status again by 2010.

2010—Listing the grayling as endangered is determined to be "warranted but precluded." Again.

I should not have come this far without providing readers with a formal introduction to the fish. Grayling differ substantially from other members of the diverse family of salmon and trout. Their scales are larger, their mouths smaller. Fishing in Alaska, I've often been amazed by a grayling's ability to get that tiny mouth around a streamer meant for salmon ten times its size. While some isolated populations occasionally venture into brackish water, they do not exist in a truly anadromous form like rainbows, brown trout and char. But the adipose fin—the small rubbery protuberance between the back of the dorsal fin and the tail—confirms the grayling's membership in the salmonid family despite these uncharacteristic features of anatomy and behavior.

While beauty may lie in the eye of the beholder, anglers seem nearly unanimous in the opinion that salmon and trout are beautiful fish. The grayling is, too, albeit in subtler ways. Brook trout offer the eye an artist's

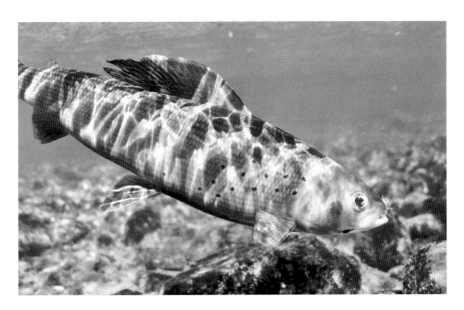

Grayling require cool, clear, evenly flowing water. *Photo by Don and Lori Thomas.*

palette of vivid color. Rainbows are linebackers tough enough to wear pink. Browns come dressed in rich, warm tones of amber and gold. At first glance, the grayling appears—well, gray. But closer inspection reveals a silvery sheen highlighted in shades of lavender best appreciated in indirect sunlight, punctuated with discreet freckles of inky black. And there's nothing in fresh water quite like that dorsal fin when extended, sinuous and rimmed with light, coral-colored hues. Like most exaggerated anatomic features in nature, that fin must have a purpose, which is probably to enhance threat display during competition between males on spawning beds.

Grayling are smaller than most of their relatives. The official world record, from the Northwest Territories, weighed just under 6.0 pounds, and any specimen half that size is a big grayling. The Montana record, from Washtub Lake in Park County, weighed 3.6 pounds, and fluvial grayling from the Big Hole are much smaller. I have eaten grayling under wilderness conditions in Alaska and Siberia where their populations remain untouched and robust, but I've never killed one within hiking distance of a road. I never plan to, either—and certainly not in Montana, where the state has prohibited the retention of grayling since 1988. I find their flesh light and delicate. However, it tastes bland after a meal or two, and if it isn't eaten immediately after the fish is caught, it isn't good for much other than a supplement to whatever is in your backpack. While grayling put up a good scrap on light fly

tackle and sometimes jump acrobatically, they lack the raw power of other trout and char on the end of a line.

Even as a dedicated angler, I consider the personal value of the grayling to be totally unrelated to its status as food or game fish. Grayling are uniquely beautiful, and their presence in a stream indicates a healthy freshwater ecosystem. They are icons of true wilderness, as Montana once was and as much of the grayling's arctic stronghold remains today. Above all, they are a reminder of how easy it is to lose what matters most, and how diligently we will all need to work to keep grayling habitat intact for future generations, of fish and their admirers alike.

Chapter 24

SALMON FLY

Pteronarcys californica

The annual ritual begins with a drive upstream along a river such as the Big Hole, Madison or Yellowstone. You stop the truck, get out and pretend to stretch your legs, but you're really looking out over the water. You may walk down the bank and bend a streamside willow over for inspection. What you see or don't see leads to an earnest discussion with your friends as you plan a strategy. The options are basically threefold: on upstream, back downstream or right here. In the latter case, you start to set up the shuttle, deciding where to launch the driftboat, which rig stays and which one goes back downstream to await you at the end of the day. Simple as this seems, the operation invariably becomes as complicated as planning the D-Day assault on the beaches of Normandy. And half the time you get it wrong no matter how many times you've done it. I thought *you* had the keys…

The object of all this attention is not a grizzly or an endangered species. It's a member of the animal kingdom, class *Insecta*, order *Pleocoptra*, all of which is a fancy way of saying it's a bug. But it's a bug that changes the social, cultural and economic landscape of Montana's upper Missouri drainage in June and early July, and as such, it warrants attention as much as the glamor species described elsewhere in this book.

Readers who aren't fly rod anglers likely won't pay much attention to Montana insect life except to swat an occasional tent-invading mosquito or flee a swarm of wasps after the accidental disturbance of their nest. Most of us just don't think about insects much, and when we do, it's usually to regard them as some form of minor nuisance. That attitude represents a serious underestimation of their importance to the planet and the humans who inhabit it.

Insects make up the largest and most diverse class in the animal kingdom. Biologists have identified roughly 1 million insect species and acknowledge that millions more still await scientific description. In most of their interactions with people, insects assume the role of pests. The problems they pose can be far more significant than the irritating whine of a mosquito, as people have recognized since antiquity. Consider this passage from the Book of Exodus:

> *So Moses stretched out his staff over Egypt, and the LORD made an east wind blow across the land all that day and all that night. By morning the wind had brought the locusts; they invaded all Egypt and settled down in every area of the country in great numbers. Never before had there been such a plague of locusts, nor will there ever be again. They covered all the ground until it was black. They devoured all that was left after the hail—everything growing in the fields and the fruit of the trees. Nothing remained on tree or plant in all the land of Egypt.*

Locusts still devour crops throughout the world. The cotton boll weevil threatened the economy of the antebellum South. Wasp and hornet stings kill more people in the United States every year than all large predators combined. In their role as disease vectors, mosquitoes have killed more humans than all wars put together.

But in the natural world, nothing is either all good or all bad, even from the limited perspective of our own species. So many plants depend on insects for pollination that the entire biosphere would become barren without them. Insects give us honey and silk. They form the base of many important avian and aquatic food chains. They provided Franz Kafka with the central metaphor for his greatest novel. But few appreciate the beauty, diversity, and practical value of insects like the diehard fly-fisher. Nowadays, fly rod anglers cast "flies" meant to imitate everything from squid and crabs to minnows and mice, but they're still called flies. As the sport's very name suggests, its historic origins were all about bugs.

Trout—still the classic fly rod quarry—feed on a wide variety of animal protein sources that vary by habitat. However, most trout feed predominantly on aquatic insects that spend at least part of their life cycle in the water. The entomology of the cold-water environment trout prefer includes terrestrial bugs that wind up there by mistake as well as true aquatic insects, of which three families make up the bulk of a trout's diet in most streams: mayflies, caddisflies and stoneflies. The salmon fly belongs to the latter group.

The name "salmon fly" is misleading in Montana because the rivers that host the best-known hatches lie east of the Continental Divide, where there are no salmon. Some call them willow flies because newly hatched adults often climb onto willows to mature and mate. The proper common name—giant stonefly—is certainly descriptive. The insect's defining morphologic feature is its size, which evidently does matter, at least in this case. However, anglers have been calling these insects salmon flies for so long that I will use that term frequently throughout this chapter.

Fly-fishing for trout usually involves imitating little bugs. In the angling world, insects and their imitations are measured by a standardized system of hook size. Anglers can communicate easily by referring to #12s or #18s (the larger the number, the smaller the size), although non-anglers will likely find that code incomprehensible. Even large mayfly imitations will sit comfortably on a dime. A random sampling from my Montana fly vest shows that almost all of my dry flies (those meant to float on top of the water) are between six and eight millimeters in length. The outliers are patterns meant to imitate the giant stonefly.

The small size of most of the aquatic insects that trout eat makes their imitations challenging to construct and hard to see on the water. A high percentage of my over-forty friends first realized they needed reading glasses while trying to attach a tiny dry fly to a gossamer tippet in failing light. The giant stonefly offers an easy detour around all those difficulties. In both its nymphal and adult form, this oversized bug usually measures between two and three inches in length.

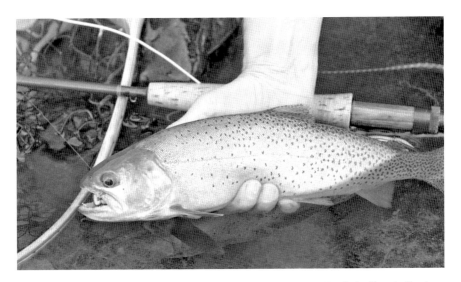

This autumn Yellowstone cutthroat was caught and released on a dry fly in Slough Creek, near Yellowstone Park's northeastern corner. *Photo by Don and Lori Thomas.*

One cannot understand any insect without understanding its life cycle. Let's arbitrarily assume that the egg comes before the chicken as we work our way through the salmon fly's. After lying dormant on the streambed over the winter, a salmon fly egg hatches into a nymph and starts to grow. Dark in color, dressed in a hard exoskeleton and sporting a pair of remarkably long antennae, the nymph will take three years to reach its full size and sexual maturity. There is nothing glamorous about its lifestyle at this point, for a salmon fly nymph is less active than the nymphal form of most aquatic insects. Literally a bottom feeder, it lies in cracks and crevices and eats whatever organic detritus happens to float by. However, because of its size and population density, it is already an important part of the food chain. Salmon fly nymphs make up the majority of the biomass in many trout streams.

As river flow rates increase and water temperatures start to rise during their third spring, nymphs begin to migrate toward shore, where trout and anglers await them. The precise environmental cues that initiate this movement aren't completely understood, but a rise in water temperature above fifty-six degrees Fahrenheit appears to be one important trigger. Finally the mature nymphs crawl ashore, split their confining cases and emerge as mature salmon flies. The hatch takes place at different times on different rivers, from early June on the Big Hole to mid-July on the upper Yellowstone, probably as a result of differences in the rate that water temperature rises in various drainages.

One aspect of the event firmly entrenched in angling lore is that the hatch begins at the lowest level of the river that holds salmon flies and then marches upstream at an orderly rate of a mile or two per day. This explains all the streamside prognostication and whispered observations such as "The flies are at Melrose!" delivered like classified data during the Cold War. As with most broad natural principles, this one is subject to frequent exception. Sometimes the hatch stalls. Sometimes the whole river explodes with salmon flies over the course of a few days. The only reliable way to sort out the confusion is to be there yourself and pay close attention to your surroundings once you are there.

The adult giant stonefly would be an impressive creature independent of its relationship to trout fishing, two and sometimes three inches in length or close to it, with long, active antennae that constantly seem to be searching for messages from outer space. Oriented parallel to the insect's body at rest, the wings lie flat against its back. A dull shade of brown or gray, the wings are diaphanous like a dragonfly's and crisscrossed in an intricate pattern of dark veins. The abdomen is an unmistakable shade of deep orange, and a thin orange collar encircles the neck. Totally harmless to people, they do not bite, sting or scratch. In fact, plucking one off a willow leaf and inviting it to

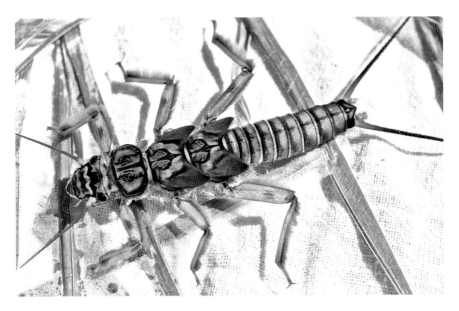

Common stonefly nymph, *Calineuria californica*, from the Blackfoot River. *Photo by Bob Hendricks.*

crawl up your finger may make you want to take it home as a pet. Salmon flies are reportedly palatable to people as well as trout, and downing one has become a rite of passage for anglers new to the hatch. Unfortunately, the volume of beer that invariably precedes this ritual makes most of the taste reports that follow scientifically unreliable, including my own.

Adult stoneflies lead a brief existence. Once they've emerged from their nymphal exoskeletons, adults usually climb onto a streamside willow to dry their wings. After copulating onshore, the gravid females fly over the water to deposit their eggs and begin the cycle anew. Like most aquatic insects, they intuitively fly upstream. Otherwise, over the course of generations, relentless current flow would sweep the entire population downstream to oblivion. At the peak of the hatch, the sight of all these gigantic insects crowding the airspace over one of Montana's Blue Ribbon trout streams can be arresting even for those who care nothing about fly-fishing for trout. Bulky and ponderous, salmon flies don't appear particularly comfortable in the air. They always seem to be losing altitude involuntarily as they descend toward the water, like an airplane with a balky engine, and they demonstrate little ability to handle a crosswind. Inevitably bug and current collide, but since the flight's mission was always to get stonefly eggs in the water to begin the life cycle again, these crash landings represent biological successes rather than

aeronautical failures. Watching these doomed bugs reminds me of Act V in a Shakespearean tragedy whose script requires everyone to die by curtain fall.

Whenever natural events concentrate a food source, an assortment of predators and scavengers can be expected to arrive in response to the easy pickings. Alaska salmon streams are a prime example, but the salmon fly hatch demonstrates the same phenomenon on a smaller scale. At the peak of the hatch, a broad sample of Montana's insectivorous birdlife can be found along the banks and in the air over the water. Brilliantly colored western tanagers like to pick a favorite branch near the edge of the stream and make brief, darting flights to pluck adult salmon flies from the air even though the bug seems several sizes too big for the bird. Trout—browns, rainbows and cutthroats—concentrate along the banks, effectively turning a big river like the Yellowstone into two small trout streams running parallel and separated by fifty yards of open water. The strategic advantage this phenomenon provides is well known to fishermen of many kinds, from ospreys and mink to visitors from afar armed with thousand-dollar fly rods.

For fly rod anglers, the salmon fly hatch may well be the country's best-known happening. Despite the wide distribution of the insect around the West, Montana stands at the cultural epicenter of the event. Biologic marvels that these huge flies are, most Montanans wouldn't know much about them if not for their importance in the fly-fishing community. To appreciate the salmon fly as a social phenomenon, one must understand the fishing itself.

In larger Montana streams, most big trout feed predominantly below the surface, on nymphs, sculpins and other trout. Because of their size and the amount of nutrition they provide in a single bite, adult salmon flies are one of the few forms of trout food that can coax big fish up to feed on the surface. Most fly rod anglers would rather fish with dry flies than anything else even when that concedes the opportunity to catch large fish. The legendary status of the salmon fly hatch derives from the rare exception to these rules it provides.

Decades of experience have taught me that on any given day, even at what appears to be the perfect place at the perfect time, fishing the salmon fly hatch is unlikely to live up to its advance billing. Occasionally, though, it can exceed the wildest expectations. The trick is to wait patiently for those days while enjoying the rest for the sheer spectacle they provide—the bugs and the wildlife they attract, the scenery and the anglers in all their often incompetent glory. This is not the place to enjoy a wilderness Montana experience, but the people-watching can rival an evening spent at a sidewalk bistro in Buenos Aires or Montreal.

In the outdoors, I don't often focus my observations on people. When I do, I might as well have a fly rod in my hand.

Chapter 25

BULL TROUT

Salvelinus confluentus

The time: late summer sometime in the 1950s—the calendar specifics are now long forgotten. The place: the northern reaches of Glacier National Park, at the end of a long, little-traveled gravel road. The sun still lay hidden behind the towering peaks to the east of the lake, and the early morning chill secretly made me long to accept the hat and gloves my mother tried to make me wear, although I was too stubborn to do so. There was no arguing with my father on the subject of life jackets, though, and even though I was an exceptionally strong swimmer for my age, I donned the bulky orange vest without protest. Then my father and I each grabbed a thwart, and we slid the Grumman aluminum canoe down the beach to the waterline with my father doing most of the sliding. As my mother and younger brother waved goodbye, we began to paddle across the mirrored surface of the lake, headed for a distant destination neither of us had visited before.

Mementos of glaciers retreating at the end of the last ice age, Glacier's major lakes are all long and lean, generally oriented along an axis running northeast and southwest. An experienced woodsman and canoeist, my father respected the potential of a rapidly rising wind, and we hugged the shoreline all morning even though there wasn't a ripple on the water. Although I was old enough to appreciate the beauty of our natural surroundings, I wasn't old enough to avoid repeatedly asking *Are we there yet?* questions even when we were still hours shy of our destination. But finally trees replaced the apparently endless expanse of water ahead, and then we *were* there.

I still remember feeling tired and hungry as we beached the canoe, but my father was wise enough to prime my pump with a peanut butter sandwich before we broke out our fly rods. The stream feeding the lake—which shall remain nameless in accordance with previously established principle—was small, but we'd caught plenty of cutthroats from smaller water during the course of the previous week. I was about to start upstream toward an inviting riffle when my father whistled for my attention back by the canoe. His eyes had spotted something I had overlooked in my haste—long dark shapes finning just above the gravel where the stream's current faltered and dropped off into the clear blue depths of the lake beyond.

I didn't know what they were, but the fish looked larger than any of the cutthroats we'd caught recently. My father graciously ceded the lie to me and suggested that I make a quartering cast across the dying current with a Wooly Worm. The water was so clear that I could easily watch the weighted fly tumble across the gravel before tension from the line began to make it swing. Then one of the lurking shapes turned and struck.

Unaccustomed to five-pound trout, I felt lucky to land it. But the inlet was free of obstructions, and once the fish was hooked, I probably couldn't have lost it if I'd tried. Soon it was lying in the shallows at our feet, leaving just one big question unanswered: what was it?

We were still easterners then, with little knowledge of fish west of the Mississippi. At first glance, the fish looked like a familiar brook trout, but I knew that it wasn't. To my dismay, my father didn't know quite what it was either. After some head scratching, he declared it to be a Dolly Varden, and he was right—at the time. The error wasn't his fault, since during the 1950s any biologist in the state would have given the same answer. The fish I'd just caught didn't officially become a bull trout until twenty-five years later.

To further the confusion, bull trout aren't even trout. Along with brook trout, lake trout, arctic char and Dolly Vardens, they are char, a closely related salmonid family technically differentiated from true trout by the absence of teeth on the palette. For those not interested in performing dental examinations on fish, char generally have dark bodies with light spots while trout have light bodies with dark spots. The distinction between Dolly Vardens and arctic char is particularly difficult but irrelevant here since neither species is native to Montana. And bull trout are so similar to Dollies that they were not formally recognized as a distinct species until 1980.

Bull trout can be distinguished from Dolly Vardens by their larger heads and more prominent kypes (the exaggerated hooked jaw that male salmonids develop prior to spawning). The bull trout's common name derives from the

exaggerated proportions of their heads and mouths. Practically, they are best distinguished by range since Dollies are generally a coastal species. This rule is not infallible though, as southern Washington State is home to a small coastal population of bull trout that out-migrates to salt water. Bull trout and lake trout are Montana's only native char, although brook trout have been widely introduced from the East.

Montana is near the southern end of the bull trout's current range, which extends south from northern British Columbia to Oregon and Idaho. Except in Alberta, the species is confined to the west side of the Continental Divide, including Montana's Clark's Fork and Flathead drainages. Like the grayling, bull trout exist in both adfluvial (lake resident) and fluvial (stream resident) populations. Lake residents make long fall spawning runs upstream that sometimes exceed one hundred miles in length. Even fluvial bull trout travel considerable distances according to water conditions, food supplies and spawning requirements. The need for long, contiguous stretches of suitable river habitat is one important reason why bull trout populations are facing serious decline as discussed below.

A long, contiguous stretch of suitable river for bull trout, seen from the Going to the Sun Road in Glacier National Park. *Photo by Ken Lund.*

Middle Fork of Flathead. *National Park Service photo by Tim Rains.*

Bull trout are striking in appearance, especially when males have acquired their vivid fall spawning colors. Like their relatives the brook trout, they have sharply demarcated white leading edges on their pectoral fins. Yellow and crimson spots contrast against dark flanks, which can turn deep red during the fall. They are big fish by freshwater salmonid standards. Resident Flathead Lake fish can exceed twenty pounds, and the Montana state record, taken from an unrecorded location in 1916, weighed twenty-five pounds. Specimens over thirty pounds have been recorded elsewhere. (Lake resident fish are usually much larger than those from fluvial populations.) Mature bull trout are aggressive predators that feed almost entirely on other fish.

Despite their tough guy appearance and behavior, bull trout have rigid habitat requirements that make them a sensitive water-quality indicator species. They do not tolerate water temperatures above sixty degrees Fahrenheit at any time. Water temperature is especially crucial during spawning, and reproductive success is greatest with temperatures as low as thirty-six degrees Fahrenheit. Smooth, porous gravel is also crucial, and even small amounts of sediment will prevent successful spawning. Stream resident bull trout require a variety of aquatic habitat with deep pools and complex underwater structure, including woody debris to provide shelter and reservoirs of cold water during the summer. As noted earlier, isolated areas of suitable habitat are not adequate for bull trout because of the distances they routinely travel, especially prior to

The bull trout were then released back into the wild. *U.S. Fish & Wildlife Service Mountain-Prairie photo by Shannon Downey.*

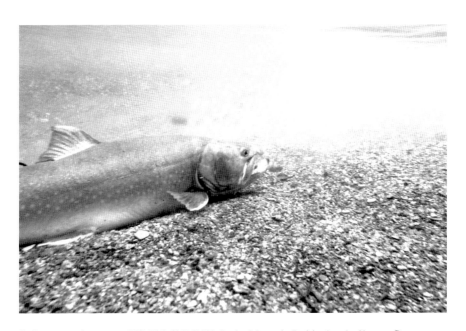

Bull trout under water. *U.S. Fish & Wildlife Service Mountain Prairie photo by Shannon Downey.*

spawning. All these factors make bull trout particularly vulnerable to many forms of human development. Logging, irrigation, streamside grazing and impoundment have all led to impaired reproduction and geographic isolation of surviving bull trout populations.

Habitat degradation is just one component of the bull trout's chronic conflict with people. Because of its aggressive piscivorous feeding habits, the bull trout was once considered an unwanted threat to more desirable fish. In decades past, Montana fisheries agencies deliberately tried to reduce bull trout populations through bounties and programs of commercial netting. Furthermore, bull trout hybridize with introduced brook trout where the two species overlap, producing sterile offspring that compete with native fish.

Montana is home to more than half of the country's surviving bull trout population, and the state has taken a leading role in reversing its decline. Instead of encouraging their take as they once did, Montana angling regulations now sharply restrict angling for bull trout. The Montana Department of Fish, Wildlife and Parks has initiated an aggressive public education program to help anglers identify bull trout and prevent their accidental retention. In 1993, the state began its own recovery program, which includes limitations on logging and grazing in riparian corridors on state lands adjacent to bull trout habitat. The USFWS listed the bull trout as threatened in 1999, and a Final Recovery Plan is due in September 2015.

<center>—◦◦◦—</center>

And that is the story of the fish I unwittingly caught all those years ago. I haven't seen much of the bull trout since, partly because I live a long way from bull trout country and partly because of a sense that they are better off left alone even in water where it is legal to catch and release them. Like the grayling and the sage-grouse, the bull trout serves as the canary in the coalmine, telling us what we are doing right and what we are doing wrong in the waters it inhabits. Important as an individual bull trout may be in its own right, it may be even more important as a measure of our collective environmental conscience.

THE TOP OF THE FOOD CHAIN

Chapter 26

MOUNTAIN LION

Puma concolor

*T*he cougar's "blood-curdling scream" is one of those clichés best interred with the grizzly's "razor-sharp claws" and similar snippets of hackneyed outdoor prose, but if blood could curdle and a scream could make it happen, this would have been the one that did it. The screeching sounded like a young woman being killed brutally, and it went on for a long, long time. I'd never heard any sound like it, not on the Alaska tundra, not in Australia's Outback, not in the wilds of the Kalahari or the remote Siberian taiga. The irony is that it woke me from a sound sleep while I was snoring away in bed at my own Montana home.

I'd had plenty of experience with cougars by then and should have recognized the source of the noise instantly. But while I'd heard cougars snap, growl and hiss, I'd never heard one scream. Until you have, it's impossible to imagine the volume and quality of the sound, let alone the primitive fight-or-flight response it awakens deep in the human brain. (The roar of an African lion arouses a similar instinctive response, although the quality of the sound is totally different.) But I finally figured it out, and soon I was sitting on the edge of the bed trying to plot a range and bearing to the cat's location in the coulee on the west side of our house.

By this time, the dogs had cut loose with a chorus of howls from the kennel, and Lori and I had instinctively placed an arm around each other's shoulders. I glanced at the clock glowing from the bedside table. Dawn was less than two hours away. We climbed back in bed and waited for morning, although I don't think either of us enjoyed a moment's sleep even after the racket finally subsided.

Most readers have likely never seen a mountain lion in its natural environment. Even in good habitat at carrying capacity, lions are sparsely distributed. Shy and reclusive, they move mostly at night. However, not seeing mountain lions does not mean lions aren't there. I've spotted over a dozen cougars while engaged in activities that had nothing to do with mountain lions, which is a lot more than most people, including others who live in the heart of lion country. I've also treed countless dozens of them with my hounds. The interesting point is that even after this considerable body of experience, I have never lost my sense of wonder at the sight of a mountain lion in the wild.

With good reason—the mountain lion is a magnificent animal unlike any other. Of the New World's dozen wild felids, only the jaguar is larger. All cats' ancestors originated in Asia around 11 million years ago. Like wild sheep, elk and grizzlies, cougars arrived in North America by crossing the Bering Sea land bridge. From there, they became one of the few cold-adapted species to disperse across the Panamanian isthmus into South America. Some scientists theorize that the original North American population of lions disappeared during the great Pleistocene die-off of large mammals and was then replaced by cats migrating back northward from South America. Mountain lions adapt to a wide variety of habitats from sub-arctic to desert and jungle, and their current range from the Yukon to Patagonia is the largest of any large terrestrial mammal in the New World.

The number of common names an animal goes by reflects the breadth of its interface with human beings, by which standard the mountain lion stands in a class by itself. In fact, it holds the Guinness record as the animal with the greatest number of names. Mountain lion, cougar, puma, catamount, panther, wildcat, painter—in this chapter, I'll refer to them as mountain lions or cougars because that's what most people in my corner of the world call them. The term "mountain lion" first appeared in the diary of Coloradoan George Jackson in 1858. "Cougar" appears to be an Anglicization of the old Portuguese *cucuarana*, in turn derived from an indigenous Tupi term meaning "the color of a deer." "Puma," which first appeared in English writing in 1777, derives from a Spanish corruption of the indigenous Quechua word for "powerful." In such ways does language confirm the adaptability of the species.

Slender but powerfully built, adult males are about eight feet long from the nose to the tip of the tail, females a foot shorter. About a third of that length lies in the tail itself, and that's almost always the anatomic feature

startled observers note first. When I had hounds, I frequently received calls from local residents who were frightened because they'd just seen a lion in their backyard or pasture. "Jeez, the tail on that thing must have been six feet long," was usually all the information I could get from them until they'd calmed down. Every anatomic feature in nature is there for a reason, but the purpose of the lion's long tail baffled me for years. Then one day I watched a treed cat bail out of the top of a tall ponderosa and sail right over my head on its way down a cliff behind me. The cat was obviously using its tail to stabilize its glide path, an observation I've subsequently repeated several times. Cougars also reportedly use their tails as counterweights while spinning quickly during attacks on prey, although I have never personally witnessed this phenomenon.

Unverified estimates of lions' weights often turn into fish stories that suffer from what's known in the trade as "ground shrinkage." Lion size varies with location and illustrates Bergmann's Rule, which holds that within any species, the size of individuals will increase with increasing distance from the equator. A typical mature Montana tom will weigh 130 to 140 pounds, a female around 90. Most specimens I've seen from Texas and Latin America look like housecats in comparison. Every few years, I hear about a 200-pound lion locally, but none of those reports has ever survived scrutiny from a scale. A few that size are probably running around the woods somewhere, but they are few and far between.

The objective specifications don't tell the story anyway. Your first good look at a mountain lion will take your breath away, even if the animal is an eighty-pound female. An aura of grace, power and dignity usually dominates first impressions. Once you start to look closer, you can begin to appreciate what a perfectly engineered predator a mountain lion really is.

Form derives from function, and understanding the way a lion hunts helps explain the way the cat is put together. In contrast to canines, which hunt in packs, have a keen sense of smell and rely on stamina to run their prey down over distance, lions are solitary ambush hunters capable of moving very quickly—but not for long. Since they have to kill without help, they're built to pounce, hang on and seal the deal without delay. Their powerful forelegs make them look like oversized housecats that have spent a lot of time at the gym, with some performance-enhancing drugs thrown in for good measure. Built to grasp, their front feet are broad, with sharply pointed claws that can dig in and keep the cat on top of a struggling elk eight times its size, a prey to predator weight ratio unmatched by any other wild felid. In proportion to their body size, their hind legs are the longest of any cat, allowing them

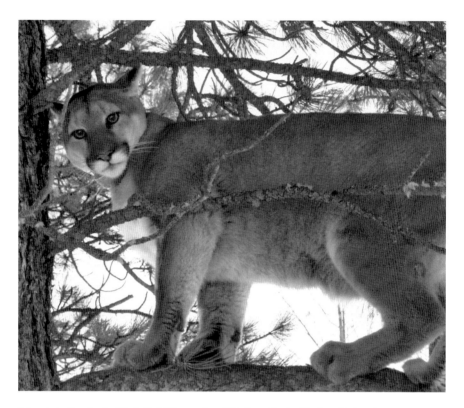

Mountain lion in the Little Belt Mountains. *U.S. Forest Service Northern Region photo.*

to cover up to forty-five feet in a single horizontal leap. The jaws may not be as powerful as a grizzly's, but they're powerful enough, with teeth that can penetrate even a large ungulate's spine. The lion will usually administer the *coup de grace* in one of two ways: by reaching forward with one paw, sinking its claws into the victim's muzzle and twisting its neck backward until it breaks or by driving its teeth into the back of the neck to sever the spinal cord. A cougar's fangs are ideally shaped to slide into the soft spot between the vertebrae in the neck of an elk or deer.

Common myth holds that lions kill only young, sick or weakened members of prey species. While they certainly will do so, I have examined many lion-killed deer and elk that appeared to have been healthy, mature animals until they encountered the cat that took them down. Cougars will kill what they can catch. Mountain lions only rarely eat carrion and usually abandon their kills in a matter of days. A female with kittens will kill around one deer per week and sometimes more often when local habitat conditions warrant.

Above: A "scratch" left by a male cougar marking its territory. *Photo by Don and Lori Thomas.*

Right: I found no evidence that this young buck was anything but healthy prior to its meeting with the lion that killed it. *Photo by Don and Lori Thomas.*

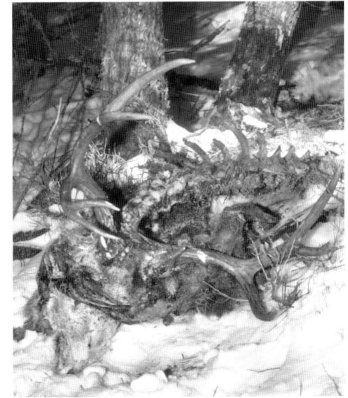

I never carried a firearm back when I was tracking mountain lions on foot. It was sobering to realize that even a ninety-pound female could turn around and kill my hounds anytime she felt like it, but none ever did. Contrary to popular misconception, fights of any kind between cougars and hounds on their trail are rare. Much of this reluctance to engage derives from the historic relationship between cats and dogs—in the lions' case, the gray wolves that share much of their range. Tough as a grown lion is, it's no match for a pack of wolves. In areas where the two species' ranges overlap, wolves displace lions from around half of their kills. Lions are instinctively programmed to run up a tree rather than turn and fight when they become the prey rather than the predator. This leads to one of the most intriguing questions of all: why do some lions occasionally attack and kill human beings?

The good news is that such attacks are rare events. Between 1890 and 1990, fifty-three mountain lion attacks were documented in the United States and Canada, of which ten led to human fatalities. Between 1990 and 2004, however, an additional thirty-three attacks, with ten more fatalities, took place. Simple math confirms a substantial increase in the frequency of lion attacks. One obvious explanation is that more people are spending more time in lion country. That's certainly true in Montana, given the increasing popularity of outdoor recreation and the extension of suburban developments into prime lion habitat. Lion numbers also appear to be increasing in many areas, and their range is expanding for a variety of reasons. Reporting of attacks has also improved since the early twentieth century. But investigation of most of these events still doesn't produce a clear explanation why an individual cat suddenly decided to try to kill a human rather than a deer. Game numbers are currently high throughout most of the lion's range, and very few of the attacking cats that were eventually killed showed signs of malnutrition or injury.

I've lived with lions in my backyard—literally—for nearly forty years. Much as I respect them, I don't worry much about them, partly because I've had so much experience with lions and one always fears most what one doesn't know. I also recognize that I'm statistically more likely to be killed by a horse or a domestic dog than a mountain lion or any other large, wild North American predator. However, children are clearly overrepresented as victims in mountain lion attacks, and when our kids played outside while they were young I always had them take one of the dogs with them. Other than an outdoorsman's intuitive awareness of surroundings, that was about my only concession to personal safety in lion country.

Nonetheless, visitors to Montana should be aware that mountain lions inhabit the whole state, and they should take appropriate precautions. Hike in groups—most lion attacks are directed at solitary people. Don't let children wander off on their own. If you see a lion, don't panic. The chance of an encounter turning into an attack is remote. Do not run. You can't outrun a cougar, and flight can trigger an instinctive predatory response. Stand up, shout and look big. Carry pepper spray. The ability of pepper spray to deter an attack isn't nearly as well documented for lions as for bears, but it still seems a reasonable means of self-defense. Above all, don't worry about lions so much that you can't appreciate your surroundings. Cougar habitat is some of the most beautiful country on the continent.

Fifty years ago, the range of the mountain lion in the United States had contracted more than that of any other predator profiled here, including the wolf and the grizzly, largely because it was more extensive in the first place. At the time of European contact, lions were plentiful throughout New England, the Midwest and the South. As their natural prey began to disappear as part of the overall decline in North American wildlife populations during the nineteenth century, the cats turned their attention to domestic livestock by default. In response, most states enacted bounty programs on lions. By 1850, cougars were rare east of the Mississippi, but a few stragglers held out. The extirpation of the mountain lion can be tracked by the dates the last cat was killed in various states: Ohio, 1845; Illinois, 1855; Massachusetts, 1858; Iowa, 1867; Vermont, 1881; Nebraska, 1890; Pennsylvania, 1891; Kansas, 1904; and so on. By the early twentieth century, with the exception of the genetically isolated Florida panther, the range of the mountain lion was confined to remote areas in our Mountain West and Southwestern deserts, leading to the artificial perception of cougars as a "western" species.

The mountain lions' survival here in the West did not reflect more enlightened attitudes toward the role of large predators in healthy ecosystems. The cats simply had better places to hide. Nonetheless, early westerners did their best in deed and rhetoric to eliminate them. Consider this excerpt from an 1849 Oregon statute:

> *Be it enacted by the Legislative Assembly of the Territory of Oregon; that there shall be paid out of the county treasury of the proper county on the*

order of the county commissioners to any person who shall...present to said court, the scalp of any panther, tiger, cougar, lynx, wild-cat...the following premiums...for each panther, the sum of three dollars; for each tiger, the sum of three dollars; for each cougar, the sum of three dollars; for each lynx, the sum of three dollars.

The nature of Oregon's perceived "tiger" problem remains a biological mystery.

Not everyone considered such state bounties sufficient. Although Colorado authorized a bounty on lions shortly after statehood, the *Denver Post* offered its own twenty-five-dollar cougar bounty privately, explained as follows: "It is the duty of every true Coloradan to do his best to rid the state of these beasts which kill so much game. By no other means than the hunting out of the mountain lion and killing them can the game be protected." (Colorado's lion bounty was revoked in 1965, with the support of the *Denver Post*.)

The vitriol sometimes rose to remarkable levels. In a 1914 presentation at Yale, noted outdoorsman and biologist William Hornaday observed as follows (in his capacity as president of the Permanent Wildlife Protection Agency, no less): "The eradication of the puma from certain districts it now infests to a remarkable degree is a task of immediate urgency...We consider firearms, dogs, traps, and strychnine thoroughly legitimate weapons of destruction for such animals, no half way [*sic*] measures will suffice."

Attitudes started to change during the twentieth century, in no small measure because sportsmen began to regard the lion as a game animal rather than a varmint. No one articulated this change in perception better than Aldo Leopold as he was founding the country's first department of wildlife management at the University of Wisconsin. A timeline of the lion's status in Montana runs as follows:

1903—Montana classified mountain lions as a "bountied predator."

1940s—A mountain lion commands a twenty-five-dollar bounty.

1963—Montana ends its lion bounty after nearly two thousand dead cats have been turned in over the life of the program. The lion is classified as a "predator," with no bounty but no regulatory protection.

1971—Montana re-classifies the lion as a game animal and establishes a regulated hunting season.

Today, Montana's Department of Fish, Wildlife and Parks manages mountain lions as carefully as any animal in the state, establishing a quota in separate districts stretching from the eastern prairies to the Idaho border. Male and female sub-quotas exist in most of these districts. A few additional

"problem" cats are killed by game wardens every year because of aggressive behavior or habitual presence near people or livestock.

The goal of this program is a sustainable population of mountain lions. Despite all the difficulties involved in the scientific management of any wildlife species, especially one as difficult to survey as the mountain lion, Montana's current approach to its lions appears to be meeting that goal. Of course, not everyone is happy. Some Montanans feel that none of our lions should ever be intentionally killed, while others would still like to shoot them all.

Meanwhile, the lion is making a successful under-the-radar attempt to repopulate its original range all on its own. Paradoxically, the mountain lion's most significant predator is not the human hunter but other mountain lions. Adult males frequently kill cubs and drive younger males from their established territories, turning them into wanderers. While sporadic reports of cougars in unlikely places often turn out to have nothing to do with cougars, creditable evidence of cougars has surfaced recently in Michigan, Illinois, South Dakota, Wisconsin, Indiana, Iowa and Connecticut, among other places. Most of these individual cats have been young males, and their presence does not confirm a breeding population. It's still hard to avoid the impression that the cats are trying to make it back to where they started.

<div align="center">━━━━━◦◦◦◦◦━━━━━</div>

The day after the screaming cat awakened us from our sleep broke cool and clear. After dressing for the winter weather, I walked down into the coulee and began to study the sign in the day-old snow. It didn't take me long to cut the track of a mature female mountain lion.

I followed the cat's trail up out of the coulee, across our fields and into an even more complicated coulee system to the east. Chatter from a gathering of magpies and ravens alerted me to the presence of what I'd expected to find all along: a dead whitetail deer, partially eaten and covered in pine needle duff scratched up from the forest floor. An absolute riot of lion tracks surrounded the kill. After repeated circling, I finally identified the female's track heading east, accompanied by what appeared to be several sub-adults. Given the cat's raucous behavior the night before, I expected to find evidence of a mature tom that was either trying to breed the female, displace her from the food source or kill the young, but I never did. Curiosity aroused, I walked back up the hill to get my pack, my camera and a hound.

Several hours later, I stood staring up into the ponderosa canopy at a quartet of mountain lions that looked like decorations hanging from Christmas trees. The youngsters all looked like healthy two- or three-year-olds, and I couldn't explain why they were still accompanying their presumptive mother. Although cats are predominantly solitary save for females with young cubs, I've run into all kinds of strange mountain lion groups over the years. After taking a few pictures, I leashed the dog and started to lead her up the hill toward home, bawling in protest.

Although we live in a rural setting, we do have neighbors scattered around the area, some of whom had kids and—almost as important in Montana—livestock. Once word of the cats got around, several of them chided me for not calling the game warden to dispose of the cats or invoking the historical local attitude toward predators myself: shoot, shovel and shut up. But I had no problem with cougars in my backyard then, and I don't now.

The truth is that I enjoy knowing I live in lion country.

Chapter 27

BLACK BEAR

Ursus americanus

*I*had just spent a week guiding a hunter in the foothills of the Alaska Range. We were tired, and thanks largely to his decision to limit his means of take to a traditional bow, the meat pole was empty. After rounding up some gear prior to flying out the following morning, we retired to the crude shelter we'd been using as a makeshift kitchen two hundred yards downhill from our sleeping tent. My guest was a highly experienced woodsman, but he was from New Zealand and had never seen a bear before his arrival in camp.

Standing with my back toward the entrance to the shelter, I was preparing to cook the last of the bacon we'd cached earlier. My hunter was sitting facing me. Suddenly his eyes grew wide and a look of shock spread across his face. I immediately understood what was happening and turned around just in time to see the hindquarters of a large male black bear disappearing through the opening behind me. The shelter was small, and we later calculated that at one point the animal's muzzle couldn't have been more than a foot away from my backside.

We were unarmed at the time. Convinced that we hadn't seen the last of the bear, we sprinted back uphill where my hunter had left his bow. While he rounded up his archery tackle, I retrieved the only firearm in camp, a fellow guide's handgun I'd brought along almost as an afterthought. While I can safely call myself a good shot with a bow, rifle and shotgun, I only shoot a handgun about once every twenty years and have little confidence in my ability with one.

While my hunter bolted his takedown bow together and rounded up some arrows, I headed back downhill to the cooking shelter, where I immediately sensed that something looked different. The bacon was gone, even though I'd been away for only a matter of minutes. This was hardly the first time I'd had my pocket picked by a marauding black bear, and I knew it wouldn't be the last.

The post hoc analysis of unwanted encounters between bears and people usually focuses on what those people should have done differently. That's a useful exercise, and in many cases, it seems obvious that the event was due to unwise human behavior. In this case, we had kept a clean camp throughout our stay and handled our food safely. The bear was a large, well-nourished adult with no apparent reason to behave aggressively except that it could. With the nearest village nearly one hundred miles away, we were likely the first people this bear had ever seen, and the animal was certainly not habituated to humans as a food source. One can argue that we could have provisioned with something less attractive to bears than bacon, but I have learned that if you plan to spend a week hiking and climbing in rugged terrain, you had better not rely on freeze-dried camp fare alone to keep you going. The only thing we could have done differently was to stay out of bear country, and I'm simply not willing to do that.

By the time we took off the following morning, all parties to this event were alive and well, even though my hunter and I had spent some time with the bear *inside* our cook tent with us when it returned for a second course. That's another story for another time. The purpose of this anecdote is to illustrate the unpredictable and sometimes contradictory nature of the black bear—ordinarily a shy and retiring animal that few people even see but occasionally capable of behavior that can become aggressive or outright dangerous.

The black bear is called *Ursus americanus* for a reason. Its genes diverged from an ancestor shared by the Eurasian grizzly 5 million years ago. The black bear became the black bear right here in North America, the only place on Earth the species inhabits. The world's most numerous bear, its population exceeds that of all other ursine species combined. A highly adaptable animal, the black bear outlived two other New World bears that appear in the fossil record, the short-faced bear and the Florida

spectacled bear, probably because of its ability to utilize a broader range of food sources.

Scientists currently recognize sixteen subspecies of black bear, most of which are similar in appearance and distinguished primarily by range. However, two are quite distinctive. The glacier bear (*U. a. emonsii*), which occupies a limited area on the coast of Alaska's Prince William Sound, has long, silvery guard hairs that make it appear blue at a distance. The Kermode bear (*U. a. kermodei*) lives on the British Columbia coast. About 10 percent of these bears have striking cream-colored coats, although they are not true albinos. No wonder coastal native peoples call them "Spirit Bears."

While neither of these exotic-looking forms occurs in Montana, our bears do offer a number of variations on the basic black the species usually wears. In Alaska, virtually all black bears are black, although occasional individuals have a white "V" on the front of their chest. After observing hundreds, if not thousands, of them I've seen just one with a dark brown coat, and the local bear biologist didn't believe me when I reported it. In Montana, however, as many as half of all black

While this large male black bear is the color its name suggests, many Montana specimens have coats in various shades of red, brown and cinnamon. *Photo by Don and Lori Thomas.*

Montana black bears often come in colors other than black. *Photo by Don and Lori Thomas.*

bears have "color phase" coats in something other than black, including various shades of dark brown, blond and cinnamon. (Some consider the cinnamon bear a separate subspecies.) One spring day, I was glassing areas of green beneath the retreating snow line in a nearby mountain range when I spotted a sow I can only describe as platinum blonde (the two cubs accompanying her were brown). That was certainly the most striking-looking black bear I've ever seen. These multiple color variations assume practical importance in the distinction between black bears and grizzlies, a topic we'll review in the following chapter. Suffice it to say here that relying on color coat to tell the two species apart can be highly unreliable, especially in Montana, where so many black bears aren't black.

The differential distribution of color-phase coats between black bears in Montana and their coastal relatives likely reflects a variation on yet another eponymic biological principle: Gloger's Rule. In 1833, zoologist Constantin Gloger postulated that within any given warm-blooded species, individuals inhabiting humid environments tended to have darker coats than those inhabiting arid terrain. In birds, this phenomenon arises because dark feathers are more resistant than light feathers to degradation by certain

bacteria associated with high humidity. The mechanism is more obscure in the case of mammals, but black bears certainly seem to follow the rule.

Familiar with black bears on the East Coast, where color phases are rare, Meriwether Lewis himself felt some confusion on this subject. On May 31, 1806, he wrote:

> [The Indians]… *said they* [black bears] *climbed trees, had shorter nails and were not vicious, that they could pursue them with safety; they also affirmed that they were much smaller than the white bear…That the uniform reddish brown black &c of this neighborhood are a species distinct from our black bear and from those of the Pacific coast.*

Black bears vary considerably in size, depending on season, location, diet, sex and other factors. Sows are usually around 30 percent smaller than boars. Bergmann's Rule, introduced in the last chapter, applies to black bears, and northern bears are generally larger than those farther south. Weight varies considerably between the time bears emerge from hibernation in the spring and the time they den again in the fall after packing on fat stores in anticipation of the winter ahead, often by an increase of up to 30 percent. Many of the largest black bears in the world come from coastal Alaska, likely due to a combination of genetics and a summer diet rich in abundant salmon. Montana black bears are generally intermediate in size, with pre-hibernation boars typically weighing around 250 pounds. However, outliers weighing 500 pounds or more appear from time to time almost everywhere across the black bear's wide range in North America, including Montana.

The black bear's capacity to adapt to many habitats and to human presence arises from its ability to do many things well. Like all bears, its sense of smell is exceptional, and it uses its nose constantly both to avoid predators and to locate food sources (like bacon). Its eyes and ears are both underrated. While black bears sometimes appear to ignore visual cues, they actually see quite well. Based on numerous close-range encounters, it is my impression that, in contrast to ungulates, they simply become too preoccupied when they are feeding to look around much, especially when they are moving into the wind, which they trust more than they trust their vision. But they are always listening. One time in coastal Alaska I was easing slowly up a narrow stream toward a black bear, using the current's babble to mask the sound of my approach. Several times the bear threw its head up in the air and looked around for reasons I could not understand. I finally realized that the bear

was hearing the change of pitch in the water flowing around my boots as I eased my feet between areas of different water depths.

Black bears swim well, an important skill when they are feeding on fish. They are excellent climbers, and they employ this talent both to feed on fruits and buds and to avoid predators. Black bear cubs can climb almost as soon as they leave the den. If you stumble upon a sow with cubs, the sow's first response will likely be to "woof" her cubs up the nearest tree before beginning an impressive threat display on the ground. This is the time for a slow, measured retreat, while you hope the threat doesn't turn into the real thing. It almost never does as long as the cubs remain safe overhead.

Another notable black bear talent is the ability to locate and consume food of almost any kind. True omnivores are surprisingly rare among mammals, but the black bear's ability to thrive on a wide variety of vegetation, meat, fish and carrion allows it to occupy a variety of habitat niches and make the most of the narrow time window between periods of hibernation. After emerging from their dens in the spring (usually in late April or early May), black bears feed preferentially on forbs and grasses while their digestive tracts recover from months of inertia in the den. In Montana, that often means following the retreating snowline up south-facing mountainsides. Bears will also capitalize on the carcasses of winter-killed animals. Leaves, grass and berries then predominate in the bears' summer diet, supplemented by whatever else they can find, including ants, bees, grubs and honey. Their fondness for the latter is well known and often leads to devastation of beekeepers' hard work. Fish is not nearly as important to Montana black bears as it is to their cousins living near salmon streams along the coast, but they will still eat fish when they are available, as when cutthroat trout are spawning in streams draining into Yellowstone Lake (see chapter 20).

As autumn begins, bears, both black and grizzly, enter a period of behavior called hyperphagia, during which they feed almost constantly in order to maximize fat reserves prior to hibernation. In Montana, huckleberries, chokecherries and Oregon grape are important fall food sources. Bears have a remarkable ability to key in on whatever is in season and abundant, even if that means travel or change in elevation. They will not be randomly distributed, and where you find one, you will likely find more.

While black bears do not share the grizzly's reputation as an aggressive predator, they kill more large mammals than many people realize. Ever the opportunist, the black bear tends to focus its predatory efforts on the young, the old and the ailing, although it has occasionally been documented killing healthy adults of virtually every ungulate species within its range. In Alaska,

black bears will often single out a pregnant cow moose in the spring, follow her patiently until she calves and swoop in quickly to grab the newborn. I once watched a cow moose successfully defend her wobbly calf from a black bear in my front yard on the Kenai Peninsula, an area that has one of the highest black bear population densities in the world. Field studies show that nearly half of all moose calves born there are killed during their first week of life—not by wolves or grizzlies but by black bears.

While black bears occupy habitats ranging from coastal beaches and tide flats to arid canyon rims in the southwest, they are most often associated with

A black bear eating seasonal berries. *Photo by Harvey Barrison.*

forested areas all across their wide range. This is certainly true in Montana, where the highest concentrations of black bears occupy densely wooded mountains in the northwestern corner of the state. However, their range extends well into open country east of the Continental Divide, where a recent population study revealed far more black bears than anyone expected.

One September day, I was studying a herd of pronghorns from the cover of a thin line of willows, trying to imagine how I might close within longbow range across the open sagebrush terrain between us. Suddenly, the antelope threw up their heads, made a short dash to the top of a little hill and stared intently back toward the sunrise. Their alarm seemed to have nothing to do with me, for I was well hidden and had the wind in my face. Then I noticed an almost unbelievable sight—a young black bear galloping across the prairie toward the pronghorns as fast as its short legs could carry it (which

can be surprisingly fast, for those who have never before seen a bear hit top speed). I could almost hear an imaginary dialogue among the pronghorns. *We are the fastest land animals on the continent. You are a black bear. Who are you trying to kid?* Undeterred by these facts, the bear chased the pronghorns around in circles for nearly an hour before it gave up and walked right past me with its tongue hanging out. There wasn't a tree around for miles. The point of this tale is simply to demonstrate that the adaptable black bear can show up almost anywhere, engaged in totally unexpected activities.

The many fascinating aspects of black bear biology and behavior notwithstanding, the question most newcomers to bear country usually ask addresses just one: is a bear going to eat me? We will review the subject of bear attacks in more detail in chapter 29. For now, I will simply note that the observations Lewis recorded in 1806 regarding black bear behavior are partly, but only partly, true. In matters of this sort, it is the exceptions to the rule rather than the rule itself that matter most. During many years spent among both black and grizzly bears, I have faced far more aggressive and threatening behavior from the former than the latter, popular assumptions to the contrary. Statistics show that black bears actually kill more people in North America than grizzlies do, at least in part because there are more of them and they occupy a far larger range. For me, a black bear encounter just doesn't evoke the same visceral response as a run-in with a grizzly, but I also know that it is a mistake to regard black bears as harmless.

Despite a recent surge in human development, black bear numbers in Montana appear stable across the state. Black bears, in contrast to grizzlies, get along well in proximity to humans—sometimes too well. Observers unfamiliar with bears may still have to do some looking to find them. Remember the food sources described earlier—find the food and you will find the bears. An opportunity to observe a black bear in the wild is always worth the effort invested, no matter how many of them you have seen before.

Chapter 28

COYOTE

Canis latrans

*I*have never met a predator capable of operating across a broader spectrum of habitat and food sources than the coyote, as illustrated by the two experiences that follow.

Even though September in Montana often ends with snow, it can begin with searing temperatures on the prairie east of my home. This is the season of parched grass, when ponds and waterholes often lie reduced to cracked layers of mud that looks as if it has been fired in a kiln. One such scorcher found me curled in the meager shade of a stunted pine halfway up a hillside, glassing the plains below me for pronghorns. Proper glassing technique requires plenty of patience, and I'd put in several hours' worth before I spotted movement in an open expanse of thin grass a half mile away. Zeroing in with my optics I realized I was watching a pair of coyotes, but I'd never seen coyotes acting quite like this. Intrigued, I dropped down into a seam in the hillside and oozed closer for a better look.

The coyotes appeared full grown, but they were frolicking about like puppies, leaping, spinning and snapping at the air with none of the caution ordinarily characteristic of the species. Then one of the innumerable grasshoppers buzzing about in the dry ground cover landed on my arm. Since I'd spent the previous day catching brown trout from a local stream on deer hair grasshopper imitations, I should have made the connection sooner, but unexpected events in the outdoors have a habit of disrupting logical connections. Creeping closer still, my eyes finally confirmed my suspicions.

The coyotes were flushing hoppers from the grass and plucking them out of the air like insectivorous birds.

Now run the tape backward twenty years. I was flying up a remote Alaska river one spring day on my way to pick up a friend when I spotted a commotion on a gravel bar beneath my wing. A mature brown bear was standing over the carcass of a winter-killed moose calf, defending its find from what appeared to be a pack of wolves. Fascinated, I banked and descended for a closer look. To my surprise, the "wolves" turned out to be coyotes, which are more common in some parts of Alaska than most people think. The coyotes were clearly working as an organized team. One or two of them would approach the bear frontally and provoke a distracting charge, somehow managing to stay just beyond the reach of the bear's front claws. Meanwhile, several more would sneak in behind the bear and tear at the carcass. I circled and watched as long as my gas reserves allowed, regretting only my uncharacteristic lack of a camera.

From catching airborne insects to battling the continent's largest land carnivore for chunks of rotten moose meat, no animal I know capitalizes on a greater variety of nature's bounty than the coyote.

If it were up to Ben Franklin, the wild turkey might be our national bird, and if it were up to me, the coyote might be Montana's state animal, although that idea would no doubt produce even more controversy than Franklin's suggestion. One of the most widely distributed species of any profiled in this book, the coyote inhabits every corner of the state, every elevation, every habitat. It is one of the few animals I know whose character lives up to every bit of its reputation. All of its senses are acute, its intelligence legendary. Above all, the coyote is the ultimate adaptable survivor.

The coyote is a New World native whose ancestors diverged from gray wolf progenitors during the Pleistocene. Its name derives from the Aztec *coyotl*, and it has long played an important role in Native American myth, usually in the role of a clever, picaresque trickster often analogous to the role the raven plays in northwest coastal native lore. The coyote often figures prominently in creation myths. According to the Nez Perce, a monster named Kamiah once stalked the earth gobbling up all the animals. The clever Coyote allowed Kamiah to swallow him and then killed the monster by biting into his heart. After freeing all the other animals, Coyote tore Kamiah's remains to pieces

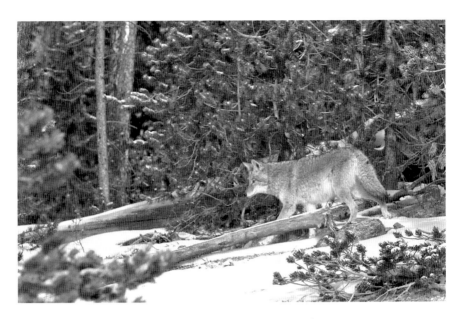

A coyote near Yellowstone Canyon. *National Park System photo by Jim Peaco.*

and scattered them to the winds, where they eventually gave rise to humans. From the Pacific Northwest to southern Mexico, dozens of indigenous languages include a unique word for the coyote.

Scientists currently recognize nineteen subspecies of coyotes. Physical differences among them are generally minor, although northern subspecies are larger than those in Mexico and Central America (another reflection of Bergmann's Rule). Montana is home to the largest of them, the plains coyote *C. l. latrans*. Coyotes tend to be smaller than they look. Typical adult male Montana coyotes weigh around thirty pounds. Females are slightly smaller. The largest specimen on record came from Wyoming and weighed seventy-four pounds. The biggest coyotes I have personally observed were in central Alberta, although I never documented any weights. Not surprisingly, northern coyotes have much thicker fur than their southern relatives, so some of the impressive size I observed in Alberta may have been an illusion. Coat color is generally gray, highlighted with shades of black, white and tan. While the color of the coat is more uniform among individuals than that of the gray wolf, there is still considerable variation among individuals and between different geographic areas.

Early accounts are difficult to interpret because of confusion between coyotes and wolves, which still occupied much of the same range at the time of European contact. Early Spanish explorers mentioned the species

long before the Lewis and Clark expedition. Clark collected a specimen in September 1804, which he described as a wolf in his notes. Lewis recognized the distinction in a typically precise account recorded in northeastern Montana in May 1805:

> *The small woolf or burrowing dog of the prairies are the inhabitants almost invariably of the open plains: they usually associate in bands of ten or twelve sometimes more…when a person approaches them they frequently bark, their note being precisely that of a small dog. They are of an intermediate size between that of a fox and dog, very active fleet and delicately formed…their tallons are rather longer than those of the ordinary woolf or that common to the atlantic states, none of which are to be found in this quarter.*

Formal scientific description of the species awaited the work of Philadelphia naturalist Thomas Say in 1823.

In contrast to the wolf's complex pack structure, coyotes usually hunt in pairs or loosely organized temporary groups. They are less reliant than wolves on large ungulates as a primary food source. Coyotes will opportunistically prey on almost any animal species within their habitat, from elk to insects. While they sometimes kill young ungulates of the year, they are much less likely than wolves to attack mature animals unless conditions are favorable, as when deep snow acquires a crust that allows the coyotes to run on top while deer or elk they are pursuing break through and flounder. Rodents and other small mammals make up the bulk of the coyote's diet when the ground is free of snow. Watching a coyote carefully stalk a mouse through prairie grass and conclude the hunt with a graceful pounce can be highly entertaining (for everyone but the mouse).

In winter, coyotes are more likely to rely on carrion—particularly ungulate carcasses—than on large animals they have killed themselves. They can be remarkably tenacious. One December I noticed coyote tracks leading to what turned out to be an elk carcass that had already been picked clean of everything but some hair and bones. All winter long, whenever I passed through that area I found new sets of coyote tracks headed straight to the carcass, as if the coyotes thought it might grow more meat by magic. Even scavenging can be dangerous. I once backtracked a female mountain lion with two kittens to a mule deer the cat had killed, where the tracks told an interesting story in the snow. A solitary coyote had approached the dead deer

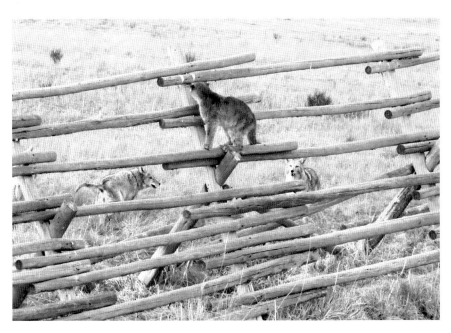

The National Elk Refuge's outdoor recreation planner witnessed a spectacular standoff between two juvenile mountain lions and five coyotes. The coyotes let the cats know they weren't welcome in the area. The mountain lions sought safety on a buck and rail fence for over an hour while the coyotes lurked in the background. The coyotes become more aggressive as one of the mountain lions moves down the fenceline. *U.S. Fish & Wildlife Service Mountain-Prairie photo by Lori Iverson.*

An inquisitive coyote receives a penetrating stare. Shortly after this shot was taken, a short bluff charge by the bison sent the coyote scampering away across the prairie. *Photo by Don and Lori Thomas.*

through the cover of some brush, where the lion had killed it and then stood by as her kittens ate it.

Coyotes are highly vocal animals, as Lewis noted in his journals. The scientific name *Canis latrans* means "barking dog." While coyotes are capable of a wide variety of vocalizations, including growls and barks used to convey threat or alarm, group howling—often around sunrise or sunset—is the coyote sound most likely to be noted by human observers. Eerie and melodious, coyote howling has long enjoyed a reputation as an iconic sound of the American West. It's hard to imagine a vintage Hollywood western without howling coyotes contributing to the background music at some point.

Coyotes, like white-tailed deer, are among the few highly adaptive large mammals that actually thrive in the presence of human development, as demonstrated by the dramatic recent increase in coyote numbers east of the Mississippi and in urban areas all across the country. In fact, coyote numbers have been increasing in the West ever since the extirpation of the wolf, with which coyotes naturally compete for food sources, often unsuccessfully. One might reasonably expect a reversal in this trend coincident with the reintroduction of the wolf to Montana, and one study showed a 39 percent drop in the coyote population in Yellowstone's Lamar Valley after wolves returned to the area.

Coyotes and humans have enjoyed a contentious relationship since the settling of the West, largely because of the coyote's combination of ingenuity, determination and appetite for domestic livestock. While coyotes will at times kill and eat everything from cattle to domestic dogs, lamb has always been a favorite menu item simply because it is so easy for coyotes to kill sheep. While many western predators, including all of those mentioned in this section, will sometimes kill sheep, the coyote heads the list. The United States Department of Agriculture's National Agricultural Statistics Service ascribed just over 60 percent of the country's predatory sheep losses to coyotes in 2004. Looked at one way, that's only about 1 percent of the total domestic sheep population. Looked at another way, those figures represent over 100,000 dead sheep—a typical example of the dichotomy in perception that often complicates predator management issues. From the rancher's perspective, the problem is compounded by the fact that those losses are not evenly distributed. Most lose few, if any, sheep to coyotes, but some have their flocks decimated. No matter how one feels about the subject, livestock depredation certainly contributes to the contentious environment in which Montana's coyotes live today.

Yellowstone's Lamar Valley. *Courtesy of Val Schaffner.*

One historically popular approach to the depredation issue is to kill coyotes, which is why so many Montana ranch pickups have a .22-250 or .243 resting in the gun rack behind the seat. The biological impact of those rifles is negligible compared to other means of reducing coyote populations. As wolves disappeared from Montana in the early twentieth century, federal predator control efforts shifted their focus to coyotes, primarily by shooting and lacing carcasses with strychnine and other forms of poison. Around the time of the Second World War, the original "coyote getter" appeared on the scene—a primer-driven device that injected cyanide into the mouth of the coyote (or whatever) in response to tugging at a bait. Around the same time, the highly toxic compound sodium fluroacetate, or 1080, became widely used to lace carcass baits on both public and private land. Then came the M-44, a more sophisticated version of the original cyanide gun. The USDA Wildlife Services division conducted most of these programs under authority of the 1931 federal Animal Damage Control Act with, in Montana, assistance from both the Livestock and Fish and Game Commissions.

Large predators have always been a controversial subject in Montana and likely always will be. Throughout this section, I have deliberately avoided editorializing and tried to present facts rather than opinions. Here I will let the idea of spending millions of taxpayer dollars to lace public lands with highly toxic substances and dangerous devices that kill both domestic animals and wildlife species indiscriminately speak for itself.

No matter how one feels about coyotes and their role in the western ecosystem (and I have friends and neighbors whose opinions span the spectrum), the undeniable fact that the species is thriving in Montana today speaks volumes about the animals' intelligence and adaptability. Perhaps the Nez Perce had it right all along.

Chapter 29

GRAY WOLF

Canis lupus

\mathcal{M}ay is a time of rapid and dramatic transition on the Alaska Peninsula, as returning waterfowl fill the air and long, sunny days chase the snowline up the flanks of the peaks with traces of green in pursuit. I had been sitting alone on top of a ridge with my binoculars glued to my face for hours, listening to ptarmigan chatter, watching courting harlequin ducks chase one another around on the surface of the lake below, trying to decide if I wanted to return to the company of my guide partner and our hunters back in camp (I didn't) and searching for bears that weren't there. That's when an anomalous flicker of white caught my eye in a clump of brush about a hundred yards down the ridgeline, and I went on full alert.

By the time I'd slowly shifted my torso into position to glass the alders, I didn't need optics to identify what had caught my eye. A fully grown, pure white male wolf was walking casually toward my position, testing the upslope breeze for olfactory clues to the presence of a winter-killed carcass or another potential source of a meal. I thought about trying to coax it closer by blowing against the back of my hand to imitate a rodent's squeak, but I didn't have to. The wolf's course already appeared certain to put him right in my lap.

I held still and watched. Had he passed behind me, the breeze would have alerted him to my presence immediately, but he chose instead to walk directly below me at a range of less than fifteen yards. As he wandered unaware down the valley, I thought about all that the two of us had in common. He

was hunting, and I was hunting. Each of us was alone, certainly by choice in my case, presumptively so in the wolf's. Surely the wilderness had room for both of us.

<center>◦◦◦◦</center>

Even in Alaska, where the sound of howling wolves regularly punctuates campfire discussions in wilderness areas around the state, such close range encounters are unusual. That was not the case in Montana back in the days when bison populations numbered in the millions and Native American presence was more likely to result in food for wolves than trouble. Do some simple math: a bison population of 1 million animals times a conservative natural annual mortality of 5 percent times two thousand pounds of meat per mature buffalo equals—well, a lot of wolf food, all at the cost of little more than being there. Lewis and Clark were familiar with the wolf before they left home, and the only thing they found remarkable about them during their journey across the plains was their abundance and boldness.

The introduction of domestic livestock to Montana during the nineteenth century changed the equation. Even their detractors acknowledge the wolf's intelligence, and a predator doesn't have to be all that smart to prefer killing a cow to tackling a ton of enraged bison—a choice made all the easier once the bison were gone. Wolves killed cows and sheep, so ranchers and settlers killed wolves, often in conjunction with organized efforts by state and federal predator control agencies. Montana's last wild wolf (at the time) was killed in 1930, in Judith Basin County, not far from my home.

That animal, Stanford's "Famous White Wolf," led a career that deserves a chapter if not a book all its own. For more than a decade, the white wolf killed local livestock despite relentless pursuit by all conceivable means and a stockmen's reward that eventually totaled $400, a huge sum in Depression-era Montana. A breathless account in my hometown newspaper by one Elva Wineman about the day A.E. Close and Earl Neill finally shot it describes the animal thus: "By nature a cunning strategist, cruel and brutal following the death of his mate in a trap a few years ago; the big wolf became still more devilish murderous, a killer and an outlaw…" Despite the anthropomorphism and lurid prose, even Wineman's account goes on to express open admiration for the intelligence and tenacity of the last wolf known to inhabit Montana for the next five decades.

The gray wolf—also called the timber wolf—is a Eurasian species that reached the New World by way of the Bering Sea land bridge long before its reputation—think Little Red Riding Hood and Peter and the Wolf—caught up with it by way of the Atlantic. (For convenience, I will refer to the species in this chapter simply as the "wolf," although the eastern wolf and the red wolf are distinct.) The wolf enjoys a wide distribution across the arctic and as far south as India and Saudi Arabia. It is the only wild canine that naturally occurs in both the Old World and the New. Because of its wide geographic range and the variety of habitats it occupies, extensive sub-speciation (biologists currently recognize thirty-seven) should come as no surprise. According to DNA studies, one of those subspecies is the domestic dog.

The world's largest wild canid (mature males average around 100 pounds and occasional specimens weigh over 150), the gray wolf is an apex predator adapted to killing large mammals, although it will eat meat in almost any form including birds, small animals and carrion. In Alaska, salmon plays an important role as a food source for some coastal wolf populations. Wolves sometimes feed on berries and other vegetation, although this is usually not a nutritionally significant part of their diet. Long legs allow the wolf to pursue prey in snow, and strong jaws and teeth enable it to crush rather than simply gnaw on bone. Coat color is highly variable. While most wolves have grizzled

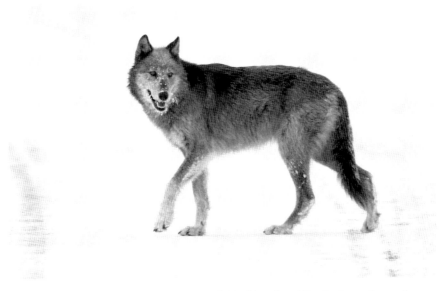

Black and gray female wolf from Yellowstone's Druid pack walking in the road near the Lamar River Bridge. *National Park System photo by Jim Peaco.*

coats in various shades of gray and brown, their color can range from pure white to pure black (see insert).

Despite the familiarity of the term "lone wolf," wolves are both gregarious and territorial animals. The basic "wolf pack" (a term that appears in reference to entities as diverse as German submarine fleets and North Carolina State University athletic teams) consists of an alpha male, a breeding female and several pups and yearlings from the same parentage. Young wolves disperse from this unit as they sexually mature, leaving to begin new packs in unoccupied territory when they encounter a dispersing wolf of the opposite sex. Pack territories vary considerably depending on prey density and competition from other wolves. Territorial encounters between packs sometimes become violent, although packs may also combine at least temporarily to hunt together.

Wolves hunting in packs are remarkably effective predators considering that a mature elk or moose may outweigh an individual wolf by a factor of ten or more. After stalking as close as possible undetected, wolves will usually attempt to goad the intended target into running in order to weaken it and allow an attack from behind, a blind spot that antlers, horns and flailing front hooves can't reach. An ungulate that stands its ground often has a better chance of surviving the encounter than one that turns and runs, and wolves will often abandon the engagement if the prey refuses to be driven. Wolves are adept at using terrain conditions to their advantage, by driving prey into deep snow or onto ice too thin to support its weight.

Pack animals with a complex social structure, wolves need to communicate more effectively than other canids, and they do so with a degree of sophistication seldom noted in non-primate mammals. Body language and a wide repertoire of facial expressions convey submission and dominance within the pack and during contact with other wolves. Although the wolf's nose isn't quite as keen as those of some domestic dogs bred for that ability, smell is still the wolf's most acute sense. Olfactory cues are very important in communication as well as hunting. The odor of the sweat produced by the apocrine glands scattered about the wolf's surface anatomy varies from individual to individual, creating a unique scent "fingerprint" for every wolf. Males also mark their territory by urinating on boundary trees. Anyone who has watched a dog investigate the complex olfactory landscape other dogs have left behind in the pet area of a highway rest stop will appreciate the amount of information these processes convey to the inquisitive canine nose.

Wolves use a variety of barks, whines and growls to communicate within the pack and convey alarm, greetings, affection and intimacy, but the

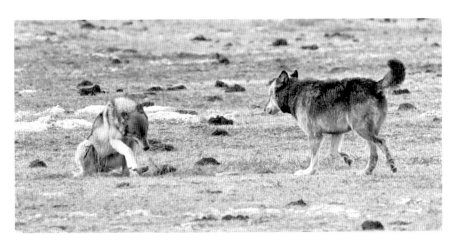

Alpha male of the Canyon pack approaching a subordinate in the Lower Geyser Basin, February 2015. *National Park System photo by Jim Peaco.*

A wolf howling on glacial erratic in Little American Flats. *National Park System photo by Jim Peaco.*

definitive wolf vocalization is the howl, an eerie, musical, quavering series of notes that can carry for miles on a clear winter night. Howling is used to locate other wolves, assemble the pack and alert others to danger, but to the human ear—or at least my own—the vocabulary is less significant than the sense of wildness it enforces. From the comfort of my tent, I've listened to

wolves howl from the north slope of the Brooks Range to the far reaches of the Alaska Peninsula to the rainforest of Alaska's Southeast Panhandle. No sound that has ever reached my ears has made me appreciate my wilderness surroundings more.

I doubt that any animal has played more roles in as many geographically diverse human cultures as the wolf. Wolves appear in many Eurasian creation myths, and ancient Romans credited a wolf for raising Romulus and Remus, the eventual founders of their city. Portrayed as symbols of mischief and cruelty, wolves appear in the sacred texts of the Babylonians and Zoroastrians. Aesop created "The Boy Who Cried Wolf," providing yet another example of the wolf contributing its name to a common, everyday expression. In the New Testament, Jesus introduces us to "the wolf in sheep's clothing." Because of their abundance in Russia, it's hardly surprising that wolves appear frequently in Russian folklore as well as modern works by writers such as Tolstoy ("But our idea is that wolves should be fed and sheep kept safe.") and Chekov ("Better a debauched canary than a pious wolf."). Bram Stoker's Dracula could change himself into a wolf. In virtually all fictional accounts after Romulus and Remus, the wolf is characterized as malicious and savage, as epitomized by legendary accounts of Russians tearfully tossing children from the back of the troika in order to distract pursuing wolves long enough to save the rest of the family (hence the phrase "thrown to the wolves"). This characterization continued virtually uninterrupted until the 1963 publication of Farley Mowat's *Never Cry Wolf*, which, if nothing else, proved that when writing about nature, emotionalism without regard to scientific accuracy may be the surest route to the bestseller list.

An overview of canid livestock depredation and subsequent predator control efforts appeared in chapter 26 and will not be repeated here. But are wolves a threat to people? That's a legitimate question to ask of any large predator. In the wolf's case, the answer is yes—but rarely. The few wolves that initiate unprovoked attacks on people as a potential food source are often either habituated to human presence or nutritionally stressed by low populations of natural prey species. Victims are often women and, especially, children. The incidence of wolf attacks varies strikingly by geography. French records document (with varying degrees of reliability) 7,600 fatal wolf attacks in that country between 1200 and 1920. That's a long period of time, but that's also a large number of dead humans. More recently, wolf attacks have occurred most often in the Middle East and India, at least partly because of a high incidence of rabies in these wolf populations due to contact with jackals, a natural reservoir of the disease. While record keeping

has often been incomplete and unreliable in many of these areas, the British administration kept accurate accounts throughout much of India during the days of the British Raj. During the 1870s, several provinces recorded between 600 and 700 fatal wolf attacks annually, with wolves killing more people than tigers. These records did not discriminate between attacks by healthy and rabid wolves.

The situation is much more benign in North America, where rabies in wolves is infrequent. However, it is not unheard of. On August 5, 1868, a rabid wolf entered the perimeter of Fort Larned, in central Kansas. Captain Albert Barnitz of the Seventh Cavalry described events as follows:

> *A very large gray wolf entered the Post and bit one of the sentries—ran into the hospital and bit a man lying in bed—passed another tent, and pulled another man out of bed, biting him severely—bit one man's finger nearly off—bit one woman, I believe, and some other persons lying in bed but did not bite through the bed clothes—passed through the hall of Captain Nolan's house and pounced on a large dog which he found there, and whipped him badly in half a minute.*

Unfortunately, this aggressive behavior is typical of rabid wolves. Rabies in animals presents in one of two ways: "dumb" rabies in which the infected animal appears listless and apathetic and "furious" rabies in which the infected animal bites everything in sight. Rabid wolves typically fall into the second category, and because of their size and underlying predatory instincts, a rabid wolf is unquestionably a very dangerous animal.

Despite such occasional incidents, wolf attacks on humans are rare in North America, especially compared to statistics from southern Asia. Precise numbers are surprisingly hard to come by, and the figures seem to vary according to their presenter's underlying attitude toward wolves. However, the contention that there has never been an unprovoked attack by a healthy wolf on a human being in North America is inaccurate.

On November 8, 2005, Kenton Carnegie, a twenty-two-year-old student doing survey work for a mining service center in Saskatchewan, failed to return from an afternoon walk by himself. His body was later found in the snow surrounded by wolf tracks. Wolves had been seen frequently in the area, where they had become accustomed to feeding on camp garbage. While some theorized that a bear might have killed him, the bulk of the evidence suggested otherwise, and a coroner's jury determined that wolves had killed Carnegie.

On the evening of March 8, 2010, a teacher named Candice Berger failed to return from her customary jog near the remote village of Chignik Lake, Alaska. Her body was soon found with what law enforcement described as "multiple injuries due to animal mauling." The Alaska Department of Fish and Game culled several wolves from the area and, after an extensive investigation, showed that genetic material from at least one of the wolves matched samples obtained from the victim's clothing.

I have cited these examples for two reasons: they were fatal (the only two fatal cases in North America since 2000), and they were very well documented. Other non-fatal attacks have occurred during this time period, in Minnesota and Idaho as well as other parts of Alaska and Canada. None has occurred in Montana.

So, back to the original question: are wolves a threat to people? The answer, as is so often the case in discussions of wild predators, lies between the extremes of opinions. Wolves are not savage killers of human babies motivated by the devil, nor are they cuddly overgrown lap dogs. They are simply well-adapted large predators that occasionally do to people what they routinely do to deer, elk and moose.

Following the 1930 death of the Judith Basin County white wolf, Montana remained a wolf-free zone until the 1980s, when occasional wolves began to wander south from Canada into the area in and around Glacier National Park and eventually south along the Eastern Front of the Rockies. An active wolf den was found inside the Park in 1986. Then, after several decades of negotiations, wolf recovery teams and management plans, forty-one wolves from Canada and northern Montana were released during 1995 and 1996 in Yellowstone National Park, and everything changed.

Part of the initial motivation driving the introduction of this "experimental, non-essential" (formal USFWS terminology) wolf population was a cascade of ecological problems linked to the extirpation of the wolf. The Yellowstone Park elk herd was exploding, overgrazing its food supply and destroying riparian habitat. The coyotes that replaced the wolf as the apex canine predator were reducing populations of birds and small mammals. Re-creating the natural structure of the food chain seemed a logical approach to both these problems.

The original recovery goals established by authority of the USFWS were for each of three regions in the Northern Rocky Mountains (NRM) to

support a minimum of ten breeding wolf pairs, producing litters of two or more pups in three consecutive years. Those goals were exceeded by 2002. As of 2013, the NRM wolf reintroduction area contained 1,691 wolves in 320 packs (visit www.fws.gov/mountain-prairie/species/mammals/wolf for current population statistics as well as a timeline of USFWS legal positions regarding wolf recovery).

The reintroduction effort's biologic success did not prevent seemingly endless rounds of lawsuits, listing, de-listing, angry town meetings, shrill letters to the editor and general animosity among farmers; ranchers; local residents both urban and rural; hunters; out-of-state environmentalists; state, federal and local agencies; and virtually every other imaginable party with an interest in the presence or absence of wolves in Montana. The litigation circus actually began in theater of the absurd fashion before the first transplanted wolves even hit the ground. In 1994, the Wyoming Farm Bureau and a consortium of environmental groups simultaneously filed suit in federal court to block the proposed reintroduction, the former arguing that the plan as proposed would grant too much protection to wolves, the latter arguing that it would provide too little.

I've known Ed Bangs for over thirty years now, a friendship that dates back to the days when we both lived and enjoyed the outdoors on Alaska's Kenai Peninsula. A thoughtful man whose quiet demeanor belies a quick sense of humor, Ed defies the stereotype of the tree-hugging environmentalist by virtue of decades spent with his boots on the ground in some of the continent's wildest terrain. He is one of the few Alaska outdoorsmen to have successfully defended himself against a determined attack by an Alaska

Wolf crossing Alum Creek in Hayden Valley. *National Park System photo by Jim Peaco.*

brown bear while armed with nothing but a handgun. A professional career biologist, he faced what was in many ways an even sterner test when he was named the USFWS wolf recovery coordinator in the Northern Rockies. After he kindly provided me with a review of a timeline for those efforts, I asked Bangs to tell me what wolf reintroduction meant to him.

"Many areas of Montana, Idaho and Wyoming now have the full complement of native predators and prey that they had when Columbus stepped ashore," he began. "While certainly controversial and still a work in progress, wolf restoration resulted in a much more diverse natural ecosystem and wilder outdoor experience. It has been called one of the most significant wildlife conservation programs of the last hundred years. A mountain without wildlife is just scenery, and wild ungulates without their natural predators are just livestock. The return of the wolf's howl has heightened the sense of wildness in the northern Rocky Mountains."

Years ago, I wrote a magazine editorial titled "The W-Word." The word in question was "Wolf," and the thesis of the piece was that I had grown so exhausted by the irrational, polarized bickering on both sides of the wolf reintroduction issue that I never planned to write about the subject or the animal again. Obviously, I changed my mind.

Opinions on the matter still largely gravitate to one of two poles. Option A: every wolf in Montana should be killed yesterday. Option B: there is no number of wolves in Montana that will ever be too many, no matter what best science has to say. If I have done my job as a reporter in this chapter, readers will not know exactly where I stand on the subject, although those who guess "somewhere in between" would be on the right track. One might assume that such an attempt at compromise would earn a bit of respect from both sides of the debate, but it doesn't. It earns irate letters and threats from both sides, hence "The W-Word." That is why I have chosen to stick to biologic facts and documented history before moving on to a totally noncontroversial subject like the grizzly bear. Yeah, right.

Of all the literary allusions to the wolf contained in the Western canon, none has endured with such simple resonance as three words written by the Roman playwright Plautus in 159 BC and recycled by Thomas Hobbes in 1651: "*Homo homini lupus* (Man is a wolf to man)." Watching the evening news at the beginning of the twenty-first century often makes that statement sound like an insult to the wolf.

Chapter 30

GRIZZLY BEAR

Ursus arctos

Over the course of many years spent in Alaska, I have experienced hundreds of encounters with these remarkable animals (subject to a definition of terms as provided shortly), often at very close range. However, my first such meeting took place right here in Montana, where it became a part of family lore that will likely outlive all its participants.

I was about ten years old, and my father and I had set off along the bank of the Middle Fork of the Flathead with our fly rods in search of cutthroats. Little brother Jeff came along with us that day. Most of the family outdoor genes had come my way, and Jeff was really just tagging along for the ride. After several hours of casting—and a few nice fish, as I recall—Jeff and I had worked our way upstream around a bend and out of sight from my father. Unbeknownst to us, another angler had leapfrogged in between us, which was hardly a problem since there was plenty of water and plenty of trout.

I was casting onto the surface of a deep pool, and I still remember the mesmerizing sight of trout rising from the green depths to inspect and occasionally strike my fly. I was standing at the waterline beneath a long, steep gravel slide when I heard noise way up the bank behind me. Too busy fishing, I didn't pay much attention until loose rock began to roll right past my legs and into the water at my feet. That's when I turned around and saw a large grizzly sitting on its haunches and sliding down the bank in my direction.

As evidenced by the gravel bouncing off my waders, I was standing directly in the fall line beneath the descending bear, which seemed to be

seconds away from rolling right over the top of me. I hadn't had much bear experience of any kind by then, but I knew the animal was a grizzly. My father had briefed me about the possibility of such an encounter, including the importance of avoiding the temptation to turn and run, a staple of outdoor advice in bear country that is far easier to adhere to in the absence of a bear. I whistled to my brother, who was idly throwing rocks in the water thirty yards downstream, despite the aggravation that favorite activity of his caused me when I was trying to fish. I pointed out the bear and told him to walk, not run, around the bend to my father.

Showing what seems like remarkable composure in retrospect, he didn't run and neither did I, probably because I didn't have the opportunity. By the time I had my brother pointed in the right direction, the bear was almost on top of me. As I took a few steps backward, it skidded to a halt at the edge of the water and we looked at each other, separated by the length of my fly rod. This was the moment when I realized my life had changed forever. I won't pretend I wasn't afraid, but something also told me that I didn't want this to be the last grizzly bear I ever saw.

A circumpolar species with a wide historic range across Old World and New, *Ursus arctos* causes more than its share of taxonomic confusion. There are only three ursine species in North America: the maritime polar bear of the Far North (a remarkable animal, but irrelevant to a book about Montana wildlife), the black bear described in chapter 26 and the brown/grizzly bear. Confusion arises because of the forward slash in the previous sentence. In Alaska, the distinction between brown and grizzly bears is in some ways arbitrary and other ways obvious. Coastal brown bears (*U. a. middendorffi*) are generally larger, more uniformly colored and somewhat less aggressive (although the latter trait should certainly not be relied on in the field). Interior grizzlies (*U. a. horribilis*) are smaller and more likely to have varying shades of color in their coats. That is the bear that inhabits Montana. A "Kodiak" bear is simply a brown bear that lives on the Kodiak archipelago and is biologically identical to brown bears across Shelikof Strait on the mainland Alaska Peninsula. All are members of the same species.

The key features that distinguish the two subspecies derive from the abundance of salmon in the brown bear's environment. The high-protein calorie content of the fish that choke coastal streams during the northern

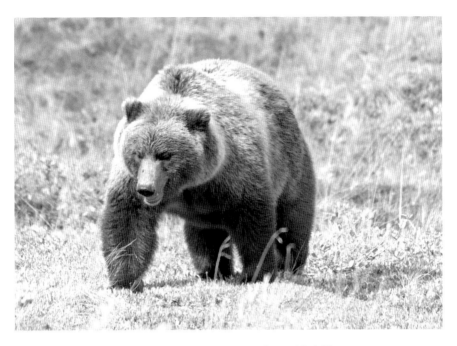

Ursus arctos horriblis—Montana's state animal. *Photo by Don and Lori Thomas.*

summer and fall has allowed brown bears to grow larger than their inland cousins and reduced their need to compete intensely for food. Interior grizzlies have to work a lot harder to meet their nutritional requirements prior to denning, and more aggressive behavior is perhaps an inevitable result. When a brown bear on a salmon stream runs into something or someone unexpectedly, its first response is usually to keep looking for its next fish. An arctic grizzly that sees something pop over the horizon a mile away is more likely to hustle over and investigate the possibility of a meal. Various record keeping organizations have drawn lines on the map defining the separate ranges of the two subspecies, but these are all somewhat arbitrary. The bears certainly don't know which side of these lines they're on. As a general rule, if a bear is within fifty miles of salt water, you can consider it a brown bear.

Montana grizzlies are all *Ursus arctos horribilis*. If that sub-specific name sounds judgmental, one need only consult the records of Lewis and Clark to appreciate its origins. Canadian explorers had already described the grizzly, so it was not unknown to Western science at the time of the expedition. However, Lewis and Clark provided the first detailed anatomic descriptions of the bear. Their relationship with the grizzly started out reasonably enough, from the standpoint of the explorers, if not the bears.

On April 29, 1805, after hearing repeated warnings from the Mandan about the bears' ferocity, Lewis reported the following encounter near Wolf Point in eastern Montana:

> *About 8 A.M. we fell in with two brown (yellow) (white) bear; both of which we wounded; one of them made his escape, the other after firing on him pursued me seventy or eighty yards, but fortunately he had been so badly wounded that he was unable to pursue so closely as to prevent charging my gun; we again repeated our fire and killed him… the Indians may well fear this animal equipped as they generally are with their bows and arrows and indifferent fuzees, but in the hands of skillful riflemen they are by no means as formidable or dangerous as they have been represented.*

This dismissal of the grizzly did not last long. Two months after this initial encounter, Lewis wrote:

> *The white bear have become so troublesome to us that I do not think it prudent to send one man alone on an errand of any kind, particularly where he has to pass through the brush…These bear being so hard to die reather intimidates us…I must confess that I do not like the gentlemen and had reather fight two Indians than one bear.*

Throughout the expedition, Lewis and Clark demonstrated considerable indecision about what to call the animal. They started out with "white bear" even though it wasn't white, probably because that was how they had heard the bear described earlier by frontier sources with no more than secondhand knowledge of the animal. They then progressed with increasing accuracy to "white or grey bear," "yellow bear" and "brown bear." Eventually, Clark wrote of the "Brown or Grisley bear," while Lewis settled on the "brown grizly."

The accuracy of the observations Lewis and Clark made throughout their journey has been confirmed so many times that I find it hard to dismiss these accounts as exaggerated hunting stories. Keep in mind that the explorers were tackling grizzlies with muzzle-loading Kentucky flintlock rifles that delivered killing power adequate for deer, elk and people, but not necessarily for animals as large and determined as grizzly bears. Whatever the accuracy of the original accounts—and I believe them—like most bear stories, they eventually grew with the retelling. By the time George Ord (see chapter 6) formally classified the grizzly in 1815, he decided to call it *Ursus horribilis*, and the bear's reputation became preserved in Latin.

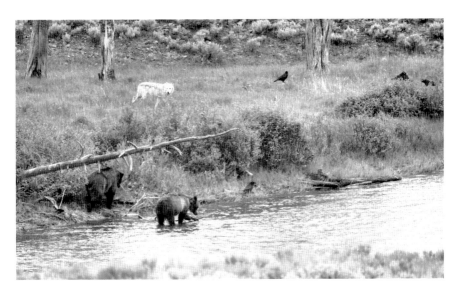

Two grizzly bears, ravens and a wolf near a bison carcass in Lamar River. *National Park System photo by Jim Peaco.*

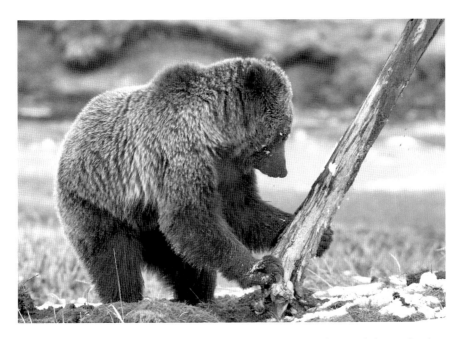

A grizzly bear tipping up a dead tree near Obsidian Creek. *National Park System photo by Jim Peaco.*

In fact, Montana grizzlies do not survive on human babies ripped from the cradle, but on an omnivorous diet dominated by vegetation. Food preferences vary by season. Forbs, grasses and occasional winter-killed carrion are important when bears emerge from their dens. Berries, particularly huckleberries in northwestern Montana, form a significant part of the bears' diet by summer and early fall. Nuts from the whitebark pine (see chapter 12) are a particularly important staple for Montana grizzlies, and destruction of these pines by mountain pine beetles has forced grizzlies to search for alternative food sources. Cutworm moths form an unusual component of the grizzly's diet. In Alaska, I once saw over a dozen bears concentrated on one rocky slope, all feeding on moths. In Yellowstone Park, spawning cutthroat trout provide an important supplement to these staples during the summer (see chapter 20).

None of this is meant to imply that grizzlies aren't capable of acting like the large predators their size and temperament suggest. While grizzlies usually show more interest in carrion than live animals as a food source, they are capable of taking down any ungulate on the continent, and occasionally they do. Young animals of the year are particularly vulnerable. Arctic grizzlies, which face limited food supplies and a short period of time in which to consume them, will follow caribou herds for miles hoping to pick off a calf or an injured adult.

One spring day, I watched a cow moose give birth to a calf on an Alaska Peninsula hillside. The next morning, I saw a bear pick up the scent of the afterbirth from nearly two miles away. The bear then followed its nose back to the spot where the cow had given birth and killed the calf despite a heroic defense by the mother moose. On another occasion, I accidently walked up on the partly eaten but still fresh carcass of a mature cow moose. The sign surrounding the body made it clear that a grizzly had killed the animal. While the cow appeared to have been healthy prior to her encounter with the bear, I did not linger long enough to perform a complete crime scene investigation.

All mature grizzlies look big to the inexperienced observer, and unconfirmed live weight estimates are notoriously unreliable. Montana grizzlies are smaller on average than their counterparts in Alaska, whose average weight is around 600 pounds for males and 300 to 400 pounds for females. Documented weights for Montana grizzlies average around 450 pounds for males and 300 for females, with as much as a 30 percent variation between spring and fall.

Grizzlies and black bears don't get along very well, although their ranges often overlap. Alaska's numerous islands, however, are home to either one

species or the other, but never both. Islands with salmon runs strong enough to support fish-dependent brown bears aren't occupied by black bears because the larger, more aggressive species displaces them. One fall day, I was watching an interior black bear feeding on berries when it suddenly threw up its head and started to run, for reasons that could not have had anything to do with me. Then a grizzly popped over a rise, cantering along in the direction the black bear had taken. The chase appeared half-hearted, and the grizzly broke off quickly, but the last time I saw the black bear, it was still galloping across the tundra several miles away.

In Montana, black bears and grizzlies often occupy the same habitat, and in the presence of an important seasonal food source such as huckleberries or spawning fish, they may appear in proximity. All backcountry visitors should be able to distinguish between the two species. As noted earlier (see chapter 26), coat color is an unreliable indicator, especially given the high prevalence of color-phase black bears in Montana. Grizzlies are most easily recognized at a distance by the presence of a pronounced hump at the top of the shoulders. The extremely long, light-colored claws on their front feet may be easy to identify on open ground. Viewed in profile, the grizzly's face shows a concave, dished-in outline. When in doubt, assume the bear is a grizzly. Visit the Montana Department of Fish, Wildlife and Parks website (www.fwp.mt.gov) for more information and a free online bear identification test.

As the Lewis and Clark record shows, the grizzly originally occupied all of Montana, including the eastern plains. Today, the state's grizzly range is limited to two areas: the Greater Yellowstone ecosystem and the northwestern corner of the state, including Glacier National Park and extending to the eastern front of the Rockies. Recently, grizzlies have been reported with increasing frequency even farther east, in open country at some distance from mountain habitat.

No discussion of Montana grizzlies would be complete without addressing attacks on humans. The good news: these are rare events and a trivial cause of mortality compared to driving a car down a highway. The bad news: they do occur, and visitors to bear country should know something about avoiding them. Fatal bear attacks provide the most reliable statistics because it is often difficult or impossible to reconstruct events after less serious encounters. Because grizzlies are more likely than black bears to attack defensively, they account for more non-fatal bear attacks even though fatal encounters are almost evenly divided between the two species, a further source of confusion in the statistical analysis of these episodes.

At the time of this writing there have been twelve documented fatal bear attacks in Montana and Yellowstone Park since 1980. Two points strike me immediately as I review these events. First, although a formal compilation of a century's worth of bear attacks shows that across North America black bears kill more humans than grizzlies, every fatal bear attack in Montana over the last thirty-five years has been caused by a grizzly. Second, virtually all of them took place in or near a National Park: five in Glacier, four in Yellowstone, two right next to Yellowstone and only one more than a few miles outside a National Park boundary.

One obvious explanation for the second point is that both parks contain a lot of grizzlies and receive a lot of human visitors. These data also suggest that park bears may behave differently than other grizzlies. That thesis would be difficult or impossible to prove, and Doug Peacock, the widely respected bear authority who co-authored the foreword to this book, disputes it. I will not speculate further except to say that although I have likely spent over a thousand nights camped out in grizzly country elsewhere, I've never camped in National Park backcountry and likely never will.

While grizzlies are always *potentially* dangerous, they are *predictably* dangerous in just a few situations, of which all should be aware. Sows accompanied by cubs are always a threat. If you encounter one and the bear hasn't seen you, back away slowly, preferably staying downwind of the bear. A bear guarding a food source may defend its territory aggressively. This situation most often arises when a bear is eating from a large animal carcass, either one it has found or one it has killed. Remember to look and listen for other scavengers when hiking in bear country (see chapter 5). If a bear seems reluctant to leave a small area, assume there is a carcass nearby and retreat. If you're picking berries, remember that bears are more likely than usual to be in the area, and one may decide to defend "his" berry patch. Surprised bears can be dangerous bears, a problem that can arise when hiking through terrain with limited visibility. Don't be afraid to make some noise or detour away from brush. Finally, habituated bears are always dangerous. I'm old enough to remember when feeding bears sandwiches from car windows was a regular activity in Yellowstone Park. The Park Service has done a good job of eliminating that behavior, along with the dumps that once doubled as bear viewing centers back in the old days. Everyone in the state should learn from those examples.

A final op-ed on a bear safety subject. Probably because I've spent my whole life around firearms, I viewed bear spray with great skepticism when it first became available. I knew what it took to stop a charging grizzly, and it

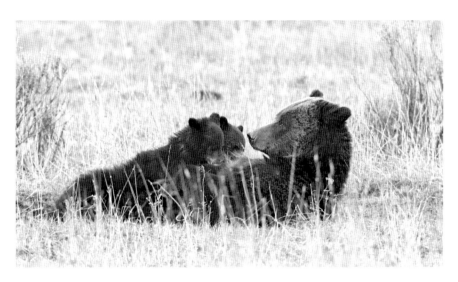

A grizzly sow nursing cubs near Fishing Bridge. *National Park System photo by Jim Peaco.*

seemed unlikely that anyone could fit it into a can. Then objective evidence regarding the effectiveness of bear spray began to mount, and I bought some to pack when I was fishing salmon streams in Alaska. I only used it once, but the effect was dramatic. I don't know if it saved my life but it certainly saved the bear's, since the animal was just a step or two away from forcing us to shoot it. Bear spray works. Buy it, familiarize yourself with its use and carry it whenever you're in bear country.

In 1975, the lower forty-eight grizzly population was listed as threatened by the USFWS, according to definitions in the ESA. In 2007, the service determined that the Yellowstone Distinct Population Segment no longer met criteria for listing, as bear populations had reached management goals. In 2009, the grizzly was re-listed by court order following litigation. Review of the bears' status is expected imminently as of this writing. An estimated 1,700 grizzly bears currently inhabit the lower forty-eight states, of which 900 live in Montana and 600 in the Greater Yellowstone area.

On the banks of the Middle Fork that day, my father's first indication that something was amiss came when the unfamiliar angler who had shown up between us went running past him on the bank at high speed with his fishing rod banging off the rocks behind him. When my father asked him what was

wrong, he replied, "There's a grizzly bear chasing two kids up there!" Then he kept running down the river.

Meanwhile, after that long, hard stare, the bear decided I was of no interest, jumped in the river and began to swim. When it reached midstream, I decided that the prohibition against running no longer applied. I overtook my brother just in time for the two of us to run into our father, who appeared as distressed as I'd ever seen him. Little wonder—ever since the unknown hero had gone sprinting past him he'd been trying to figure out how he'd drive off a grizzly with a fly rod if the bear had one of us in its mouth. Like the vast majority of grizzly encounters, that one ended peacefully (although it wouldn't have remained that way if my father had caught up with the guy who abandoned us to the bear).

Anecdotes about grizzlies killing large animals and statistics about bear attacks are in some ways an obligatory but unfortunate part of their species profile. These things happen, and people interested in learning about bears deserve to know about them. The fact remains that most grizzlies, most of the time, are more interested in eating fish and berries than moose and people. *Ursus arctos* is the most formidable mammal on our continent, but it's still vulnerable enough to be undone by a beetle that kills pine trees. Grizzlies make wild places wilder, and I'm glad they're there. While I don't let them terrify me or compromise my enjoyment of the outdoors, I always grant them the utmost respect.

They deserve it.

Chapter 31

GOLDEN EAGLE

Aquila chrysaetos

I've spent a lot of time around wild turkeys, remarkable birds that likely would have earned a chapter of their own in this book except that they are not native to Montana. I thought I'd seen every behavior and heard every vocalization they had to offer, but what the turkeys did one crisp fall day a few years back reminded me that you never know it all whenever wildlife is the subject.

The little flock was feeding in the pine mast at the bottom of the hill just north of our house. I'd been watching them for a while, trying to decide whether the time had come to procure a real turkey for our Thanksgiving dinner table. (It hadn't.) The turkeys appeared as relaxed as wild turkeys ever get, although one of the old hens in the flock always had her head up while the rest scratched around in the duff. Then all hell broke loose.

The flock exploded as if a bomb had gone off in its midst. In a matter of seconds, the birds all wound up crammed together in a ball inside a dense patch of thorn apple at the bottom of the coulee. By that time, my ears were ringing from the noise of the loudest, most strident ruckus I'd ever heard turkeys make. I'd spent plenty of time calling wild turkeys and had mastered a fairly extensive vocabulary of yelps, clucks, cuts, cackles and purrs, but this was qualitatively different. Imagine the sound of a dozen people dragging their fingernails across a blackboard run through an amplifier at rock concert decibel levels and you'll get the idea. I'd seen plenty of turkeys spooking at the sight of predators, but I'd never seen or heard anything quite like this. So, I asked myself the obvious question: what had caused this state of panic?

Then a shadow slid across a sunlit patch of ground on the side hill, like something out of *Lord of the Rings*. I looked up in time to see a mature golden eagle settle into the top of a nearby ponderosa. The bird was so massive that the tree's thin upper limbs would not support it without drooping and recoiling, and the eagle had to flap around for some time before it found a stable perch. Meanwhile, the turkeys kept screaming and trying to worm their way deeper into the shelter of the thorn apple. The eagle was certainly targeting the turkeys, and it had chosen a position that allowed an unobstructed view of the brush so that no bird could make a break for freedom unseen.

I had seen lots of raptors fly over turkeys without producing a reaction like this. Most had been buteos, and I honestly didn't know whether or not a red-tailed or rough-legged hawk could kill a mature turkey. (Some say they can, but I've never found it documented.) I'd also seen eagles, including some goldens, flying over turkeys without producing this kind of dramatic reaction. I concluded that this particular eagle was turkey hunting and that somehow the turkeys knew.

And the eagle evidently knew that it couldn't swoop down through the tight canopy of brush where the turkeys had taken shelter. I watched the standoff for nearly an hour. The eagle never moved. The turkeys quieted down over time but never left the brush. To employ a sports metaphor, the offense and the defense were evenly matched. I didn't stick around for the conclusion of the standoff, but when I saw the flock again a few days later, one bird was missing.

The range of the golden eagle includes virtually all of North America except the high arctic. Our goldens are all of one subspecies, *A. c. canadensis*, but five other subspecies range across every other continent except South America and Antarctica. Here in Montana, their size alone makes adults almost unmistakable, although juveniles could be confused with immature bald eagles. While goldens demonstrate some size variation, wingspans of seven feet and weights of nine to ten pounds are typical for adult males, with females slightly smaller. While juveniles have white markings on the tail and wing (which are more clearly defined than the streaky white markings on young bald eagles), adults appear uniformly dark brown save for the

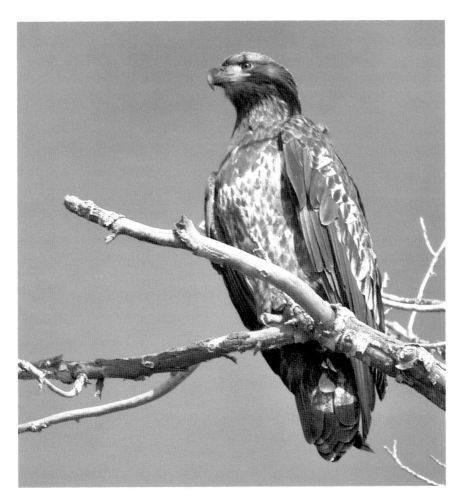

Golden eagle. *Photo by Tom Byrne.*

golden head and neck that give the bird its name. A turkey vulture could be mistaken for a golden eagle at a distance, but the eagle is much larger and has a steadier flight pattern than the vulture. The angle at which the bird holds its wings while soaring provides a good key to the identification of large raptors. The bald eagle holds its wings level, the vulture holds its wings at a fairly steep angle and the golden holds its wings slightly upturned.

In suitable terrain, goldens prefer to nest on cliffs beyond the reach of their few terrestrial predators. These locations also allow them to take advantage of thermal currents, allowing the long, gliding flight that is characteristic of the species. In Montana, goldens also occupy prairie terrain, where they

usually nest in the cottonwood trees that often provide the greatest elevation in the area. Nests are large and heavy. Breeding pairs of eagles often construct three or four of them, allowing a choice at nesting time so the pair can take advantage of the highest prey density in the area.

While many golden eagles occupy one home range throughout their lives, northern populations are migratory. Many of the eagles observed in Montana during the winter flew south from Alaska and northern Canada. One golden banded in Montana eventually turned up 1,200 miles away in Texas.

Eagles can be strongly territorial, especially during breeding and nesting season, and sometimes engage in spectacular aerial battles to defend their home turf. In the nest, newly hatched eaglets engage in a peculiar form of behavior called cainism (from the Old Testament) or siblicide, in which the strongest, usually the firstborn, kills its fellow nestlings. Often, the dominant chick simply out-competes them for food brought to the nest, but sometimes it kills and eats the other nest occupants. This strange behavior is not unique to the golden eagle, as it occurs in the nests of other raptor species, especially those of other eagles. While siblicide may seem counter-adaptive, it does give the breeding pair the best chance of raising at least one product of the brood to adulthood, which is what matters most to sparsely distributed, high-end predators like eagles. Some observations suggest that siblicide is more common during periods of prey scarcity, which would be logical.

Golden eagles provide an interesting comparison with Montana's other eagle, the bald. While bald eagles will hunt mammals, their principal sources of food are fish and carrion. They are happy to let others do the work, and will often rob fish-hunting ospreys of their catch. No wonder Ben Franklin wrote disparagingly of them during the discussion of the selection of our national bird:

> *For my part, I wish the Bald Eagle had not been chosen the Representative of our Country. He is a Bird of bad moral Character. He does not get his Living honestly. You may have seen him perched on some dead Tree near the River, where, too lazy to fish for himself, he watches the Labour of the Fishing Hawk; and when that diligent bird at length takes a Fish, and is bearing it to his Nest for the Support of his Mate and Young Ones, the Bald Eagle pursues him and takes it from him.*

In defense of our national bird, I have seen bald eagles catch large salmon at sea and drag them to shore by flapping their wings across the water's surface for remarkable distances.

The golden eagle is a much more capable predator, although it, too, will eat carrion, especially during the winter. For most of its life, the golden eagle is a hunter, feeding primarily on small mammals supplemented by birds, snakes and even young ungulates. A dietary analysis of eagle droppings done near Livingston showed that 87 percent of the birds' diet was of animal origin, with 80 percent consisting of lagomorphs—cottontails and jackrabbits. In areas with large colonies of prairie dogs and ground squirrels, those species become important components of the eagles' diet. In the alpine, goldens feed heavily on marmots. However, this is also the terrain in which young mountain goats and bighorn sheep sometimes fall prey to golden eagles. The golden is an accomplished aerialist that soars at thirty miles per hour and can hit speeds up to two hundred miles per hour when "stooping" on its prey—velocities comparable to what a falcon can attain, although the eagle is less agile. However, a golden can lift only about seven pounds, so it kills young goats and sheep by hooking them with its talons, dragging them to the edge of the nearest cliff and letting them fall to their deaths before dining on the carcass.

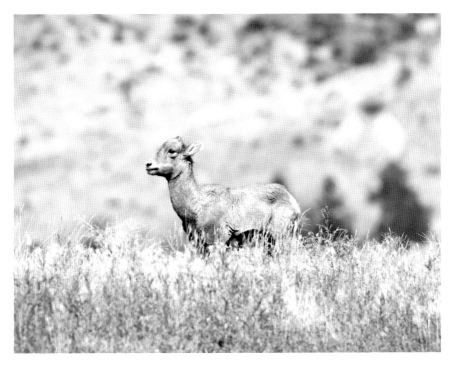

Golden eagles are powerful enough to kill young mountain goats and wild sheep such as this bighorn lamb. *Photo by Don and Lori Thomas.*

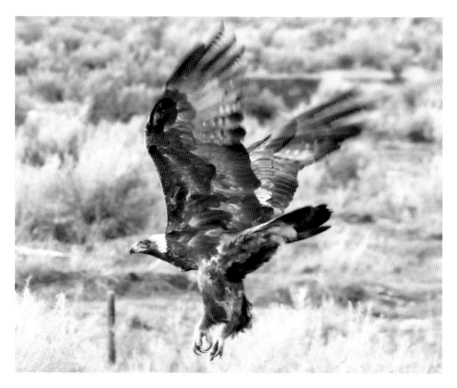

A golden eagle in flight. *U.S. Fish & Wildlife Service Mountain Prairie photo by Tom Koerner.*

One winter day, I was driving down a back road looking for lion tracks when a rancher friend flagged me down from his parked truck, handed me a cup of coffee from his thermos and said, "You've got to watch this!" Sometime that night, a vehicle had struck a full-grown whitetail doe, and the deer had made it to the middle of the adjacent pasture before it died. Magpies and ravens were circling overhead, but the only bird on the ground was a large golden eagle that clearly didn't want to enjoy this windfall in the exposed area where the deer had fallen. Tracks in the snow already indicated that the bird had dragged the deer over thirty yards, and it was still hard at work. Grasping the carcass in its talons, the bird was using the power of its wings to skid the dead deer across the snow a few feet at a time. A half hour later, the eagle had dragged the deer, which weighed around a hundred pounds, all the way to the trees at the far side of the pasture, where it finally opened the skin over the deer's hindquarter with its beak and began to eat. Such is the strength and tenacity of the golden eagle.

We humans have always appreciated those qualities in wildlife, perhaps because they sometimes seem so scarce in ourselves. The golden eagle (remember its worldwide distribution) has been an important icon of power since the dawn of western civilization. In ancient Greece, it was the symbol of Zeus. In Rome, the eagle was the symbol of Jupiter, and it appeared on many standards and emblems of the Roman Legions. In Arabic culture, the eagle was the personal symbol of the great military leader Saladin. Although they are difficult to handle because of their size and strength, golden eagles played an important role in medieval falconry, when they were reserved as hunting birds for emperors and kings. Golden eagles are still used to hunt in many parts of central Asia. The eagle is the national symbol of five countries today: Albania, Germany, Austria, Kazakhstan and Mexico.

The eagle has always been an especially important symbol among Native American tribes, and the bird figures prominently in many Plains Indian initiation and battle rituals. Not all eagle feathers were created equal. Friends in the Sioux community report that golden eagle feathers were strongly preferred over bald eagle feathers for ceremonial purposes.

Golden eagle populations are currently stable throughout the West, and the bird is not listed as threatened or endangered anywhere within its range despite a number of potential threats. A recent winter count in Montana revealed more than thirteen thousand goldens, more than in any other state. Nonetheless, the big birds have dodged some bullets and still face a few more. The widespread introduction of DDT into the environment caused a precipitous drop in bald eagle and peregrine falcon populations by interfering with the external calcification of eggs, but for some reason, goldens didn't experience this problem, at least in comparable severity. DDT was banned in 1972, but the bald eagle had already been listed under the ESA in 1967. (It was de-listed in 2007.) Electrical lines have always extracted a death toll from raptors, by electrocution and direct trauma, and the golden eagle is no exception. The proliferation of wind turbine generators across the West introduces a new variable to the eagle conservation equation. Turbine blades are particularly harmful to high-altitude flyers like eagles, the extent of which remains a matter of ongoing study. The moral of this story may be that even the cleanest energy comes at an environmental price.

What was then the Montana Fish and Game Commission offered a five-dollar bounty on eagles during the 1940s because of their real or perceived impact on game species and domestic sheep herds. The bald eagle received federal protection from Congress in 1940. The golden eagle received similar protection under the Bald and Golden Eagle Protection Act of 1962. This

legislation made it illegal to kill, molest, disturb, sell or otherwise interfere with both species of eagle, although enrolled members of recognized Indian tribes could obtain permits allowing them to use eagle parts for legitimate traditional purposes, a provision that has led to frequent litigation.

On March 24, 1993, a caravan of at least ten vehicles rolled down a gravel road in a remote section of Garfield County, the same general area where the Freemen standoff would take place three years later. Their destination was a large sheep and cattle ranch operated by Paul and Rosie Berger, and the caravan contained both federal USFWS agents and a CNN news crew. A disgruntled former ranch employee had reported to the USFWS that the Bergers had been killing protected eagles with firearms and poison. The Bergers summoned the local sheriff, who ordered the media representatives off the property. The Bergers were eventually charged with multiple felony counts of killing eagles. At trial, the Bergers were acquitted on all counts except one misdemeanor charge involving misuse of a pesticide. The Bergers subsequently filed a civil suit against both law enforcement and the involved media, claiming violation of their Fourth Amendment protection from unreasonable search and seizure. After an initial dismissal of the suit, an appellate court found for the Bergers on most claims. Residents of eastern Montana are still talking about the fiasco.

I describe this incident at the end of this section simply to illustrate with a local example the convoluted directions the relationships between humans and large predators can take, as wonderfully explored by David Quammen in his book *Monster of God*. I have no idea what did or did not go on at the Berger ranch, but as a rancher friend from the area later told me, "It couldn't have been anything that wouldn't have been better settled over a cup of coffee." While I hate to trivialize the illegal taking of protected wildlife—unproven, in this case—he had a point. As much as I respect the USFWS, it is hard to see how the addition of a large news crew contributed anything positive to this confrontation. Unfortunately, the future of wildlife in America will likely be driven more by politics than biology, and wildlife needs all the friends it can get.

SUGGESTED READING

Alt, David, and Donald W. Hyndman. *Roadside Geology of Montana.* Missoula, MT: Mountain Press Publishing, 1986.

Bakeless, John, ed. *The Journals of Lewis and Clark.* New York: Penguin, 1964.

Bodio, Stephen. *Eagle Dreams.* Guilford, CT: Lyons Press, 2003.

Cutright, Paul. *Lewis and Clark: Pioneering Naturalists.* Lincoln: University of Nebraska Press, 1989.

Duncan, Dayton, and Ken Burns. *Lewis and Clark: The Journey of the Corps of Discovery.* New York: Alfred Knopf, 1997.

Egan, Timothy. *The Big Burn.* New York: Houghton Mifflin Harcourt, 2009.

Herrero, Stephen. *Bear Attacks and Their Avoidance.* New York: Lyons and Burford, 1985.

Jones, Allen Morris. *A Quiet Place of Violence.* Bozeman, MT: Spring Creek Publishing, 1997.

Kerasote, Ted. *Bloodties.* New York: Random House, 1993.

Leopold, Aldo. *Game Management.* New York: Charles Scribner's, 1933.

Lott, Dale. *American Bison.* Berkeley: University of California Press, 2002.

MacClean, Norman. *Young Men and Fire.* Chicago: University of Chicago Press, 1993.

McCabe, Richard E., Bart W. O'Gara and Henry Reeves. *Prairie Ghost.* Boulder, CO: The Wildlife Management Institute, University Press of Colorado, 2004.

Peacock, Doug, and Andrea Peacock. *The Essential Grizzly.* New York: Lyons Press, 2006.

Picton, Harold, and Terry Loner. *Montana's Wildlife Legacy.* Bozeman, MT: Media Works Publishing, 2008.

Punke, Michael. *Last Stand.* New York: Harper Collins, 2007.

Pyrah, Duane. *American Pronghorn Antelope in the Yellow Water Triangle, Montana.* Helena: Montana Department of Fish, Wildlife, and Parks, 1987.

Quammen, David. *Monster of God.* New York: W.W. Norton, 2003.

Schullery, Paul. *The Bear Hunter's Century.* New York: Dodd, Mead & Company. New York, 1988.

Sibley, David. *Field Guide to Birds of Western North America.* New York: Alfred. A. Knopf, 2003.

Smith, Alexander. *A Field Guide to Western Mushrooms.* Ann Arbor: University of Michigan Press, 1975.

Thomas, E. Donnall. *How Sportsmen Saved the World.* Guilford, CT: Lyons Press, 2010.

ABOUT THE AUTHOR

*D*on Thomas grew up in the Pacific Northwest, the eldest son of bone marrow transplant pioneer and Nobel Laureate E. Donnall Thomas and his wife, Dottie. Higher education in Berkeley, Seattle and Montreal eventually led to a medical degree and board certification in internal medicine. After beginning his medical career on the Fort Peck Reservation in northeastern Montana, he eventually moved to Alaska, where he worked as a physician, pilot, commercial fisherman and hunting guide. For years, he bounced back and forth between Alaska and Montana, where he eventually ended his medical career on the Fort Belknap Reservation.

Throughout this time, he wrote regularly about wildlife and the outdoors for numerous national publications, including *Gray's Sporting Journal*, *Ducks Unlimited*, *Sporting Classics*, *Alaska*, *Big Sky Journal*, *Retriever Journal*, *Shooting Sportsman*, *Northwest Fly Fishing* and many others. He has served as co-editor of *Traditional Bowhunter* for nearly twenty years. He

has written eighteen previous books on outdoor topics, and his work has appeared in numerous anthologies.

Thomas and his wife, Lori—a photographer, outdoorswoman and fourth-generation Montanan—currently live in a rural area in the central part of the state. They have four grown children scattered around the West, their places in the home now occupied by numerous bird dogs.

ABOUT THE FOREWORD AUTHORS

*D*oug Peacock is the author of *Grizzly Years, ¡Baja!* and *Walking It Off: A Veteran's Chronicle of War and Wilderness* and co-author (with Andrea Peacock) of *The Essential Grizzly: The Mingled Fates of Men and Bears.* A Vietnam veteran and former Green Beret medic, Peacock has published widely on wilderness issues ranging from grizzly bears to buffalo, from the Sonoran desert to the fjords of British Columbia, from the tigers of Siberia to the blue sheep of Nepal. A friend of the late author Edward Abbey, Peacock was the model for Abbey's infamous character, George Washington Hayduke. He was named a 2007 Guggenheim Fellow and a 2011 Lannan Fellow for his work on his latest book, *In the Shadow of the Sabertooth: Global Warming, the Origins of the First Americans and the Terrible Beasts of the Pleistocene.* (His full, unedited bio can be found at http://www.dougpeacock.net/biography.html.)

*A*ndrea Peacock has covered western politics and conservation issues for more than two decades, for publications including *Mother Jones, High Country News,* the *Denver Westword* and *Austin Chronicle.* She writes frequently for Counterpunch.org and is the former editor of the *Missoula Independent.* She was the recipient of a 2010 Alicia Patterson Foundation fellowship for her work on the ways oil and gas development affects communities in the Rocky Mountain West. Her books include *Wasting Libby: How the W.R. Grace Corporation Left a Montana Town to Die (And Got Away With It)* (AK Press, 2010)

and *The Essential Grizzly: The Mingled Fates of Men and Bears* (The Lyons Press, 2006). She runs a used bookstore with Doug's cousin, poet Marc Beaudin, in Livingston, Montana, and lives near Emigrant, Montana, with her husband, author Doug Peacock.